Over the course of just a century in the city-states of ancient Greece, the foundation of our culture was established in philosophy, the arts, and government. *The Greek Miracle: Classical Sculpture from the Dawn of Democracy, The Fifth Century B.C.* attests to the impact that philosophical and political development has on artistic innovation. The remarkable sculptures in this exhibition were created in a period of reform and enlightenment that followed the birth of democracy 2,500 years ago and that mark a pivotal point in the growth of Western civilization.

Philip Morris Companies Inc. thanks the government and the people of Greece for permitting these splendors of antiquity to visit the United States. This unprecedented exhibition helps us to understand our artistic and democratic heritage. As a longtime leader in support of the arts and a company committed to the broader ideals of freedom, we are proud to help to make these seminal works available to the American public.

Michael A. Miles
Chairman and Chief Executive Officer
Philip Morris Companies Inc.

THE GREEK MIRACLE

THE GREEK

DIANA BUITRON-OLIVER

MIRACLE

CLASSICAL SCULPTURE FROM THE DAWN OF
DEMOCRACY • THE FIFTH CENTURY B.C.

With contributions by Nicholas Gage
Olga Palagia
Jerome J. Pollitt
Olga Tzachou-Alexandri
Vassilis Lambrinoudakis
Angelos Delivorrias
Peter G. Calligas
Daniil I. Iakov
Robertson Davies

NATIONAL GALLERY OF ART, WASHINGTON

THE GREEK MIRACLE IS MADE POSSIBLE BY PHILIP MORRIS COMPANIES INC.

The exhibition has been organized by the National Gallery of Art in collaboration with The Metropolitan Museum of Art and the Ministry of Culture of the Government of Greece.

Exhibition Dates:

National Gallery of Art, Washington
22 November 1992–7 February 1993
The Metropolitan Museum of Art, New York
11 March–23 May 1993

Produced by the Editors Office, National Gallery of Art
Editor-in-Chief, Frances P. Smyth
Editor, Jane Sweeney
Designer, Cynthia Hotvedt

Typeset in Meridien by Artech Graphics II, Inc., Baltimore
Printed by Peake Printers, Inc., Cheverly, Maryland

The hardbound edition is distibuted by Harry N. Abrams, Inc., New York. A Times Mirror Company

Cover: cat. 8

Title page, back cover: cat. 2

Photo credits:
Photographs of works of art from Greece by Giorgios Fafalis. All others in the exhibition supplied by their owners except cat. 3 and p. 103, left, by James Pipkin. Other photos: Alexandri figs. 1–3, James Pipkin; Delivorrias figs. 1–4, Hirmer Fotoarchiv, Munich; Lambrinoudakis figs. 1, 3, 6, 7, I. Iliadis, fig. 2, P. Grunewald, DAI, Berlin.

Library of Congress Cataloging-in-Publication Data
Buitron-Oliver, Diana.
 The Greek miracle: classical sculpture from the dawn of democracy: the fifth century B.C./Diana Buitron-Oliver; with contributions by Nicholas Gage . . . [et al.].
 p. cm.
 Includes bibliographical references.
 1. Marble sculpture, Greek—Exhibitions. 2. Bronze sculpture, Greek—Exhibitions. I. Gage, Nicholas. II. National Gallery of Art (U.S.) III. Title.
NB90.B74 1992
733'.3'074753—dc20 92-34046
 CIP

ISBN (paper) 0-89468-186-9
ISBN (hardbound) 0-8109-3371-3

Contents

The exhibition of sculpture being shown at the National Gallery of Art in Washington and the Metropolitan Museum of Art in New York celebrates the birth of humanism in Greece twenty-five centuries ago. There the value of the individual was first recognized, and that recognition produced the first self-government on earth—the first democracy. Perikles told Athenians that "The memory of our greatness will be bequeathed to posterity forever." He also foresaw that the Greek miracle of the fifth century B.C. could not last long. Although we take it for granted in our time, democracy is a delicate political plant that has flourished for brief periods in the long sweep of history. Only in ancient Athens and in the United States has democracy lasted as long as two centuries on a continuing basis. That is why our two countries have special roles to play in nurturing the democratic system, the United States providing the political leadership and Greece the spiritual force to ensure that free men live in harmony everywhere.

The birth of humanism 2,500 years ago in Greece also produced an outburst of the creative spirit that has never been surpassed. The sculptures in the exhibition are the finest pieces that have survived from Greece's Golden Age. It is fitting that their first journey from their homeland is to the United States, a country founded on the model of Greek Democracy.

It is fitting as well that in exchange for the loan of twenty-two works of art from Greece, the two American museums have lent seventy masterpieces of European painting to exhibit in Greece. The exchange of the two exhibitions dramatizes the deep connection between Greece, the birthplace of humanism, and the United States and Europe, where Greek ideals were reborn. The magnificent sculptures of this exhibition powerfully demonstrate why the Greek miracle has left its stamp on Western civilization for all time.

CONSTANTIN MITSOTAKIS

THE WHITE HOUSE

WASHINGTON

July 2, 1992

At a time when peoples around the world are beginning to establish systems of representative government, at a time when national elections have reminded Americans of the importance of having, and exercising, the right to vote, it is fitting that we commemorate the birth of democratic ideals some 2,500 years ago. What better way to celebrate the origins of democracy than with this magnificent exhibition of ancient Greek sculptures, which has been made possible by the cooperation and generosity of the Government of Greece.

These sculptures, which date back to the fifth century B.C., might well be viewed as symbols of the long-standing ties that exist between the United States and Greece. Two hundred years ago, the experiences of the ancient Greek city-states and the ideas of Solon, Plato, and other Greek philosophers and statesmen greatly influenced our Nation's Founders as they worked to craft a just and enduring system of government for the United States. Today, modern Greece stands as a valued partner in an alliance that has helped to defend and to promote human rights around the globe while ensuring the collective security of Europe.

It is my hope that each visitor to this exhibit will gain not only a deeper appreciation of ancient Greek sculpture but also a renewed sense of gratitude for our shared democratic heritage.

GEORGE BUSH

Foreword

Greek art centered on the image of man: man who of all the wonders in the world was the most wonderful, capable of great good, but also of great evil; sometimes falling back but, in the fifth-century Greek view, ultimately rising in the face of all odds to take charge of his destiny. Naturalistic representation of the human form had been one of the goals of artists in the preceding centuries, and by the fifth century artists were capable of expressing emotions and ideals as well.

The Greeks had a saying, καλὸς κἀγαθός (*kalos kagathos*), "the beautiful and the good," which they applied to those whose outer beauty reflected moral goodness of mind and spirit. This thought helps explain the appeal of classical Greek art. Beyond the formal and technical means for creating harmonious and balanced images, the Greeks imparted to their works of art something of this greatness of spirit.

Dramatic political developments had made the fifth century a time when the individual could indeed take charge of his destiny, for this was the first time in the history of the world in which a democratic government flourished. The reforms of Kleisthenes in 508–507 B.C. finally broke the power of the wealthy and of the landed aristocracy. By grouping the people of Athens and Attica into ten new tribes, Kleisthenes shattered old power alignments and gave every citizen a voice. A new sense of the power of the individual was in the air, and with it came a new sense of responsibility. Thus we have firm cultural grounds for seeing in the works of art a sense of measured action with full consciousness of its consequences, a sense of power tempered with calm deliberation.

This exhibition, comprising thirty-four original Greek works of marble and bronze sculpture, displays the development of the Greek classical style. Though relatively few fifth-century originals survive today amid the wealth of ancient works of art from all of antiquity, chance has preserved, at least in part, architectural sculpture from four great temples of this period. An example from each is included in the exhibition: the Temple of Aphaia on the island of Aegina, which marks the transition from the archaic to the early classical style; the Temple of Zeus at Olympia, the prime example of the early classical style; the Parthenon on the Acropolis of Athens, the apogee of the classical style; and a temple perhaps originally constructed at Eretria, also in the high classical style. The exhibition also includes freestanding sculpture dedicated as votive gifts in sanctuaries, both large-scale marbles and small bronzes. A magnificent series of gravestones takes the story to the end of the fifth century.

Such an exhibition has not previously been attempted. The difficulty of bringing together even a selection of the surviving original sculptures has heretofore been a deterrent. There are few such pieces in the entire Western hemisphere, and two of them are in this exhibition. While a more complete story of fifth-century art could be told by including later Roman copies of lost originals, Roman copies do not convey the subtlety and magnificence of the Greek prototypes; above all, they lack that inner life we sense in the original works.

This exhibition would not have been possible without the generous assistance of Philip Morris Companies Inc., which continues its distinguished tradition of cultural philanthropy in the United States and throughout the world. Specifically, we thank Michael Miles, chairman and chief executive officer, and the entire Philip Morris board of directors, as well as Stephanie French, vice president, corporate contributions and cultural affairs, for their approval and support of this historic endeavor.

An exhibition of this magnitude is not organized without the cooperation of many people, most especially the lenders whose generosity made the undertaking possible. We thank our esteemed colleagues in Greece, Europe, and the United States for their willingness to share with us their remarkable treasures from fifth-century Greece. We are immensely grateful to Prime Minister Constantin Mitsotakis and Mrs. Mitsotakis, who have shown keen personal interest in this historic and unprecedented exhibition and have enthusiastically supported it from the outset. Deputy Prime Minister Tzannis Tzannetakis and Prof. Anna Psarouda-Benakis, minister of culture of Greece, and Dr. Katerina Romiopoulou, director of antiquities for the Ministry of Culture and coordinator for the exhibition on the Greek side, have been instrumental in guiding the project. The Greek ambassador to the United States, Christos Zacharakis, and the United States ambassador to Greece, Michael Sothiros, together with their respective staffs, have been most helpful. We are most grateful to the Central Archaeological Committee and the directors of the lending Greek museums, particularly Dr. Olga Tzachou-Alexandri, director of the National Archaeological Museum, and Dr. Peter G. Calligas, director of the Acropolis Museum, who supported the loan of these magnificent sculptures from Greece. We are also grateful to Stavros S. Niarchos, who has provided an additional grant for the audiovisual presentation at the National Gallery.

We also wish to recognize our European colleagues, in particular the director of the British Museum, Robert G. W. Anderson, and the keeper

of the department of Greek and Roman antiquities, Brian F. Cook; Michel Laclotte, director, and Alain Pasquier, conservateur en chef, département des antiquités grecques, romaines, et étrusques at the Musée du Louvre; Dr. Wolf-Dieter Heilmeyer, director of the Antikensammlung in Berlin; Dr. Klaus Vierneisel, director of the Staatliche Antikensammlungen und Glyptothek, and the directors of the Wittelsbacher Ausgleichfonds in Munich; and our colleagues in Italy, most notably Prof. Anna Mura Sommella of the Musei Capitolini e Monumenti Communali, Dr. Paolo Battistuzzi, Assessore alla Cultura del Comune di Roma, Dott.ssa Maria Grazia Benini of the Ministero per i Beni Culturali e Ambientali, and Prof. Eugenio La Rocca, all of whom graciously agreed to add their rare works of fifth-century Greek sculpture to the core group lent from Greece.

Particular thanks are due to our guest curator, Diana Buitron-Oliver, whose vision and dedication to the spirit of Greek art helped guide the exhibition from its initial inception through its fruition, and to Carlos Picón, curator-in-charge of Greek and Roman art at The Metropolitan Museum of Art, who coordinated the exhibition in New York. Arthur Beale, Stephen Koob, and Paul Jett offered valuable conservation advice. Thanks are also due to Nicholas Gage, our remarkable Greek-American friend whose initiative, insightful advice, and boundless energy guided the project, to Artemis Zenetou, who served as liaison for the American organizers with Greek colleagues in Athens, and to Vangelis Tsangaris.

Those involved in mounting the exhibition at the National Gallery and The Metropolitan Museum of Art are numerous. From the National Gallery of Art we acknowledge the contributions of the Gallery's recently retired director, J. Carter Brown, and D. Dodge Thompson, who were involved in the negotiations from the beginning; Ann Bigley Robertson, who juggled the myriad administrative details, and Deborah L. Miller and Stephanie Fick, all of the exhibitions department; Elizabeth Weil Perry and Elisa Buono Glazer, who directed and coordinated the successful corporate sponsorship efforts; Ruth Kaplan and Deborah Ziska of the information office; Frances P. Smyth, Cynthia Hotvedt, and Jane Sweeney, who oversaw the complex task of producing the catalogue; Sally Freitag, Michelle Fondas, and Mary E. Suzor, who coordinated the details of packing and shipping; Mervin Richard, Michael Pierce, and Shelley Sturman of the conservation laboratory; our talented designers, Gaillard F. Ravenel, Mark Leithauser, Gordon Anson, and William Bowser; and Susan Arensberg, Lorraine Karafel, and Marcia Kupfer of the

education department, who were responsible for the exhibition brochure, the wall texts, and the audiovisual accompaniment. Thanks are due also to Charles S. Moffett.

From The Metropolitan Museum of Art we take this opportunity to acknowledge the essential contributions of Mahrukh Tarapor, assistant director, Ashton Hawkins, executive vice president and counsel to the trustees, Emily Rafferty, vice president for development, and Everett Fahy.

The unprecedented artistic creativity and genius that took place in Greece during the fifth century B.C. have been surpassed in no period since that time. On behalf of the National Gallery of Art, The Metropolitan Museum of Art, and the American people, we take great pleasure in bringing to our public for the first time these magnificent sculptures during a year in which we celebrate the twenty-five-hundredth anniversary of the birth of democracy and bear witness to the American tradition of free elections.

Earl A. Powell III
Director
National Gallery of Art

Philippe de Montebello
Director
The Metropolitan Museum of Art

12

Lenders to the Exhibition

Acropolis Museum, Athens

Agora Museum, Athens

Archaeological Museum, Eleusis

Archaeological Museum, Olympia

Archaeological Museum, Samos

The British Museum, London

Kerameikos Museum, Athens

The Metropolitan Museum of Art, New York

Musée du Louvre, Paris

Musei Capitolini e Monumenti Communali, Rome

National Archaeological Museum, Athens

Staatliche Antikensammlungen und Glyptothek, Munich

Staatliche Museen zu Berlin, Antikensammlung

Acknowledgments

Works of classical art speak to us across the centuries, eliciting timeless homage because of their beauty and grandeur. We use the word "classical" to describe the art of fifth- and fourth-century-B.C. Greece, but in a more general sense, particularly in the form "classic," the term has come to denote something prototypical, excellent, authoritative. The word seems to have first been used by the Romans: the Latin *classicus* appears in the writings of Cato the Censor in 170 B.C. to signify the first and richest of the five property classes into which the Roman people were divided. By the second century A.D., Roman scholars applied the term to authoritative works of Latin literature.

For a comprehensive definition of the formal aspects of classical art we can thank the German art historian Heinrich Wölfflin who, in 1899, first published his work *Classic Art* in which he defined the term as applied to fifteenth-century Italian art. His definition is equally appropriate for the classical art of fifth-century Greece: works characterized by a sense of repose and spaciousness, a feeling for mass and size, simplification and lucidity of form, but at the same time complexity of motion and meaning, for this art has as one of its principal characteristics a strong interest in the psychology of events. All of these features are presented in a way that suggests unity and inevitability. In the mid-eighteenth century, J. J. Winckelmann had already sought to define the best of Greek art as having "noble simplicity and quiet grandeur." For the late British art historian Bernard Ashmole, the classical artist excelled in the "unhurried, unsensational revelation of the beauties of the commonplace."

This exhibition makes it possible for an American audience to see celebrated original works of Greek art for the first time in the United States. Many people worked to achieve this, not least the custodians of the classical legacy in Greece today. The directors and ephors of several museums in Athens and elsewhere in Greece facilitated study and examination of the works of art in the exhibition. We are grateful in particular to Olga Tzachou-Alexandri, director of the National Archaeological Museum, Katerina Romiopoulou in her role as curator of sculpture there, and Rosa Proskinitopoulou, curator of bronzes. At the Acropolis Museum, we thank Peter G. Calligas and Ismene Triandis; at the Agora Museum, Maro Kyrkou, and at the Kerameikos and Eleusis Museums, Theodora Karaghiorga. At Olympia we thank Xenie Arapoyanni, and at Samos, Photeini Zaphiropoulou. We warmly thank Steleos Triandis, chief sculptor in charge of the exhibition.

We chose a number of works of art from museums in England, France, and Germany in order to enlarge the scope of the exhibition. We owe

thanks to our colleagues in these museums who collaborated with us on every level, facilitating photography, sharing ideas, and agreeing to lend pieces under their care: at the British Museum, Brian F. Cook and Dyfri Williams; at the Musée du Louvre, Alain Pasquier and Brigitte Bourgeois, and especially Sophie Descamps who provided new insights into the bronze figures lent to the exhibition; in Berlin, Wolf-Dieter Heilmeyer and Gerhard Zimmer; in Munich Klaus Vierneisel, Raimund Wünsche, and Martha Ohly-Dumm; in Rome, Anna Mura Sommella and Eugenio La Rocca. For help in facilitating the loan from Rome we also thank Maxwell L. Anderson, director of the Michael C. Carlos Museum of Art and Archaeology at Emory University, Atlanta, and Jay Levenson.

We also acknowledge the interest and assistance of Arthur S. Giuliano, counselor for public affairs, Lynn Sever, cultural attaché, and Claudia Lolas at the United States Embassy in Athens.

Carlos Picón, curator-in-charge of Greek and Roman art at the Metropolitan Museum of Art, has offered welcome advice and support during the planning of the project.

In the catalogue that accompanies the exhibition we have sought to provide extensive photography of each work of art. Thanks are due to Georgios Fafalis for the excellent photography of the objects in Greece, and to the photographers of the British Museum, the Musée du Louvre, the Antikensammlung in Berlin, and the Capitoline Museum in Rome. James Pipkin photographed the head of the warrior in the Munich Glyptothek. Accompanying the photographs are brief, descriptive catalogue entries designed to help the visitor look at the objects and understand their stylistic relationships. To suggest the similarity of spirit that infected other branches of the arts, quotations are included from some of the great literary figures of the fifth century: the poet Pindar, who wrote odes to victorious athletes, and the tragedians Sophokles and Euripides, whose theatrical productions were a stimulating and vivid factor in fifth-century Athens. Olga Palagia has contributed an essay on the development of the classical style, which expands the stylistic discussion and places the objects in the larger context of fifth-century art. Jerome J. Pollitt has elucidated the political background of the period that saw the development of the classical style. Robertson Davies, the noted Canadian novelist, addresses the question of how these classical works of art speak to us today. We are also most grateful to the five authors suggested by the Greek Ministry of Culture for their informative essays: Olga Tzachou-Alexandri, Peter G. Calligas, Vassilis Lambrinoudakis, Angelos Delivorrias, and Daniil I. Iakov. We thank the translators of these essays: Judith Binder,

Alexandra Dumas, and Leslie Finer. Nicholas Gage, who has played a significant role in the realization of this exhibition, provided a thoughtful introductory essay.

Finally we thank several individuals who reviewed all or parts of the catalogue text: Jerome J. Pollitt, Andrew Oliver, Evelyn B. Harrison, Carol Mattusch, Richard Mason, and Glenn Bugh.

Throughout this endeavor I have been deeply grateful for the cheerful and efficient organization of the National Gallery of Art. At all times I have had the generous and attentive support of J. Carter Brown. I am also grateful to Earl A. Powell III who has continued to place the resources of the Gallery behind this exhibition.

Diana Buitron-Oliver
Guest Curator

Introduction

First, there was the vision. In the fifth century before Christ, an unprecedented idea rose from a small Greek city on the dusty plains of Attica and exploded over the Western Hemisphere like the birth of a new sun. Its light has warmed and illuminated us ever since; sometimes obscured by shadows, then bursting forth anew as it did when our own nation was created on the model of the Greek original. The vision—the classical Greek idea—was that society functions best if all citizens are equal and free to shape their lives and share in running their state: in a word, democracy.

With this new day came an explosion of the creative spirit in Greece, producing the architecture, the art, the drama, and the philosophy that have shaped Western civilization ever since. Jason's harvest of armed soldiers, grown in a day from dragon's teeth, seems no more miraculous. "What was then produced in art and thought has never been surpassed and very rarely equalled," wrote the classicist Edith Hamilton, "and the stamp of it is on all the art and all the thought of the Western world."

The concept of individual freedom is now so much a part of our spiritual and intellectual heritage that it is hard today to realize exactly how radical an idea it was. No society before the Greeks had thought that equality and freedom of the individual could lead to anything but disaster.

The revolutionary notion that ordinary man could rule himself took root 2,500 years ago in the late sixth century B.C. after the Athenian lawgiver, Solon, extended power sharing beyond the aristocracy. It crystallized in the last decade of the century with the reforms of the statesman Kleisthenes, reforms that distributed political rights to all free citizens and established equality before the law.

Long before the Greeks, mankind realized that order was necessary for society to function, but it was always believed that order was impossible without autocratic rule. The great empires of the ancient world—Egypt, Mesopotamia, Persia—were all tyrannies. It took the small and unimpressive city-state of Athens to produce the idea that individual freedom and order are not incompatible.

The Greeks did not come up with that concept because they were naive optimists. They were, in fact, realists who understood very well that unlimited freedom can produce chaos. The principles they most revered were moderation, balance, self-control, all summarized by the words attributed to Solon carved in the stones of their holiest shrine, Delphi: "Nothing in Excess." The Greeks embraced this golden mean because they were a passionate, individualistic people, quick to vent their emotions, and they realized how difficult moderation is to achieve. Every Greek considered himself a

battlefield where Apollo's reason and Dionysos' passions struggled for control.

The fact that the Greeks knew the extremes of passion so well was precisely why they placed such a high value on self-control. Knowing the dangers of excess, they struggled to restrain the impulses for unrestricted freedom that can make life in a community intolerable. Perikles said: "We are a free democracy, but we obey the laws, more especially those which protect the oppressed and the unwritten laws whose transgression brings shame." The faith of Greeks in every person's unique capacity to reason and to impose self-control from within was a major force in creating that peculiar Athenian experiment, the world's first democracy, which involved every farmer, shepherd, and tradesman in the government. "The individual can be trusted," Perikles said. "Let him alone."

Mortal man became the standard by which things were judged and measured. Buildings were built to accommodate the body and please the eye of a man, not a giant. Gods were portrayed as resembling human beings, not fantastic creatures. And the ruler—the lawmaker and judge— was for the first time the ordinary citizen. As Sophokles wrote in *Antigone:* "Wonders are there many—none more wonderful than man."

The ancient Greeks believed there is a divine spark to be found within every mortal. Their gods looked and acted like humans, complete with human foibles and weaknesses. This is an essential difference between the Greeks and all previous societies, which stressed that good behavior must be enforced upon men by the threat of retribution from outside, superhuman forces. It was no coincidence that the Greek discovery of individual worth and freedom produced the most profound advances in art and sculpture. If the spark of divinity is to be found in man, then the form and appearance of man would inevitably be the proper subject matter of the artist. The truth could be found in the natural world, including man's body and mind, not in some mystical, incorporeal world. While the artists and religious leaders of the East tried to find truth by distancing themselves from the physical world, the Greeks studied the real, the physical, the natural in their search for truth and wisdom.

Before the Greek miracle, the great civilizations of the world produced art that was rigid, formal, symbolic rather than realistic. In Egypt life was ruled by overwhelming forces of nature: rain, wind, sun, drought. Egyptian sculpture and architecture, such as the sphinx and the pyramids, were equally colossal, beyond the ken of mere mortals who were tiny as ants in comparison. The Eastern artist was taught to consider the outside world merely an illusion and to withdraw from it through solitude, meditation, and chanting until he lost all consciousness of self and beheld the image

of a god that would have no human shape. By banishing the flesh, the art of the East became mystical and supernatural; fantastic figures with multiple hands, arms, and breasts, whirling in ecstasy, were symbols of spiritual truth. In contrast, an artist who believes that man holds the spark of divinity, that there is "none more wonderful than man," will make the human form his object of study.

When reason and spirit fuse, as they did in the time of Perikles, the natural goal of the artist is to portray beauty in the image of man, but idealized. Like the philosopher and the scientist, the artist sought the essence of the thing, trying to strip away confusing details and variations to uncover the purest ideal of the human body, the perfect balance between flesh, spirit, and intellect. This, for him, was the best rendition of a god and of spiritual perfection. No symbols or special trappings of divinity were required beyond the figure's physical harmony. The most perfect beauty, to the Greek of the fifth century, was the pure and unadorned.

This miracle did not happen instantly. By studying the development of the human figure in Greek sculpture, we can see the perfection of naturalstic art emerging from the chrysalis of what went before. Archaic kouroi are stiff, stylized, portrayed frontally with their mystical smile. Like figures in the art of earlier civilizations, they are rigid as the stones from which they are carved. In the *Kritios Boy* of the early classical period the human form takes a revolutionary step out of the block of marble, turning his head and escaping the restraints of centuries. He is a synthesis of *ethos* (noble character) and *pathos* (emotion) never before achieved. Within a stunningly brief period of time, the representation of the human figure achieved its finest expression, idealized yet completely natural, in a bronze masterpiece called the Zeus of Artemiseion, frozen in perfect balance in the instant before he hurls a thunderbolt. The Greek miracle was complete.

Why did this miracle spring from the soil of Attica rather than a mightier, richer, or more ancient civilization? No one can say for certain, but one reason may be the nature of the landscape of Greece. It is not a place of extremes. Greece is a land of unceasing variety, austere but beautiful, where everything can be taken in by the human eye and understanding. Ancient Greeks believed Mount Olympus touched the sky, yet it is only 9,750 feet high. Nature built Greece on a human scale and the Greeks followed suit, creating their gods and designing their temples to the measure of man. This idea of human proportion as the basic unit pervades Greek thought.

Another reason for the Greeks' unique vision may be that they lived at the crossroads of three continents, venturing from their land all over the Mediterranean world to trade and establish colonies. This gave them, with

the explorer's boldness and the philosopher's yearning for basic truths, the opportunity to examine the ideas of other civilizations and compare them to their own. Ultimately their experiences and instincts led to the creation of the Greek miracle that astonished the world. Such greatness of art, literature, philosophy, and government set a standard for the civilizations that came after. For nearly a century, on the austere plain of Attica, men reached a level of excellence that has remained an inspiration for mankind, the mind and spirit in equilibrium as never before or since.

The objects in this exhibition are the most moving and vivid illustration of what the Greeks attained in that time and place. It is a unique privilege to experience them for the first time in our democracy that was modeled on theirs.

Nicholas Gage

THE GREEK MIRACLE

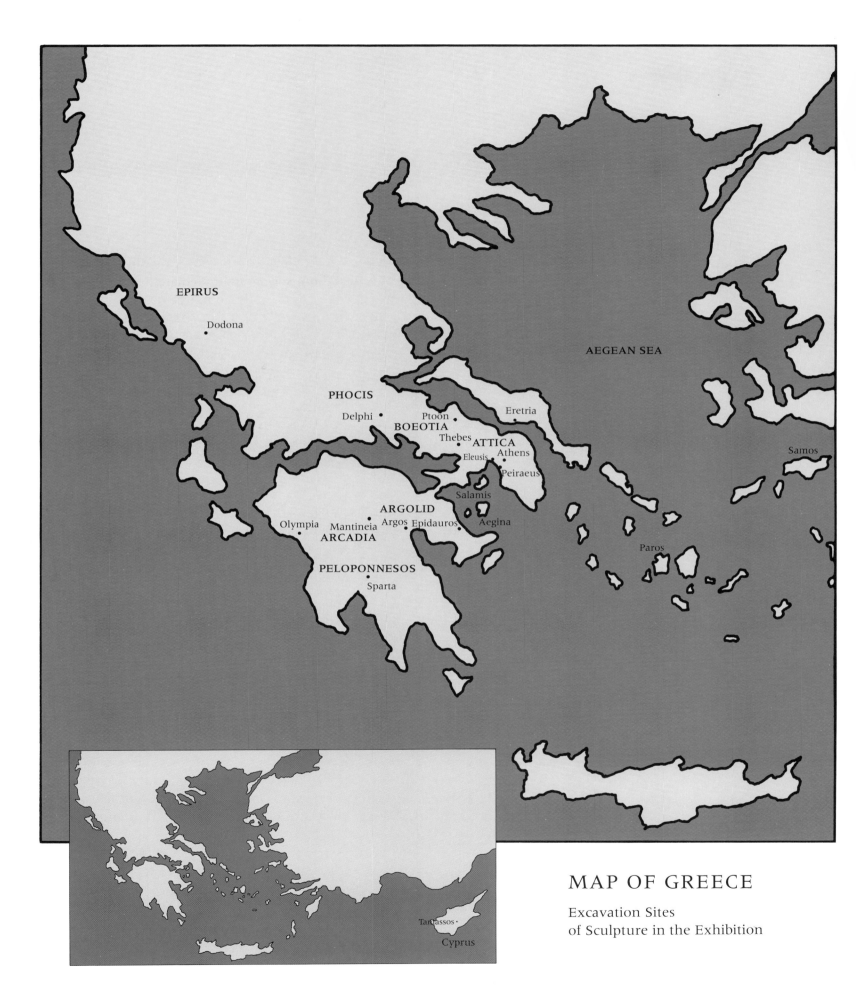

MAP OF GREECE

Excavation Sites
of Sculpture in the Exhibition

The Development of the Classical Style in Athens in the Fifth Century

Olga Palagia

Although the classical style did not spring up immediately at the inception of democracy after 510 B.C., and had moreover begun to emerge before the Greek triumph in the Persian Wars in the first two decades of the following century, it is difficult not to associate it, however indirectly, with historical circumstances. Just as the writing of history gradually emerged in Athens as a science, Greek sculpture was emancipated from the conceptual idiom of the Orient and directed toward a naturalistic representation of the visual world. It is often asked why Greek artists abandoned the archaic tradition in which they had worked successfully for two centuries. The classical moment seems to have developed as a result of mental adjustment from the timeless to the temporal and from the objective to the subjective: as mythology gave way to history, so was formulaic art replaced by the art of illusion. Free of the magical associations of the East and permeated by the individuality of the artists, classical sculpture was based upon perception of changing visual phenomena. Its emergence was based on ceaseless experimentation with ever more lifelike renderings of the human form, which was almost its sole subject.

It is only by comparison with earlier art forms that we begin to understand the impact of the classical. Archaic Greek sculpture (650 – 480 B.C.), which was a product of visual abstractions operating through a rigid set of proportions adapted from Egyptian and Near Eastern proto-types, is exemplified by the sixth-century kouros from Mount Ptoön (cat. 1). Ruled by the laws of symmetry and frontality, the figure is split in half by a vertical axis running through its spine. As a result, lateral movement is inconceivable. Although designed as a walking figure, its posture is not made visually intelligible since its weight is equally distributed between its legs. Dominated by the frontal plane, the figure appears two-dimensional, with its four cardinal profiles meeting at barely disguised right angles. In archaic relief sculpture too, the juxtaposition of frontal and profile views added up to a whole made up entirely of linear patterns with purely decorative effects.

Classical sculpture retained the geometric principles of earlier periods, underlining rather than dominating the recently discovered naturalistic forms. Although it is not possible to specify a single geographical origin for the classical style, which seems to emerge in several places at once, Athens is clearly dominant. A transitional period of adjustment took place in the first two decades of the fifth century. New tendencies began to blend with traditional elements in the ultimate creations of the archaic period. As these tendencies first appeared in narrative sculpture,

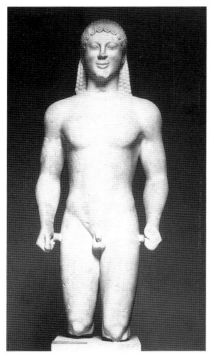

cat. 1

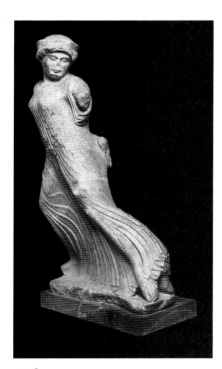

cat. 2

it has been suggested that the classical style developed as a result of the need to liven up narration. The odd character of transitional pieces makes them rather hard to date. A good example of the uneasy mixture of archaic and classical is the running maiden of Eleusis of circa 480 B.C. (cat. 2). This figure is interpreted as the goddess Hekate, companion of the Eleusinian goddesses Demeter and Kore, and restored with torches lighting Kore's return from the underworld. The linear patterns of her dress are subordinated to her bodily forms. As a result of the running pose, her weight appears to fall on the right leg, while her swollen eyelids betray an attempt to suggest three-dimensional shapes.

The transitional style of 500 – 480 B.C. was followed by the early classical, which ran into the middle 440s. The graceful linearity of archaic forms gradually gave way to a nearly brutal emphasis on volume and a novice's delight in anatomical details. This marked an almost clean break with the past. Rules of proportions now tended to follow the asymmetries of the human body, while the relaxed stance of the standing figure strove for balance between taut and relaxed muscles. The law of frontality was broken by movement. These tendencies found their perfect expression in the high classical phase of the second half of the fifth century. New fashions in dress and hair included the heavy woolen fabric of the Doric peplos for women, the sober vertical folds of which are sometimes taken to symbolize democratic mores, and bangs of hair covering the foreheads of both men and women. In an effort to emphasize the solidity of volume, facial features became more rounded, imparting a severe expression to the faces, hence the term "severe style" given to the early classical phase. The more advanced manifestations of this style in the pedimental sculptures of the Temple of Zeus at Olympia introduce an element of realism in the depiction of pain and old age.

Formal developments were abetted by technical innovations in both marble and bronze. As a result of the development of the indirect lost-wax method of bronze casting in the first half of the fifth century, bronze became the standard medium for monumental statuary. This method involved the use of full-scale models in clay for the production of clay piece-molds. The statue was then cast in pieces that were put together by means of iron pins. The models were not destroyed in the process of casting and probably served for the reproduction of more than one original. Bronze-casting methods may well have influenced the processes of marble carving, gradually relegated to architectural sculptures, reliefs, or marble variants of celebrated bronzes. It has been argued on the evidence of the measuring bosses on the foreheads of certain pieces from

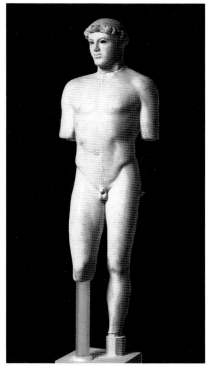

cat. 5

the Temple of Zeus at Olympia that full-scale preliminary models were employed for the creation of larger-than-life-size marble groups placed in the pediments of early classical temples. Full-scale models were in fact essential for the reproduction of the classical forms. The versatile poses and accurately observed anatomy of classical figures suggest that they were initially modeled in clay rather than carved directly on the stone as had been the practice in the archaic period.

The study of classical sculpture is plagued by our inability to correlate the extant works of art with the information preserved in ancient literary sources. Most fifth-century sculptures named by Greek and Latin authors have disappeared, and many of the signed statue bases that have come down to us lack statues. Original sculptures of the fifth century are now either anonymous or the creations of artists otherwise unknown. Only in rare circumstances are we able to associate later copies with famous names. We are thus forced to consider the evolution of style as the mechanical process of an impersonal craft, which is not what ancient critics believed about the visual arts.

The dawn of the early classical era in Athens is heralded by a group of small-scale marbles from the Acropolis. Their size suggests private dedications. Their informal charm marks a sharp contrast to the over-elaboration of the last years of the sixth century. The so-called *Kritios Boy* of about 480 B.C. is a well-known example of the first systematic manifestation of the new style (cat. 5). The kouros schema is replaced by a breathing, natural form. The rigid walking stance has turned into a relaxed pose with weight shifted onto one leg. The displaced hip, arms free of the sides, shoulder moved back, and head slightly turned away invite the spectator's participation in the drama of the human form in its naturalistic nakedness. Fresh and unpretentious though he may appear to be, the *Kritios Boy* is thought to represent a hero, possibly Theseus, symbol of Athenian democracy. His inlaid eyes, now lost, were once interpreted as the influence of metalworking, but are in fact a survival of archaic practice.

In the second quarter of the fifth century a new type of image was created for the goddess Athena, patroness of Athens, which was to last until the end of antiquity. By contrast to the enthroned or striding types of the archaic period, she now stands quietly, with helmet, spear, and shield, dressed in a peplos girded at the waist. This dress was suitable for young girls. Two pieces from the Acropolis are the earliest surviving sculptured examples. Both exemplify a favorite motif of repose of the early classical, with one hand resting on the hip. The votive relief (cat. 8)

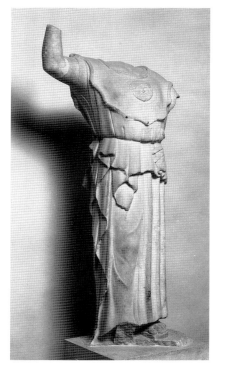

cat. 7

of the so-called "Mourning Athena" shows the goddess divested of her weapons except for her helmet and spear, quietly contemplating a pillar. The iconography is so unusual as to elude interpretation. Does the pillar perhaps carry a casualty list? Athena's skirt, formed by continuous vertical pleats, is reminiscent of the roughly contemporary bronze *Delphi Charioteer.* The armed Athena (cat. 7) probably stood on a column inscribed with a dedication by Angelitos and signed by the sculptor Euenor, whose other works are unknown. Despite its small size, this work is of enormous significance for the development of the early classical style. All the seeds of the new era are here contained. It is the earliest extant example of a freestanding female figure whose skirt carries a vertical division in two. While her bent leg clings closely to the garment, vertical folds reminiscent of column fluting cover her weight leg. This was to become standard for representations of women in the classical period, but here it is still in an experimental stage: the arrangement is reversed at the rear, where the relaxed leg disappears under the folds. The elongation of the right side of the figure as opposed to the contraction of the left heralds a growing preoccupation with perspective foreshortening, while the vertical axis is effectively broken in search of a precarious balance.

It was during the fifteen years of construction of the Parthenon on the Athenian Acropolis (447–432 B.C.) that the early classical phase (480–445 B.C.) finally made way for the high classical (445–390 B.C.). This marked a fresh break, diverting the streaks of nascent realism into more formal channels. The Parthenon was an exceptional temple of great magnificence created to glorify Athens, now capital of an empire, and as such it introduced a new style in both sculpture and architecture. A formative influence on the architectural sculptures of the Parthenon was the personality of the Athenian sculptor Pheidias, officially responsible for the colossal statue of Athena Parthenos in ivory and gold that stood inside the temple. There is only indirect evidence for Pheidias' involvement with the Parthenon itself. On stylistic grounds, his associates Agorakritos and Alkamenes are thought to have supervised the carving of the frieze and pediments. Both temple and statue carried decoration of special religious and political significance. Many of the mythological themes depicted on the statue were duplicated on the temple. The battle of Greeks and Amazons on the west metopes of the temple reappeared on the exterior of Athena's shield; the battle of gods and giants on the east metopes recurred on the interior of her shield; while the battle of Lapiths and centaurs was shown both on the south

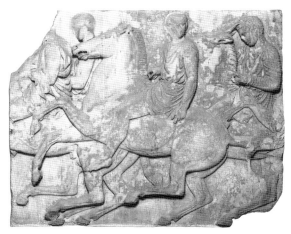

cat. 22

metopes and Athena's sandals. Such mythological conflicts were meant to evoke the glorious days of the defeat of the Persians at Marathon in 490 B.C. Athena's miraculous birth shown in the east pediment of the temple was echoed in the birth of Pandora on the statue base. Both scenes were attended by the twelve gods of Olympus, ostensibly patrons of the Athenians. The capture of Troy shown on the north metopes of the Parthenon was a popular theme of the fall of an Asiatic city into Greek hands.

No contemporary events were represented on Greek temples, but the rule was broken on the Parthenon: the relief frieze running along the exterior walls of the cella showed the procession of the Panathenaic festival, celebrated every four years on Athena's birthday. The high points of the festival were the dedication of a garment to Athena and a sacrifice of cows and sheep at her altar on the Acropolis. Large parts of the frieze are occupied by a cavalcade of Athenian knights (cat. 22). The overlapping horsemen carved in low relief introduce a contemplative mood. They are accompanied by a procession of chariots, musicians, officials, and young men and women carrying the instruments of sacrifice. Athena's garment also forms part of the ceremony that is watched over by the twelve gods of Olympus. Great expertise in the handling of very low relief gives the illusion of depth. The artists' preoccupation with perspective, attested by contemporary literary sources, is apparent in the treatment of the relief, where the upper parts of the figures are made to project farther while those standing in the background may appear in lower relief. The frieze was carved directly on the building in contrast to the rest of the architectural sculptures, which were produced in a number of workshops set up on the Acropolis. Public building accounts on stone record the processes of quarrying the marble for the Parthenon sculptures on Mount Pentelicon and carting the material to the site, which went on simultaneously with the actual carving on the Acropolis. Increased awareness of the natural forms is here tempered by idealism, by means of which all humans are carried onto a higher plane of unruffled youth. There is little variation in facial expressions and all heads seem to have been carved after one cartoon. Grace and refinement set the tone. The archaic elements of repetition and linearity are reintroduced and superimposed on the classical form, adding elements of aloofness and grandeur appropriate to the imperial mantle of the Athenian democracy. The subtle representation of great events on the frieze is enhanced by the informal appearance of the gods, who are thus made to appear closely involved in human affairs.

Even more revolutionary is the treatment of the pedimental sculptures of the Parthenon, depicting the birth of Athena in the east and the contest of Athena and Poseidon for the land of Attica in the west. Both themes were unusual for architectural sculptures and were meant to glorify Athens, elevating it to the level of the abode of the gods. Colossal statues carved in the round, sometimes of a single marble block and carefully finished in the rear that was never meant to be visible, formed closely knit compositions of unprecedented complexity. They are master-pieces of marble carving and exerted considerable influence on later Greek sculpture, which was not the usual fate of architectural sculptures. Their advanced style, transcending the limits of the classical, looks forward to the Italian Renaissance. The genius of the Parthenon sculptures in fact consists in their rapid development from the robustness of the early classical style of the metopes to the idealism of the frieze and finally to the almost baroque excesses of the pediments.

From the archaic period onward, Athens, being fertile ground for the cultivation of many diverse currents, had attracted sculptors from all over Greece. A good number of sculptors from outside the city must have worked on the Parthenon sculptures, assimilating the high classical style as it developed through the carving of the frieze and metopes. After the completion of the Parthenon, many found employment in the construction of temples around Attica; others set up shops for the production of reliefs. All those trained on the Parthenon and the statue of Athena Parthenos became to some extent pupils of Pheidias and were responsible for the next, post-Pheidian phase of high classical sculpture. Inspired by the style of the pediments of the Parthenon, post-Pheidian sculpture exploited to the full the potential of drapery for the expression of both movement and volume. Pictorial effects of light and shade, created by drilling large and small holes and cutting grooves into the marble, enhanced the illusion of three-dimensional forms.

The building program on the Acropolis, initiated in the Parthenon in 447 B.C., continued almost to the fall of Athens with the completion of the Erechtheion in 406 B.C. In between, the temple of Athena Nike, erected on the bastion near the entrance to the Acropolis in the 420s, was embellished circa 410 with a marble balustrade running along three sides of the bastion. The balustrade slabs carried reliefs of winged Victories paying homage to Athena as goddess of war by erecting trophies on battlefields. They also lead cattle to sacrifice as part of the Panathenaic festival, which included sacrifices to Athena Nike, originally worshiped as a vegetation deity. Although no historical associations are

28

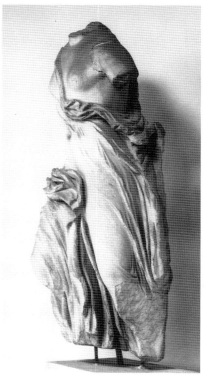

cat. 27

probably meant, the Persian spoils on some of the slabs may carry a nostalgic allusion to the past glories of Marathon, evoked in the hard years of the war with Sparta. The playful, carefree style of the Victories is the purest expression of the "rich style," which flourished in the last years of the fifth century. It is characterized by clinging draperies and sweeping curves, sometimes leading to effects of almost irrational motion. A Victory unfastening her sandal (cat. 25), easily the most famous figure on the balustrade, is precariously balanced in a momentary pose with her clothes about to slide off her robust body. Her transparent dress is modeled by a series of ridges. The swirling movement of her outline holds the figure together, while the pendent folds of the mantle over her left arm serve to clarify the vertical accent of the composition. This slab is an example of the perfect blend of rationalization and sensuousness that gives a true measure of the Greek miracle. By contrast, the akroterion of a Nereid (cat. 27), dated about twenty years later, with her almost dislocated limbs and immature naked body occasionally scarred by incised drapery folds, marks the dissolution of the rich style.

Votive and grave reliefs proliferated in the years following 430 B.C. Although humble products of an anonymous craft, at first they retained the high standards set by the Parthenon masters. It is only in the fourth century that the effects of mass production would be felt in the quality of the workmanship. At any rate, they always tended to reflect developments in major sculpture, sometimes even copying famous statuary types of the previous decades. The earliest reliefs of the last quarter of the fifth century were highly individualized. The iconography of most votive reliefs of this period is unique. Most unusual is the relief dedicated to Hermes and the nymphs by Kephisodotos (cat. 26), not least because it is crowned by a pediment, rarely found on votives. It is carved on both sides, and it has been suggested that the rear was an afterthought. The god Hermes takes pride of place at the left on either side. The rear carries an abduction scene, while the principal side is a gathering of minor deities, including the horned river god Kephisos and three nymphs at the right. Profile figures oddly appear on a slightly larger scale. Gods standing in a row, often not easily identified, were very common in sculptures of this period.

Fifth-century grave reliefs usually showed one or two figures in quiet contemplation. There were no attempts at portraiture: the idealized features automatically carried the depicted on a higher plane. Gestures were very restrained, nearly always laden with meaning. Handshakes symbolized family unity lasting beyond the grave, while the gentle lifting of drapery could be a greeting, a farewell, or simply a matron's gesture. All principal

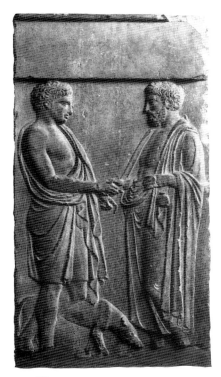

cat. 32

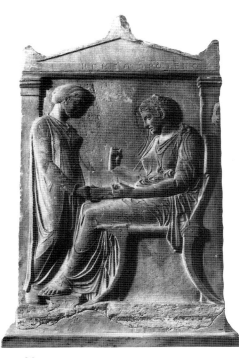

cat. 33

figures were upper-class, depicted with symbols of leisure occupations. They could be accompanied by boy or girl slaves, a reflection of contemporary society. Young boys could hold athletic equipment or hunters' weapons, accompanied by dogs; women were shown with babies or jewelry boxes; children held toys. Adults could be enthroned in imitation of Zeus or shown as soldiers or priests, none of them professional.

Among the earliest grave reliefs, that of Eupheros (cat. 29), from the grave of a fifteen-year-old boy, shows him dressed in his best and holding a *strigil,* a symbol of amateur athletics. The unique scene of almost pictorial quality of a young boy about to place his pet bird in a cage (cat. 30) incorporates the representation of a cemetery, suggested by a grave relief topped by a feline, which is partly obscured by a slave boy steeped in sorrow. The style betrays a hand trained in the workshops of the Parthenon, but the iconography is closer to funerary vase painting. More conventional reliefs were surely not custom-made, for example the pairs of father and son (cat. 32) and husband and wife (cat. 34). The dead and the living gaze into each other's eyes, their subtle gestures indicating a unity of emotion that outlives death. Around 400 B.C. both the highly idealized overtones of the Parthenon and the sharp contrasts of the rich style gave way to gentler gradations of textures directed toward a slightly more realistic rendering of drapery. The grave relief of Hegeso (cat. 33), dated to the first decade of the fourth century, exhibits the new trends in sculpture, leading to the classicism of the fourth century. Hegeso's hairstyle, drawing on a Pheidian model for Aphrodite, the opaqueness of her dress, and a rather restrained mood herald the new style, which will be based on a new interpretation of the classical.

Art, Politics, and Thought in Classical Greece *J. J. Pollitt*

Throughout most of its history, ancient art had been bound by formal conventions designed to evoke a sense of order that was seldom if ever apparent in nature. The goal of mature archaic Greek art, like that of the geometric style of Greek art before it and of the even earlier art of ancient Egypt and Mesopotamia, had been not so much to imitate nature as to create analogues for it. Forms observed in nature were transformed into semi-independent structures governed by principles of geometrical design that were handed down from generation to generation. Sometimes these principles were simply traditional conventions, but in the case of the finest works of mature archaic Greek art they clearly were an expression of the artists' innate feelings about what was right and perfect. Whether conventional or inspired, however, their excellence was not gauged by how closely they resembled their prototypes in nature, but by their own internal coherence.

Toward the end of the sixth century B.C., however, this balanced, formal perfection of archaic art began to show signs of disintegration, and a relatively unusual period ensued in which naturalistic representation became as important a consideration for Greek artists as formal conventions of design. Naturalism in the visual arts—the interest in reproducing in art the sense impressions derived from one's everyday optical experience of nature without resorting to the superimposition of preconceived formal patterns of design—has often been touted as a special characteristic of Greek art, but the fact is that, in the broad development of sculpture and painting in Greece, it was the exception rather than the rule and only became an important factor in a few critical and infrequent moments of transition. Probably the most influential of these moments was the late archaic period, that is the years between circa 510 and 480 B.C., during which Greek artists, especially painters, began a technical and conceptual revolution in artistic representation that has continued to have influence on the visual arts in Europe and America right up to the twentieth century.

The revolutionary character of the late archaic period appeared first in the work of the painters of the era and is most clearly documented in Athenian red-figure vase painting. The seemingly simple shift around 525 B.C. from the black-figure to the red-figure technique—that is, from decorating vases with black silhouettes with incised details to reserving figures on a reddish ground, surrounding them in black, and drawing rather than incising their anatomical details—invited Greek painters to concentrate more on the internal structural details of individual figures, and in a short time they embarked upon a remarkable series of experi-

ments that effectively revolutionized the visual arts. Instead of drawing a frontal eye on a profile face or a frontal torso set on hips seen from the side, for example, Greek painters strove to represent the human form as it actually looked when it twisted and moved in space. They began to draw, in other words, not what they knew in an abstract way to exist, but what they actually saw. As Greek vase painters experimented with new forms and vied with one another in depicting "difficult" poses such as raking views of torsos and folded legs with foreshortened ankles receding behind the soles of the feet, there was clearly a sense of excitement that is conveyed both in their drawings and in the accompanying inscriptions. Contributing to this excitement, perhaps, was an awareness that they were living in an age of innovation that encompassed not only their craft but also the society of which they were a part.

It may not be a coincidence that this revolution in artistic forms took place at a time when Athens was also experiencing a social and political revolution that was to shape its history for centuries to come. In the year 510 B.C. the autocratic government of Peisistratos and his sons, which with brief interruptions had controlled the political life of Athens for fifty years, was overthrown, and two years later a complex series of constitutional reforms, proposed by the Athenian lawgiver Kleisthenes, led to the creation of a new, democratic system of government. In this new order the powers to make decisions and conduct affairs of state were ultimately vested in an assembly of all the citizens, with day-to-day business entrusted to a representative council whose members were elected, partly by lot, from all social classes and geographical regions of Attica. The underlying assumption of the new social order shaped by the constitutional reforms of Kleisthenes was that the ordinary citizen was fully capable of managing the affairs of the polis. Wealth, noble lineage, and aristocratic cultural standards might still be admired, but they were not prerequisites for leadership. The ordinary man, endowed with new dignity and authority, was no longer an insignificant man, and the details of his life came to have a new interest and appeal.

In Athenian vase painting this changed political outlook is reflected not only in more naturalistic depictions of the human figure, but also in a democratization of subject matter. During the period dominated by Peisistratos and his sons, painters had for the most part chosen their subjects from heroic myths and epic poetry. In the new atmosphere that accompanied the Kleisthenic reforms, these themes, which were associated with an essentially aristocratic culture, began to give way to scenes that depicted ordinary citizens engaged in the familiar activities of

everyday life: athletes training in the gymnasium, teachers with their pupils, artisans practicing their crafts.

For practical reasons the remarkable changes that took place in Greek vase painting during this period were slower to develop and are somewhat more difficult to trace in sculpture. Sculptures were more expensive and time-consuming to produce and less easily adapted to major changes in design than the drawings on vases, and the possibilities for experiment in sculptures may have been curtailed by the aesthetic predilections of the patrons who commissioned them. The visual and conceptual revolution that is documented in vase painting can be discerned in a number of important sculptural monuments of the late archaic period (for example relief sculptures such as the "game reliefs" in the National Museum in Athens), but the full effect of the revolution in painting was not fully absorbed in sculpture until the beginning of the early classical period, that is between 480 and 450 B.C., after the newly formed Athenian democracy, like other Greek cities, had emerged from a period of danger and trauma, and a new, chastened political atmosphere was taking shape. Under these changed conditions the innovative naturalism of late archaic art was not forgotten, but it was reined in, so to speak, and recast into a new sober, austere, and disciplined style that marks the true beginning of the classical period in Greek art.

During the twenty years from the time that the Ionian Greeks had first revolted against Persian control in 499 B.C. to the ultimate defeat of the invading Persian army at Plataia in 479 B.C., the Greeks had faced the possibility of absorption into a huge polyethnic empire, with a consequent loss of their individual character, or even of extinction, as had actually happened to the citizens of the Ionian city of Miletos in 494 B.C. The defeat of the Persians, against seemingly overwhelming odds, therefore impressed many thoughtful Greeks as a kind of miraculous deliverance that had both a moral and a religious significance. In Aischylos' drama *The Persians,* first performed in 472 B.C. and composed as a public meditation on the meaning of the war, we find the clearest exposition of what was thought to have been its lesson for both the victors and the vanquished. The destruction of the Persians' army is portrayed as a divinely sanctioned punishment for their arrogant pride and aggressiveness. In their drive toward unlimited power, as the Greeks saw it, the invaders had abandoned all sense of self-restraint and reverence, so much so that they had not hesitated to burn temples and defile the altars of the gods. The Greek cities, by contrast, were thought to have prevailed because they had learned to curb aggressive local self-interest in the

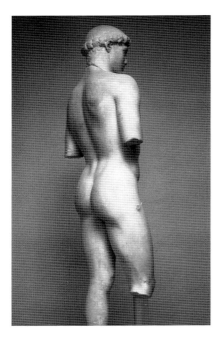

cat 5

interest of a greater common good and had adhered to a course of *sophrosyne* and *eusebeia* (moderation and respect for divine power). In effect what emerged from this exploration of the significance of the war with the Persians was a new view of the moral order of the universe in which it was not simply what one did that mattered but also what one thought. Divine judgment on the motives as well as the actions of men had been seen to reveal themselves, in a comprehensible way, in the events of history, and hence human attitudes became as important as traditional heroic action in determining the excellence of both an individual and a society.

The sculptors and painters who forged early classical Greek art expressed this outlook in a variety of ways, but above all in their efforts to endow their works with a feeling of austerity and seriousness that embodied the ideal of *sophrosyne*. In the style they created to achieve this effect, often called the "severe style," they rejected the jewel-like, geometric ornamentation that had been a distinctive feature of archaic art (perhaps because such details evoked both the art of the ancient Orient and the earlier aristocratic culture of Greece) in favor of smooth, unadorned surfaces and heavy, simple features. Along with this new approach to surface details in sculpture, a new system of composition was developed for representing the standing human figure, which broke up the bilateral symmetry and rigorous frontality that had been typical of archaic kouroi (such as cat. 1) by shifting the (apparent) weight onto one leg and turning the head toward one side. The effect of this design is to bring the figures out of a seemingly detached world of formal perfection and into a relative world of time and change, consciousness and choice.

Because attitude and character had now become as important as action, the artists of the period also became interested in ways to express states of mind, and the new body language in sculpture was soon complemented by subtle facial expressions designed to express both the character and the emotions (ethos and pathos) of figures in mythological and heroic scenes. Eventually the exploration of character in narrative contexts led to an interest in capturing the personalities of living contemporaries, and the first certifiable sculptural portraits began to appear in Greek art.

The deep-seated need to define and interpret change that underlies early classical sculpture also had an effect on the way the artists of the time represented physical motion. New patterns of design (called *rhythmoi*) were devised for expressing the movement of figures in space,

34

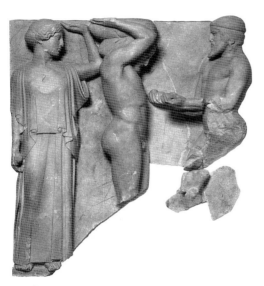

cat. 9

patterns which, in contrast to those of the mature archaic period, were based not on essentially decorative geometric formulae but on a close analysis of the crucial stopping points in observed movement. Such stops, such as the maximum extension of the backswing of a swordsman or the windup of a diskos thrower (as in the widely admired figure by the sculptor Myron), conveyed the whole nature of an action in a smooth and natural way and yet with diagrammatic clarity.

Several key monuments that embody this new atmosphere and the stylistic innovations that went with it can be seen in the current exhibition. The *Kritios Boy* (cat. 5), for example, whose weight rests on one leg and whose head is turned slightly to his right, seems as if he is pondering alternatives before taking a step and thus projects a sense of awareness and freedom. Critics have seen this figure as perhaps the first sculptural image designed to express the new sense of individual responsibility that grew out of the Kleisthenean reforms and the Persian challenge. An early example of the new severity of surface and sobriety of expression can also be seen in the head of a warrior from the temple of Aphaia at Aegina (cat. 3), and it should be noted that the pedimental group to which this head belongs was also one of the earliest monuments of Greek sculpture in which the dramatic atmosphere that could be created by facial expression and figural composition were seriously explored. In this respect the Aegina statues led the way to the greatest sculptural creation of the early classical period, the pedimental and metope sculptures of the Temple of Zeus at Olympia. In addition to being a quintessential example of the spareness and quiet dignity of the severe style, the metope seen in the current exhibition (cat. 9) also represents an episode in a mytho-historical cycle of metopes in which Herakles, in the course of his labors, is shown reacting to a variety of experiences and, as he does so, growing old. In the first of the labors depicted in the cycle, his battle with the Nemean lion, he had been shown as a beardless youth with a creased brow and downcast look designed to express the worry and exhaustion that followed his initial struggle. (The head can be seen in the archaeological museum in Olympia.) In the last metope of the cycle, exhibited here, by contrast, we see him at the end of his labors as a mature, calm, full-bearded figure who temporarily takes the world on his shoulders while the giant Atlas brings forward the apples of the Hesperides. The metope beautifully captures what the Greeks of the early classical period saw as important in their own experience. Herakles has been tested by adversity, has

prevailed, has grown in understanding, and has in the end attained a kind of mature philosophical calm.

In addition to being the precipitating factor that shaped the style, composition, and expressive character of the art of the early classical period, the Persian Wars seem also to have played a kind of backhand role in establishing the popularity of certain categories of subject matter in classical Greek art. It is now a widely held view among classical art historians that the pervasive appeal of scenes depicting the mythical and legendary battles of the gods with the giants and of Greek heroes with Amazons and centaurs stemmed from the fact that these myths came to be understood by the Greeks as allusions, a form of indirect discourse, so to speak, to the Greeks' struggle with the Persians and to the moral nature of their ultimate victory.

The Amazons, who dwelled in the East, who were sometimes depicted in Eastern costume and who not only had fought against the Greeks in the East but also had besieged the Acropolis in the time of Theseus, provided a particularly effective mythological doublet for the Persians. In both cases they had committed acts of sacrilege before the Athenians had finally prevailed and driven them from Greece. The popularity of the Amazonomachy in the public monuments of Athens is well documented. Paintings by Mikon and Polygnotos in the Stoa Poikile and in the Theseion depicted it; it is the subject of the west metopes of the Parthenon; Pheidias used it on the shield of his great gold and ivory image of Athena in the Parthenon; and it was a common subject in vase painting of the early classical period. Whether or not all these monuments specifically depicted the Amazonian siege of the Acropolis is uncertain, but in the case of Pheidias' shield for the Athena Parthenos, at least, which seems to have set the Amazonomachy against a background of rocky terrain and ramparts, there seems to be little doubt that this is the story that the sculptor had in mind.

The battle of the Olympian gods against the giants was, of course, an ancient symbol of the struggle to preserve the institutions of Greek civilization and culture against savage forces bent on destroying them. It was woven into the sacred shroud (the peplos) that the Athenians presented on the Acropolis every four years to Athena Polias, a tangible expression of cultural revitalization and continuity, and it was the subject of the east metopes of the Parthenon. That the story served as a political and historical metaphor there seems to be little doubt. It has been suggested that when Aristophanes praised the heroes of Marathon as being "worthy of the Peplos," he meant that they were comparable to

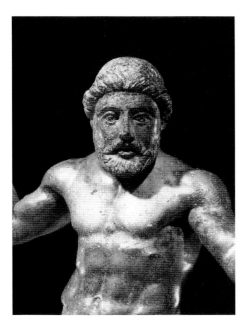

cat. 20

the Olympian gods who were depicted on the peplos of Athena. If the Olympian gods could be understood as a metaphorical representation of the Greeks, the giants could naturally be interpreted as the Persians or any other enemy that set "barbarian" gods against those of the Greeks. (When the Western Greeks placed the Gigantomachy in one of the pediments of the Olympieion at Akragas, for example, they most probably intended it as metaphor for their struggle with the Carthaginians.)

The Centauromachy is again one of those archetypal myths that seem to pit civilization against a savage, primitive force. In early Greek art Herakles' fight with the centaurs in the Peloponnesos had been the most commonly depicted version of the myth in early Greek vase painting. After the Persian Wars, however, the story of the centaurs' riot at the wedding of Peirithoos in Thessaly, an event at which the Athenian hero Theseus was present, superseded the Peloponnesian story in popularity. It occupies one of the pediments of the Temple of Zeus at Olympia; was the subject of a prominent painting by Mikon in the Theseion in Athens; is the subject, or part of the subject, of the famous south metopes of the Parthenon; and is the subject of one of the friezes of the Hephaisteion. The presence of Theseus, of course, made the story useful to the Athenians as yet another example of Athens' role as the protector of civilized institutions, but its use at Olympia indicates that it also had a broader, Panhellenic significance. The centaurs' betrayal of friendship and trust when they attacked the Lapith women and broke up the wedding of Peirithoos, which was a sacred rite, was perhaps interpreted, for example, as an act of impiety that provided an analogy for the barbarous behavior of the Persians when they sacked and destroyed temples in various parts of Greece. It is also possible, as several scholars have proposed, that the centaurs served as a symbol of those Greeks who had "medized" during the Persian Wars, that is, those who had gone over to the Persian side. Foremost among these had been the kings of Thessaly, and since Thessaly was the homeland of the centaurs, the Thessalian rulers and other Greeks who joined them may have come to be regarded as the centaurs of the present. When viewed in this way, the frequent pairing of the Amazons and centaurs in Greek art becomes a logical one. They served as an expression of reproach against, as well as a celebration of victory over, enemies both external and internal.

Whether or not we have an example of this political language of forms in the present exhibition is uncertain, since the original context of many of the sculptures is not known. It is possible, however, that the small bronze image of Zeus from Dodona (cat. 20) was originally understood

as an allusion to the battle of the gods and giants, and to all that the myth implied.

After the middle of the fifth century B.C., Athens became overwhelmingly the most influential and innovative artistic center in Greece. It was here that the high classical style of Greek art was created, the style that eventually spread throughout most of the ancient Mediterranean world and established a standard that has periodically been emulated and rebelled against for more than two millennia. The city's rise to dominance in the cultural and artistic life of Greece was due, at least in part, to quite specific historical circumstances. Following the defeat of the Persian land army at Plataia in 479 B.C., the Athenians had organized a confederacy of Greek cities on the Aegean Islands and neighboring coasts for the purpose of driving the remnants of the Persian navy from Greek waters. The allies of Athens were asked to provide, according to their size and capacity, either ships and men to the alliance or, failing that, a fixed sum of money. A treasury to keep track of the league's funds was established on the sacred island of Delos and was overseen, like the naval operations, by the Athenians. In the 470s this "Delian League" carried out a number of quite successful naval operations, and by the end of the decade the Persian threat had largely vanished. At this point some of the allies, the most important of which were Thasos and Naxos, attempted to withdraw from the confederacy, but Athens, which had become a major power in the Greek world as a result of controlling the fleet and its treasury, used force to prevent them from doing so. In this way cities that had been voluntary allies of the Athenians were gradually transformed into Athenian subjects, a process that was eventually acknowledged in both a practical and symbolic way in 454–453 B.C. when the league's treasury was transferred from Delos to the Athenian Acropolis. Even though it may not have been spent directly on works of architecture, there can be little doubt that the wealth derived from the confederacy made it possible for the Athenians, in the second half of the century, to begin building the Parthenon and the other remarkable structures for which their city continues to be famous.

Wealth alone, however, does not explain the artistic and cultural flowering of Athens. An attitude and a vision were also required that made the arts important enough to have public funds lavished on them, and these were furnished by the man who was incomparably the most thoughtful and adroit statesman of the time, Perikles. He rose to a position of influence in the late 460s as leader of a faction (roughly, but only roughly, equivalent to a modern political party) within the

Athenian assembly that in foreign affairs pursued a policy that non-Athenians understandably viewed as imperialistic, but that in domestic affairs advocated a policy of continuing democratic reform. In the late 460s and early 450s Perikles instituted a series of constitutional changes that ended once and for all the dominance of the wealthy landed aristocratic classes in Athenian government. Chief among these were laws that provided for the election of magistrates, jurors, and members of the council purely by lot (a procedure that had been introduced in the constitution of Kleisthenes but not fully applied) and that provided payment for their services to all of these officers from public funds. The effect of these reforms was to make it possible for any Athenian citizen, no matter how humble his background, to play an active role in the public life of the city.

Whether Perikles was ever seriously troubled by the contradiction between an increasingly democratic policy at home and an undeniably authoritarian one abroad is not known, but late in his career, in the great oration that he delivered in 430 B.C. in honor of those who had fallen in the first year of the Peloponnesian War (Thucydides 2.34 – 46), he did propose an idealistic argument aimed at reconciling them. The speech, which seems to convey the essence of his personal vision and testament, portrays the new Athens as an ideal society in which any citizen had an opportunity to rise to greatness in political life; where the same justice applied to all; where a free intellectual life and a keen appreciation of the arts were cultivated; but where at the same time hardship and danger were accepted without complaint when they were required to protect the community. Athens had made itself, in Perikles' view, "the school of Hellas," and since it not only continued to protect its allies but also gave them access to a level of cultural life that would otherwise have been beyond their grasp, they should consider themselves fortunate rather than oppressed.

Apparently impelled by his own idealistic vision of Athens and harnessing the sense of optimism and self-confidence that was generated both by the extension of democracy in Athens and by the availability of vast new wealth, Perikles resolved after 450 B.C. to create a series of monuments in the city that would serve as an outward expression of its cultural achievements. Much of the inspiration that has lent these buildings and sculptures their timeless appeal seems to have come from the sculptor Pheidias, who belonged to a circle of intellectuals and artists of which Perikles was the patron and who was appointed as the artistic overseer of the entire program. Plutarch (*Life of Perikles* 12–13) records

that the Periklean building program "provided paid employment for virtually the entire city," and there is no doubt that as a vast public works project it brought political benefits to Perikles. But there can also be little doubt that he sincerely wanted these monuments to serve as a tangible expression of his own vision of society. The exact significance of the great frieze of the Parthenon has been the subject of much speculation and debate by scholars (for example, were the figures on it understood as contemporary, historical, or mythical?), but it is virtually certain that, in some way or other, it was intended to be an image of the Athenian community as a political and social ideal.

Whether as a result of coincidence or as an effect of some deeply ingrained zeitgeist, the blending of pragmatism and idealism that characterized Periklean political policy was also a feature of the major lines of philosophical thought and of the aesthetic sensitivities of the age. The influential school of Pythagoras and his successors, for example, held that behind the sensible phenomena of the world there was a perfect structure or pattern that was expressible in mathematical relationships. Running counter to this essentially idealistic view of knowledge and reality, however, there was a trend toward empiricism, represented by the teaching of Protagoras and others, who argued that whether an unchanging reality existed or not, we could only know it through analyzing with our individual minds the impressions that reach us through the medium of our senses; the subjective judgment of individual human beings therefore had to be regarded as the basis of all knowledge, and in that sense man, as Protagoras put it in a famous phrase, was "the measure of all things."

Subtle reflections of these two distinct visions of how the nature of things is known and understood can be seen to pervade the art of the high classical period. In the architecture of the Parthenon, for example, a pervasive system of arithmetical proportions is fused with a complex system of "refinements" that take into account and make adjustments for the imprecision of everyday optical experience. These contrasting approaches to formal design also characterize the sculptures of the Parthenon, especially its frieze, in which the simplified geometry, unruffled serenity, and all-pervading youthfulness of human forms create the atmosphere of a timeless, quasi-divine world; but in which these ideal forms are set off by a new impressionistic way of rendering drapery and hair that conveys a sense of transient movement and fleeting shadows.

After the outbreak of the Peloponnesian War (431– 404 B.C.), the self-

confidence and optimism that had enabled the Athenians to hold contradictory forces in balance, both in politics and in art, and to sustain the idealistic vision of human society that is expressed in Periklean art began quickly to erode. The historian Thucydides describes the progress of this long war as resembling in some respects the development of a disease that produced symptoms in the form of changing social mores. As he tells it, the demands and dangers of the war led to a gradual abandonment of both the *sophrosyne* of the early classical period and the political idealism of Perikles in favor of an amoral attitude in which power became the only factor to be weighed in decisions about political policy. The first outbreak of the historical disease, so to speak, seems to have been provoked by the outbreak of a biological one: the great plague that struck Athens in the summer of 430 B.C., when most of its population was crowded within the city's walls in order to escape the invasion of Attica by a Spartan army. The terrible and bewildering sufferings of the plague, the source of which could not be understood and against the devastation of which no human ingenuity or action seemed to have any effect, is described by Thucydides as having had a ruinous effect on the Athenian cultural psyche, an effect virtually the opposite of that produced by the Persian Wars. It seems to have suggested to many Athenians that they lived in an essentially irrational world in which there were no consistent and convincing values except perhaps the need, or at least the desire, to survive. Thucydides depicts the whole Greek world, most of which was eventually drawn into the war, as undergoing a gradual conversion to this outlook, with the culmination of its acceptance occurring in 416 B.C. when Athens sought to compel the island of Melos, which had previously remained neutral in the war, to join their alliance. When the Melians refused, the Athenians proceeded to lay siege to the island, and when they finally took it, they executed or enslaved the entire population. In his re-creation of the debate between the Athenians and the Melians that took place before this brutal decision was made, the historian has an Athenian spokesman enunciate the attitude that made it possible: "You as well as we know that justice is only a factor in human discussions when there is equal power on both sides and that otherwise the strong impose their will and the weak are obliged to yield to it." (5.89)

Without saying it in so many words Thucydides seems to have seen the political policies of Athens during the later stages of the war as following a course similar to that which Aischylos had seen in the downfall of the Persians. *Hybris* (arrogance based on raw power), like

that shown in the Melian episode, led to *até* (delusion), and delusion to *nemesis* (retribution in the form of disaster). The enthusiasm with which the Athenians launched their great Sicilian expedition (415 – 413 B.C.) in the hope of creating a western wing for their empire was a form, the historian seems to suggest, of delusion, and *nemesis* could be seen in the disastrous end of the expedition and its aftermath, in which most of the fleet was lost, thousands either died or were taken prisoner, many cities in the Athenian alliance revolted, and internal conflicts threatened to overturn the democratic constitution.

At the end of the war in 404 B.C., after Sparta had effectively detached the allied cities from the Athenians' control, destroyed their fleet, and set up a blockade that starved the city into submission, the idealism and optimism with which the Parthenon had been begun had yielded to anxiousness and uncertainty. The contrast between the beginning of the Periklean building program and its end is poignant. During the last decade of the century the Athenians struggled desperately to complete the last of the temples envisioned for the program, that of Athena Polias (now more commonly referred to as the Erechtheion), hoping thereby, it would seem, to placate the host of mysterious and inscrutable divine forces that were housed within and beneath its elegant walls and porches.

Given what in retrospect seems a downward spiral in Athens' fortune during the Peloponnesian War, one might expect to find a strain in the art of the late fifth century that expresses anxiety, despair, or affliction; yet, on the surface at least, one finds no such thing. On the contrary, both the sculpture and painting of the period are marked by an elegant, decorative style in which the curvilinear designs that had been developed in the sculptures of the Parthenon, particularly in its pediments, to express the texture and movement of windblown drapery are exaggerated to create an effect of mannered calligraphic elegance. It may be the case, of course, that the Athenians, until very late in the war, which had its inevitable ups and downs, did not think of the period as a depressing one and felt no impulse to express a dark side of life in either their public monuments or private art. The famous Nike adjusting her sandal from the parapet of the temple of Athena Nike on the Acropolis (cat. 25), for example, a paradigmatic example of the calligraphic style that was probably made during a brief period of peace (the Peace of Nikias, 421 B.C.) negotiated in the wake of an encouraging victory over the Spartans, may simply have been intended as an unambiguous expression of joyous relief.

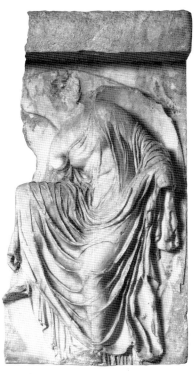

cat. 25

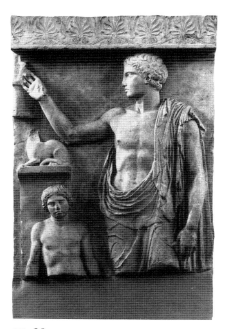

cat. 30

The fact that the "Sandalbinder" and the other figures of Victory on the parapet appear like decorative motifs on pottery or furniture gives them, however, an aimless and insubstantial quality. The image of conviction and purpose embodied by the citizens on the Parthenon frieze seems to have been replaced by a fantasy world in which ethereal, angel-like, dancing apparitions dispense a benign fortune that requires neither labor nor worry; and it may be that this preoccupation with ornamental flourish for its own sake, a feature that can be paralleled in contemporary rhetoric, poetry, and music, reflects not so much a genuinely joyful outlook as a state of mind that is tinged with a tendency toward escapism, a reluctance to face hard realities.

In any case, whatever the motivation behind them, compositions based on elegant patterns of windblown, transparent drapery became the artistic signature of the period. In addition to the panel from the Nike temple parapet (cat. 25), an excellent example of it in freestanding sculpture can be seen here in the female figure, possibly an akroterion, found in the Athenian agora (cat. 27). Once again we seem to confront an angel-like deity, in this case probably one of the Nereids, elegant goddesses who were thought to confer protection and good luck on those who, like most of Athens' military force, spent much of their life at sea.

If there is any hint in Greek sculpture of a kind of sunset melancholy brought about by the war years, it may be expressed not in civic monuments but in the beautiful series of grave stelai that began to be produced in Athens beginning around 430 B.C. Whether or not their quiet solemnity reflects the political atmosphere of their time or not, they almost certainly give us an indication of how some of the sculptors, who were trained during the heyday of the Parthenon, continued to earn their living when the funds that had supported them were increasingly devoted to the cost of the war. The youth and boy on the Cat Stele (cat. 30) seem to have stepped out of the frieze of the Parthenon, and it is not difficult to believe that the artist who carved them once worked on the temple.

If most of what has been said here about the art of the high classical period has concentrated on Athens, it is because Athens was unquestionably the chief center of artistic innovation at this time. While not all of the important art of the period was produced in Athens and there were prominent artists outside Athens, such as the sculptor Polykleitos of Argos, who followed their own interests and had a considerable impact on later Greek art, it was clearly the style of Athenian art that

dominated the late fifth and early fourth century and remained in the consciousness of sculptors and painters throughout the Hellenistic period and well into the Roman Empire. The process by which the style that was developed in Athens came to permeate Greek art as a whole is not difficult to envision. Many of the sculptors and painters, including some quite famous ones, who had worked in Athens during the time of the Periklean building program were *metoikoi* (resident foreigners), who, when opportunities for work in Athens dwindled, undoubtedly moved on to other areas—not only on the Greek mainland but also in Asia Minor, southern Italy, and Sicily—where commissions could be found. Thus even when the creative energy of Athens was temporarily spent at the end of the Peloponnesian War (it would bounce back with vigor in the next century), there were artists working in many Greek cities who had learned their trade in Athens and went on disseminating the skill that they had acquired until the classical style became not just Athenian but also Greek.

Athenian Democracy

Olga Tzachou-Alexandri

The first kind of democracy therefore is the one which receives the name chiefly in respect of equality.
(Aristotle, *Politics* IV, 4, 1291 B, 30)

Democracy is a Greek concept. The ancient Greek word *demokratia* is a compound of *demos* (the people or citizen body) and *kratos* (power), meaning rule by the people. In this system of government the citizens make the main decisions and entrust their common interests to officials they choose themselves. A basic characteristic of democracy is freedom as defined by law; another is for all citizens to be members of the deliberating body and to decide all matters. Perikles' funeral oration, recorded for us by Thucydides (fig. 1), praises this system of government and formulates its main characteristics. The *Athenian Constitution* and *Politics* by Aristotle are our chief sources of information for the democratic state. The picture is filled out by the works of various orators, the comedies of Aristophanes, and contemporary inscriptions.

The political development of Athens took place within the more general framework of Greek history. In the mid-seventh century B.C. the districts of Attica were united into a single city-state. Government was in the hands of the chief magistrates, the Council of the Areopagus, which had unlimited power, and the Assembly of the People. Responsibilities were left undefined, limited to the ruling class, and not subject to control.

The constitutions of Solon and Kleisthenes are considered to be preliminary phases leading up to classical democracy. Solon, who was elected archon (chief magistrate) in 594 B.C., was the first statesman in Athenian history whose political and legal reforms show democratic tendencies. Solon canceled debts, abolished personal security for loans, and freed those who had been sold into slavery. These measures are known as the *seisachtheia* (shaking-off of debts). He divided the citizens into four classes, assessed on the basis of annual produce from the land: *pentakosiomedimnoi* (those whose incomes amounted to five hundred measures of farm produce), *hippeis* (those who could keep a horse or whose income was three hundred measures), *zeugitai* (with an income of two hundred measures), and *thetes* (farm laborers). Only the *pentakosiomedimnoi* served as chief magistrates, although the first three classes bore all of the expenses. The fourth class, the *thetes*, took part in the Assembly of the People for the first time. Solon founded a second body, the Council of the Four Hundred, which was chosen by the Assembly of the People. He also founded the first court of law, the Heliaia, which had a jury of sworn citizens chosen by lot.

In 508/507 B.C. Kleisthenes founded the Athenian democracy, the first known democracy in the world. Kleisthenes himself and his family, the family of the Alcmaeonidae, were instrumental in expelling the tyrants, forming political alliances, and playing a leading role in the political life of Athens. Kleisthenes reorganized the administrative structure of the

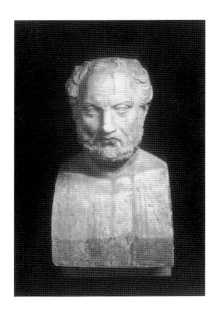

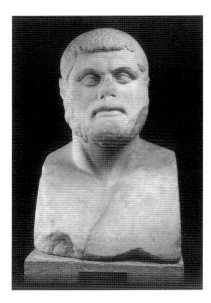

fig. 1.
Thucydides.
National Museum, Naples,
inv. 6239

fig. 2.
Themistokles (524–459 B.C.),
marble, Roman copy after
fifth-century Greek prototype.
Ostia Museum, inv. 85,
Courtesy Soprintendenza
Archeologica di Ostia

government in such a way that the power blocks formed by the old aristocratic families were broken up. Whereas revolutions in modern times, such as that in France, abolished monarchy, aristocratic titles, and privileges, Kleisthenes achieved equality the other way around. The old noble families were aristocrats by virtue of their lineage, tracing their ancestry back to gods and heroes, preferably Homeric heroes, upon which their entrenched power and authority depended. Kleisthenes divided the citizen body into ten tribes and took the names of a hundred heroes to Delphi, where the Delphic oracle chose ten to be the heroic ancestors of the ten new tribes. Thus at a stroke every citizen acquired a heroic ancestor. In order to further break up local power politics, Kleisthenes assigned the 140 *demes* (local geographical units, the equivalent of boroughs) to the ten tribes, making sure that each tribe was composed of citizens from a mixture of *demes* in different parts of Attica.

Kleisthenes founded a new council, the Council of the Five Hundred, made up of fifty councilors from each of the ten tribes representing all of the districts of Attica. The council had limited powers, whereas the Assembly of the People gained power. He introduced the procedure of ostracism, a measure designed to forestall tyranny. The councilors were required to take an oath that anyone responsible for an attempt to overthrow the government would be condemned to death. The army was reorganized in accordance with the new system of tribes; military service and the institution of the ten generals were introduced.

After Kleisthenes' time, the main leader of the democrats was Themistokles (fig. 2), the outstanding political and military personality of the Persian Wars. His farsighted policies made possible the victory at the Battle of Salamis (480 B.C.). Themistokles was the first to convince the Athenians that their future lay in marine power; when in 483–482 B.C. a rich silver lode was unexpectedly discovered in the Attic mines, he persuaded the people to use the profits to build a fleet and fortify the Peiraeus peninsula. From 487 B.C. onward the nine chief magistrates were chosen not only from the *pentakosiomedimnoi*, but also from the class of *hippeis*. At this time it became customary to inscribe decrees on marble, another victory for democracy in that now legislation was made public.

The most brilliant period of Athenian history was the time between 479 B.C., the year of the victories at Plataea and Mykale, and 431 B.C., the beginning of the Peloponnesian War. With the founding of the Delian League in 478–477 B.C., the Athenians assumed leadership of the Greek allies, and this leadership brought the city wealth and fame. During this time democratic institutions and the arts developed rapidly. After Themistokles had been

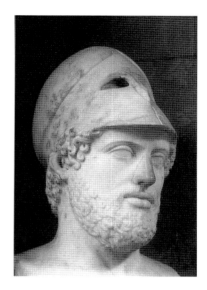

ostracized and banished in 471 B.C., Ephialtes, son of Sophonides, became the leader of the democratic party in 465 B.C. In 462 B.C. Ephialtes removed political responsibility from the Council of the Areopagus, a decisive move toward perfecting the workings of the democracy. He gave the rights removed from the Council of the Areopagus to the Assembly of the People, that is to the citizens. At the same time the *graphe paranomon* was introduced, enabling citizens to take legal action against an unconstitutional measure.

With the changes introduced by Ephialtes, equality before the law was established. The people could criticize the magistrates and subject their actions to inspection. The citizen body controlled the government, since all the members of the Council of Five Hundred came from the people and it had judicial power.

After Ephialtes was murdered in 461 B.C., Perikles (495–429 B.C.) became the leader of the democratic party. Perikles himself was an aristocrat, son of Xanthippus, the victor at Mykale, and Agariste, who belonged to the great family of the Alcmaeonidae. Perikles (fig. 3) received a remarkable education from his teachers Pythokleides and Damon and the philosophers Zeno the Eleatic and Anaxagoras. He was an especially gifted man: an outstanding orator and able general. Perikles' first appearance in Athenian history is in connection with religious and artistic concerns. In 472 B.C. he was the sponsor who staged Aischylos' drama at the festival of Dionysos. In the first phase of his political career he was elected general many times, and later he was elected general fifteen times consecutively. Supplementing Ephialtes' reforms, Perikles instituted a series of laws creating the most democratic constitution that had ever existed. He placed power in the hands of the Assembly of the People and the people's courts. He gradually arranged for payments to be made to jurors, to councilors, and to those who attended dramatic performances. In 458 B.C. the *zeugitai* were made eligible for the nine archonships chosen by lot. The *thetes,* the fourth class, acquired this highest political right on the eve of the Peloponnesian War.

Under Perikles' enlightened leadership, Athens evolved into the leading power of Panhellenic unity, promoted by the transfer of the allied treasury from Delos to Athens in 454 B.C. Between 450 and 446 B.C. the allies adopted Attic coinage and the Attic system of weights and measures. A democratic form of government was also imposed on most of the allied towns, the Athenian colonies, and the *cleruchies* (a system of settling Athenian citizens in territories of their allies to prevent revolts). At the height of their hegemony, Athenian power extended from Sicily to the Nile delta; they controlled central Greece and had outposts in the Peloponnesus. Two important events in the area of foreign policy made it possible for

the great statesman to realize his far-reaching plans. The Peace of Callias in 449–448 B.C. guaranteed peace with the Persians and the Thirty Years' Peace in 446–445 B.C. assured peace with Sparta and Argos.

Within the framework of the Periklean democracy, the great number of government posts and the annual rotation of administrative offices made it possible for virtually all citizens to have a share in the government, contributing to a deep-rooted feeling of personal civic responsibility.

The center of political life in Athens was the Agora (fig. 4), an extended area under the northwest slope of the Acropolis where civic and other public buildings stood. The Assembly of the People, the main governing body, ruled the Athenian state directly and supervised the actions of the chief magistrates, who were chosen by the people and who carried out its decisions. It was the arena where issues were debated and the source of final decisions. Until Perikles' time the generals presided over the assembly; later on, the president of the assembly was the chairman of the *prytaneis* (the executive committee of the Council of the Five Hundred). The Assembly of the People met on the Pnyx, a hill near the Acropolis overlooking the Agora (fig. 5). The citizens sat on the earth of the sharply sloping hill, and the speaker stood on a low platform. Male citizens, both of whose parents were Athenian and who had passed their eighteenth year, were eligible to take part. The number of those qualified is estimated at 43,000.

The Council of the Five Hundred was the main administrative organ and worked closely with the Assembly of the People. The council prepared the agenda that was to come before the assembly and also saw to it that the decisions taken in the assembly were carried out. It was the general coordinator of administrative business. The councilors were chosen by lot annually from representatives elected by all the *demes*. The *prytaneis* were the fifty councilors from one of the ten tribes and served for one-tenth of the year as an executive committee. The archonship, formerly a powerful office held by Attic aristocrats, operated at Perikles' time with reduced influence; the nine archons were chosen by lot from the candidates from the ten tribes. In terms of rank and power the ten generals had the highest office. They were elected by the Assembly of the People. This annual office required military experience and political and diplomatic ability. At the end of the year the work of the generals was scrutinized in order to ascertain if they had acted as protectors of the people. Perikles is an example of a person who held this office and through it was able to influence policy.

Aristotle described the Greek democracy as follows:

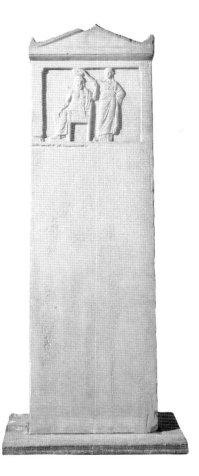

fig. 6.
Demos and Demokratia,
marble relief.
Agora Museum, Athens, I6524

Election of officials by all from all; government of each by all, and of all by each in turn; election by lot either to all magistracies or to all that do not need experience and skill; no property-qualification for office, or only a very low one; no office to be held twice, or more than a few times, by the same person, or few offices except the military ones; short tenure either of all offices or of as many as possible; judicial functions to be exercised by all citizens, that is by persons selected from all, and on all matters, or on most of the greatest and most important, for instance the audit of official accounts, constitutional questions, private contracts; the assembly to be sovereign over all matters, but no official over any or only over extremely few; or else a council to be sovereign over the most important matters...; also payment for public duties, preferably in all branches, assembly, law-courts, magistracies, or if not, for the magistracies, the law-courts, council and sovereign assemblies, or for those magistracies which are bound to have common mess-tables. (Politics VI, 1, 1317 B, 19-38)

The democratic ideals of the Periklean period left their mark on his great building and artistic program. Carrying out this program provided the population with employment and evoked the admiration of contemporaries and generations to come. The main buildings were the Temple of Poseidon at Sounion, the Temple of Ares at Acharnai, the Temple of Nemesis at Rhamnous, the Temple of Hephaistos above the Athenian Agora, the Odeon on the south slope of the Acropolis, and first and foremost the sanctuaries of the Acropolis with its crowning glory, the Parthenon, a dedication to Athena Parthenos, goddess of wisdom, symbol of the new Athens.

Among the visual arts, the Parthenon is the embodiment of Greek thought and experience. The sculptural decoration of the temple presents themes relating to the goddess, such as her birth or her contest with Poseidon, and also has traditional themes to which symbolic significance was attached. The fight of the Athenians with the Amazons was interpreted as the victory of mankind over wild beings, the victory of intelligence over force; the victory of the Greeks over the Trojans is interpreted as the triumph of Athenians over Asiatics, of wisdom over arrogance, a significant political message serving Perikles' aims. The Ionic frieze depicting the Panathenaic procession represents mortals in temple decoration for the first time. The depiction of Olympian gods in context with mortals is important symbolism because it exalts contemporary Athenians and at the same time reveals their philosophy. Under the inspired guidance of Perikles, Pheidias and his associates created the triumph of democracy. The great statesman, influenced by Protagoras' ideas about the value of education, made the visual arts a part of that

education. Thus the monuments of Athens are also a part of political training, "the education of Greece."

The *demos* was the main governing power in Periklean Athens at the time that the cult of Demos, a personification of the citizen body of the Athenian people, was founded. The oldest cult of Demos, dating to the mid-fifth century B.C., was in the Sanctuary of the Nymphs on the Hill of the Nymphs beside the Pnyx. There was also a sanctuary of Demos and Graces in the ancient Agora, the second important center of political life in Athens. The cult of Demokratia was founded in Athens in 403 B.C. when democracy was reestablished. It is thought that the figures of Demos and Demokratia existed as political allegories in the second half of the fifth century B.C. *Demos* and *Demokratia* are shown on the document relief (fig. 6) recording the decree against tyranny, passed in the archonship of Phrynichos in 337–336 B.C.; the two figures represent the personifications of the two leading political institutions and express their religious and political character.

The Athenian democracy, the main factor in "the eternal miracle," has become a universal symbol and is admired throughout the civilized world.

Architecture in Fifth-Century Greece *Vassilis Lambrinoudakis*

Of all of man's creations, architecture most directly shapes and reflects the physical organization of human life. Greek architecture of the fifth century B.C. is one of the principal surviving records of the new principle for human life that the diffusion of radical democracy signified. To the Greeks of the classical era, knowledge of the correct way of life in a city and the balanced management of common affairs was the most important art; at the same time they considered architecture, which created the context for this new organization, the pinnacle of the visual arts. The Greek word *architecton* means chief builder; its second component derives from the same root as the word *techne,* meaning art. It is perhaps not fortuitous that the fifth-century town planner Hippodamos was also an intellectual who proposed theoretical governmental systems.

Two particularly decisive advances were consolidated in the field of architecture in the fifth century. First, the plan of the polis reached full flower; in its essential elements, it was based on a functional organization of space into residential districts and areas for public activities of a democratically constituted community. It continues to this day to underlie the basic framework of city life. Second, the monumental architecture of public buildings was shaped in such a way as to reflect the community's will, to express the balance between the contradictory forces of freedom and the rules of collective life.

Yet the classical city was not suddenly created in the fifth century B.C. The division of land into equal lots for habitation began with the founding of the Greek colonies in the eighth century; places for public gatherings (agoras) are attested in the Greek cities of the seventh century; small secular civic buildings most probably existed in the sixth, and the democratic body politic itself, without doubt one of the fundamental formative factors of the classical polis, evidently had precursors in archaic times. The new organization of life experienced in the fifth century was the outcome of the social and spiritual maturing of Greek cities that had taken place in the years preceding the Persian invasion of Greece in the 490s.

The concept of democracy implemented the concept that man himself shapes his world and is therefore free and responsible for his actions. This meant that the citizen, as a member of the community, had the right to participate equally in the conduct of common affairs and the obligation to respect the rules of life formulated by common consensus. The dynamic identification of the free individual with the whole made the public place of the agora crucially important to the classical city. Monumental civic buildings underlined the role of the Agora in Athens' new organization. Among these were the Bouleuterion, built around 500 B.C. for assemblies

of Attica's five hundred deputies, and the Tholos (fig. 1), the distinctive circular building of around 460 B.C. that served as the headquarters of the assembly's executive committee. The Athenian Agora began to compete with the sanctuary of the patron deity, Athena, as a symbol of the community. People were now conscious that their fortunes were determined not so much by divine forces as by the responsible confrontation of issues discussed in the assemblies. In addition, long porticoed buildings, which had previously accommodated gatherings in sanctuaries, now began to serve the corresponding needs in the Agora. Its space was ordered accordingly, both formally and conceptually: the Poikile (Painted) Stoa, approximately 165 feet long, rhythmically articulated the north side of the Agora. The facade featured columns of the Doric order; the interior colonnade of the Ionic order made reference to Athens' links with her Ionian allies; the subjects of the paintings on its back wall narrated the city's mythical and contemporary power.

In addition to the development of architecture affecting public life in the cities, the practice of democracy had a decisive effect also on the organization of the private residential sectors. Even in classical Greece, life imposed many compromises between the ideal and its application. Athens itself is a case in point, where, after the Persian destruction in the 490s, the houses were irregularly rebuilt on their old sites. However, in new cities incorporating public planning, a new organization was evident. The town planners laid out streets in a repetitive, rectangular grid system, some streets wider than others depending on their importance. Houses and sets of houses forming blocks were fitted into the grid. This was the system that Hippodamos of Miletos applied immediately after the Persian Wars to Peiraeus (fig. 2), the port founded in an uninhabited area expressly to serve the naval policy on which the post-Persian city of Athens based its power. Some have maintained that even the interior of the house incorporated the new concepts: despite the design in which the rooms opened on an internal courtyard, thus ensuring privacy, the development in the men's quarter of the *andron*, a spacious room for banquets, was considered to have constituted the extension of the *prytaneion* (town hall) into the private domain for the continuation of discussions on public issues.

Man no longer accepted the given divine truth. He believed that truth is conceived through the human intellect. Thus he imposed on the Acropolis a new rhythmical and symmetrical form. By filling and terracing the south flank of the rock, the designers created space for the development of axially arranged buildings on the summit; and by the erecting the Propylaia (gateways), they organized the natural slope leading up to it (fig. 3) into

fig. 1.
Model of the Tholos
showing restoration of the roof
with diamond-shaped tiles.
Agora Museum, Athens.
American School of Classical Studies

fig. 2.
Model of housing units of the
classical period in Peiraeus.
Architekturreferat des Deutschen
Archäologischen Instituts,
Berlin

a single reception and entrance area (fig. 4). In the Propylaia visitors were prepared for the perfectly articulated buildings beyond by architectural elements that symmetrically embraced them as they ascended. However, the ideal perfection of symmetry was compromised by political realities: the asymmetry of the two sides of the Propylaia has been interpreted as the result of competitive progressive and conservative forces and the ultimate need to maintain or incorporate earlier places of worship in the area.

In the earlier archaic period, monumental architecture had seen greater progress than town planning. Stone architecture had been the rule since the beginning of the sixth century B.C., and buildings constructed entirely of the finest stone, marble, appeared in the Cyclades in that century. And they were full size. Although the majority of archaic temples has proportions in which length was emphasized over width, early buildings did exist, mainly in the Greek Islands, in which width was also developed. By the beginning of the fifth century the architectural types and their conventions were already established. The precedent for the social function of public and, in early times, exclusively sacred buildings as mediums of collective expression was already set in the archaic period; even though their execution was initiated by tyrants or commissioned from wealthy private individuals, the work was undertaken in the name of the community.

Now in the fifth century, however, changes indicated the new spirit: monumental architecture was determined by common intent. Literary sources and inscriptions reveal that a democratic building policy, attested almost immediately after the institution of democracy, prevailed in Athens. This limited to the state the initiation and the execution and control of all public buildings. Proposals, architectural programs, and the financing of buildings were worked out by the *boule* (council) and the *ekklesia* (assembly)

fig. 3.
Model of the Athenian Acropolis before
the classical period. Ephorate of the
Acropolis, Athens

fig. 4.
Model of the Athenian Acropolis
during and after the classical period.
Ephorate of the Acropolis, Athens

 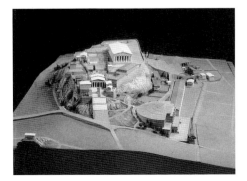

fig. 5.

Marble pillar inscribed with the annual
accounts of the Parthenon building
(IG I^3, 436–451), 447–432 B.C.
Epigraphical Museum, Athens

while annually alternating committees monitored the construction (fig. 5).
Athenians in the fifth century persistently refused to accept the contributions
of private citizens to public works, even if the individual possessed the
persuasiveness of Perikles, in order that the work reflect the concept of the
community as expressed through the democratic bodies of the council
and assembly.

The design, materials, and decoration of fifth-century monumental
buildings were also evolving. The ideal material was marble, eminently
suited by its hardness and durability to the clear expression of articulated
architecture. In contrast to archaic buildings, in which the columns seem
to struggle to support the mass of stone bearing down on them, this
apparent opposition of forces now was alleviated by proportions that seem
to cancel the weight of the material, emphasizing rather the organic unity
of the whole. Just as sculptors of the human figure abandoned symmetry
and frontality in favor of a more naturalistic image moving in space, so
did architects develop perfect fine proportion for buildings, a canonical,
rhythmic movement complete itself. With the placement of the individual
at the center of the cosmos, yet another already known formal element
was perfected. Greek art had never ignored the individual who experienced
it; thus from the beginning there had existed experimental optical correc-
tions of the lines of the building so that its span as seen from different
angles was not distorted in the eye of the beholder. On the Parthenon,
these refinements were developed into the well-known system of slight
curvature of the stepped platform and cornice, as well as convergence of
the columns, that created in the individual spectator the sense of perfectly
articulated organic unity. This turn of architecture, toward the result
visually perceived rather than constructionally or materially perceived,
was made manifest in the fifth century B.C. by other features too, such
as the use of color tones for emphasizing the lines of the building, for
example in the dark stone on the base of the portal wall of the Propylaia;
or the use of architecture as scenery without functional purpose, as the
case of the south wing of the Propylaia (see fig. 4), which was to be put
to various uses in later times.

Equally important in fifth-century architecture was the organization of
the interior of the buildings. Although buildings with columned halls of
considerable width existed in the sixth century, articulation of the space
into aisles had not previously been satisfactorily resolved. Architectural
design now stressed the significance of the space within buildings both
sacred and secular: in Athens the Parthenon, the Hephaisteion, and the
Odeon of Perikles, in Eleusis the Telesterion designed by Iktinos, in Phigaleia

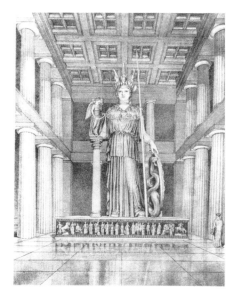

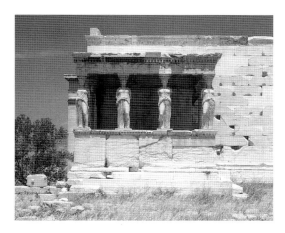

fig. 6.
Interior of the Parthenon with the
colossal statue of Athena.
Graphical reconstruction,
C. Praschniker

fig. 7
Porch of the Caryatids on the south side
of the Erechtheion on the Acropolis,
Athens

in the Peloponnesos the temple of Epikourios Apollo. Breadth was increased, the columnar rhythm of the external faces was transferred to the interior, and instead of a longitudinal two-dimensional arrangement of aisles, a three-dimensional, centrally organized space was created. In the Parthenon, the most characteristic example of this development, the central aisle acquired unusual breadth; its area was defined by colonnades on the periphery while the narrow, subordinate side aisles were illuminated by windows. Thus organic space was created in the interior of the temple, at the center of which stood a colossal gilded ivory statue of the goddess Athena, who represented a perfect world (fig. 6): a world expressed by the architectural form and experienced by the individual citizen who entered the building. Here the value of ordinary man and his ability to express truth were stated through architecture.

Another characteristic of public architecture was its decorative wealth. In the Parthenon the sculptured decoration of the metopes, pediments, and akroteria (ornaments on the roof) was pushed to its limits and the building was enriched by the introduction of an Ionic frieze. The profusion of carved and painted ornaments gave the building the character of a precious work of art (fig. 7). It has rightly been observed that this evolution indicates an already diminished intensity of faith. The inherent holiness in buildings was no longer self-evident in clarity of structure and monumental size; the ideal cosmos now was expressed by wealth of detail.

It is within this same spirit of the fifth-century conception—that the ideal human creations impinge upon the divine—that the tendency of architecture for political symbolism should be interpreted. The Parthenon and its decoration as a whole constitute an expression of the perfect world of contemporary Athens. This symbolism is repeated in the decoration of the large gold and ivory statue of Athena in its interior, which alluded to the city's triumph over evil in the motif of Athenians fighting against amazons and gods fighting against the giants on the shield and in Victory in the right hand. On the frieze of the Nike temple, at the entrance to the Acropolis, the political content of the representations was more direct: the historic struggle of the Athenians against the Persians, for the salvation of the ideal way of life that the city represented was depicted alongside the mythical battles of the Greeks. Both battles were waged under the gaze of the gods, who were gathered together on the frieze of the facade.

The use of Ionic architectural traits in Attic buildings and their mixture in the Attic Doric order also embody a strong element of symbolism. The Ionic stoa erected by the Athenians at Delphi in 477 B.C., an interesting

fig. 8.
Base of an Ionic column in the
Stoa of the Athenians,
Delphi, showing a combination
of Attic-Ionic forms

early attempt at the Attic remodeling of the Ionic order (fig. 8), was certainly intended to stress, at the moment of the founding of the Delian League on the initiative of Athens, on the one hand the Athenians' affinity with the members of the alliance and on the other the city's de facto leading role among the Ionian Greeks: the stoa was built for the display of the booty from the first joint victory of Athenians and Ionians over the Persian fleet at Sestos in 477 B.C. The use of Ionic columns in the Parthenon in the chamber behind the cella, as well as in the Propylaia in the interior, undoubtedly facilitated the solution of construction problems arising from the development of internal space; however, in combination with other Ionic features in the frieze and decoration, it underlined both the city's links with the Ionian world and its hegemony within it.

This last fact indicates just how faithfully Attic architecture expressed the world of the Athenian polis: during these years Athenian democracy achieved the realization of the highest form of human freedom. However, in its endeavor to consolidate this ideal polis, the democratic Athenian state in its relations with its allies damaged their freedom and ignored the very principle of the functioning of the city-state. Attic architecture expressed the world of the Athenian polis, which was at once free and regulated by the community. At the same time, however, it absorbed and appropriated forms and ideas deriving from a much wider area and shaped a language that was attractive to an even wider world. Thus it presented the first traits of an internationalism and transcended the age that created it. The future of this architectural creativity, like that of the idea of democracy, was, even after the demise of the system of the city-state, a splendid one.

The Human Figure in Classical Art *Angelos Delivorrias*

Since the time of Homer, man—as an absolute spiritual, moral, and aesthetic value, as the motive force of the social and historical process—has stood at the center of Hellenic civilization. Indeed, it was its anthropocentric content that enabled ancient Greek art to free itself from its original links with the weighty complexes of oriental cultures and to encompass with amazing swiftness the entire spectrum of expressive manifestations, determining the directions of subsequent inquiries of European creativity, until those times when the significance of human existence became less important.

Up to the end of the archaic period, artists in the major centers of Hellenism were experimenting with the complex problems posed by the conception and rendering of the human figure. During the fifth century B.C. these virtually autonomous exploratory paths, which had already begun to converge, conceded precedence to the workshops of Athens. There the evolutionary processes followed the gradual conquest of self-awareness, the parallel flowering of philosophical discourse and tragic poetry, and the discovery of the harmony in both the relation of form to content and the concept of order to the meaning of freedom; but above all in the formation of the ideal system of government that was, henceforth, to guarantee man's transformation into a responsible citizen.

Truly remarkable in the shaping of the human figure in the fifth century B.C., and particularly in monumental sculpture, is the coincidence of aesthetic parameters with two historical termini that delimit the phenomenon of the so-called Golden Age of classicism: the final defeat of the Persian threat with the valiant victories of 480 and 479 B.C., and the collapse of the Athenian democracy at the end of the Peloponnesian War in 404 B.C. Between these boundaries, the human figure ran through a wide gamut of psychological nuances: from the self-confidence brought about by a deep-seated certainty of the outcome of the struggle with the environment in the course of the "severe style" (fig. 1) to the resignation brought by dashed hopes, the fickleness of illusions and escapism in the ever more fragile creatures of the "rich style" period (fig. 2). However, the fathoming of the human world is characterized by a profound respect for the truth of reality, which is never expressed naturalistically, as well as by a continuous transmutation of the experiences and heritage of past artistic achievement, nevertheless avoiding the resurrection of obsolete prototypes.

The astonishing change of consciousness from the allure of archaic extroversion to the deep internal probings of classical times is accompanied by the passage of visual perception from the analytical to the synthetic level, as well as by the transfer of interest from an awestruck appraisal of the macrocosm to cognition of the microcosm of the individual. Awareness

57

fig. 1.
Kritios and Nesiotes,
The Tyrannicides, 477–476 B.C.,
marble copy after bronze original
erected in the Agora, Athens.
Museo Nazionale Archeologico,
Naples

fig. 2.
Standing Youth,
c. 400 B.C., marble.
Peiraeus Museum

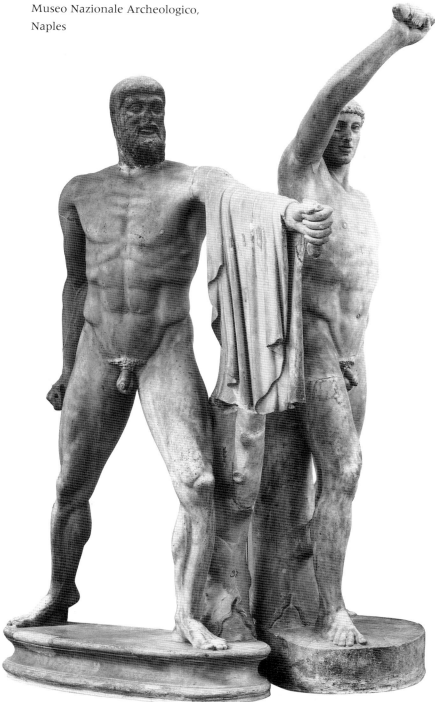

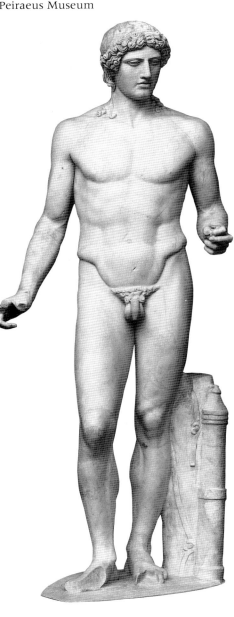

fig. 3.
(opposite)
Pheidias (?), **Apollo,** c. 450 B.C.,
marble copy after bronze original
probably on the Acropolis, Athens.
Staatliche Kunstsammlungen,
Kassel

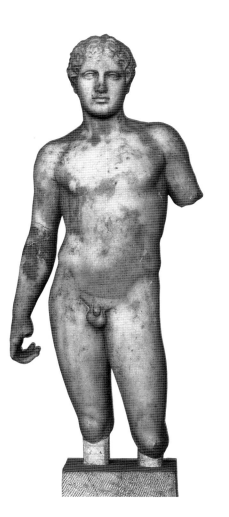

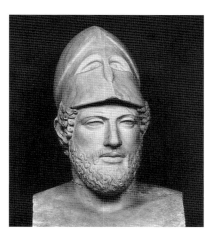

fig. 4.
Head of Perikles,
Roman copy after the bronze
by Kresilas, 429/425 B.C.
Vatican Museum, Rome

of the measure of human potential imposes on the figure the internal structure that allows its reconstitution as a seamless unity of spiritual order and exemplary value. Thus we can interpret the declaration of faith, apparent at all stages of the process, that the concept of beauty is equated with that of good and of ethos, the latter being the most intangible of the measurable values of the post-modern age. Christos Karouzos' remarks on the classical period (450–420 B.C.) apply equally to the human figure in the middle of the fifth century B.C.: "Its dialectical miracle can only be expressed in feeble oxymora: where tranquility is a form of a tremendous psychological and spiritual struggle, catholicity a form of the richest individuality, ideality an expression of the proximate reality."

It is, of course, impossible in so short an essay to consider the many questions bearing on the subject. Single answers are inappropriate, as is a one-sided evaluation of the data and the necessarily aphoristic style of writing. And more so since exactly the same principles of relativity and indefinability that determine the nature of other disciplines govern the relationship of the observer to the object observed. Nevertheless, the human figure of classical times may be considered the bearer of a system of messages that signal the transformation of quantitative into qualitative values: mass into energy, matter into spirit, inertia into momentum (fig. 3). Moreover, the distinct preference for the general rather than the specific enables this classical figure to stand forth, purified of all suspicion of deviation toward the ephemeral, while the refraction of its subject matter through the prisms of the divine and the heroic adds a symbolic distillate of moral measure.

Through the continual mirrorings of reality upon an imaginary field of reference, as a dialectical synthesis of will with discipline, of dream with fantasy, and of the impossible with the attainable, the human figure can never be understood independent of its function; it should always be perceived in conjunction with the public interest. The very fact that the shaping of body and mind was achieved within the community of the state, as well as the definition of man's ideal purpose, explains the tendency to free the human figure from the bonds of the incidental and the transient tensions of space and time. Hence its indifference to the natural and the built environment, to genre depictions of social, professional, and private life, and to the rendering of old age and infancy. Furthermore, its elevation to heroic heights, which is obviously predicated on spiritual and corporal maturity, resulted in the idealization of features even in the rare instances of portrait statues (fig. 4).

Ancient Greek Bronze Sculpture
Peter G. Calligas

From early historical times, known in art as the geometric period, the Greeks used bronze, an alloy of copper and tin, to make vessels, jewelry, and other objects of personal adornment and household use. The use of the alloy continued a prehistoric Mycenaean tradition despite the introduction of iron in the manufacture of tools, weapons, and other articles of daily use.

In the manufacture of jewelry, the lovely red-gold shimmering surface of bronze (the greenish patina we usually see nowadays being due to oxidation) made it a substitute for gold, a material that was not plentiful in Greece and perhaps for that reason much more costly. At the same time bronze was easy to work and durable, qualities that made it entirely suitable for household vessels. Copper was to be found in various districts of ancient Greece, but tin, indispensable for the alloy, had to be imported from abroad, from either the East or far to the west, from what were known as the Tin Islands. The high cost of importing tin made the alloy so valuable that, after a bronze object went out of use or was destroyed, the bronze was often melted down and used again. This habit of reusing the metal, typical of the ancient Greeks who had a well-developed sense of thrift, is the reason why relatively few ancient bronze objects have survived to our day, in contrast to many objects made of other substances such as clay. Greek bronze objects have been found mainly in graves, where they had been deposited as offerings to accompany the dead to the afterworld, and in sanctuaries where worshipers dedicated them to the gods.

Working bronze demanded specialized knowledge and techniques. Melting the metal, making the right mixture for the alloy, preparing the model and the molds, casting the bronze, and the final retouching of the object are successive phases of the work, each one requiring knowledge and experience. A small number of technicians seem to have acquired this expertise early on and handed it down from generation to generation.

Because the metal was much sought after, increased population and prosperity having contributed to a growing demand for bronze objects, artisans rapidly turned to creating hollow rather than solid objects. By the eighth century, large geometric votive fibulae (pins used to fasten garments) and some statuettes were cast hollow to reduce their weight, to use less of the precious alloy, and to reduce the risks involved in pouring solid objects. In the seventh and sixth centuries a core and/or armature, perhaps made of wood, was used inside hammered sheet-metal objects, especially statues. But cast metal proved more desirable for the production of statues. As early as the geometric period, the Greeks had developed the lost-wax method of casting bronze. The so-called direct version of this relatively

complicated procedure involves making a clay core and sheathing it with a thin layer of wax modeled to create the exact form of the desired object. This final model is covered with an outer clay mold, and pins are stuck through the mold and wax to the core. Next the completed molds are baked and the wax melted out, the pins holding the core in place. Molten bronze is poured through channels in the clay mold to fill the cavity left by the "lost" wax, duplicating its form. An indirect version of the lost-wax process involves making a model first, and then taking molds from it that are lined with wax and cored before being baked and cast as in the direct process. Today as in antiquity craftsmen use combinations of these two procedures, depending upon their specific objectives. After casting, the molds are removed and the surface of the metal is cleaned. At this point details such as eyes, lips, and nipples may be added in other materials. Greek bronze workshops themselves were temporary establishments. After the metal objects had been cast, the molds were thrown away and the casting pit and oven were dismantled; they would have been made anew for each project.

Starting in the early eighth century, the founding of the Greek cities and the development of public sanctuaries, both local and Panhellenic, affected religious practices. Religious life was centered in the sanctuaries, and religious feeling was expressed by numerous offerings dedicated in the sanctuaries, including bronze offerings of miniature animals, human figurines, and richly ornamented vessels such as caldrons and tripods. Because sculptors came under the influence of Eastern art and wanted to increase the size of the statues to life size or even larger, they turned to another medium, the abundantly available stone. Island and mainland marble, of the highest quality, became the chief material for statues in the seventh and sixth centuries, remaining in use throughout antiquity.

The form of these early statues, whether dedications in sanctuaries or objects placed on the graves of the dead, always follows the same formal tradition, the head looking straight ahead, hands attached to the thighs, and feet set slightly apart so that the statue balances well. Female figures (korai) were richly clad in garments with voluminous folds. Young male figures (kouroi) were naked, in so-called heroic nudity. In any event a complete figure is always depicted, sometimes representing a divinity in human form, at other times the dedicator of the statue.

From the middle of the sixth century onward, bronze became as popular as stone as the material for large-scale statuary. New techniques, better understanding of the material, and richer patrons (towns or private people) encouraged the bronze workers to try out their skill in sculpture

of larger size. The so-called *Peiraeus Kouros* (Apollo), dated around 510 B.C., is more than six feet tall, evidence of the technical capabilities of the bronze casters of the period; the strict frontal pose of the figure however stands in the earlier stylistic tradition of the nude male divinity. As the number of bronze statues increased during the late sixth century, it becomes evident that they follow the other far more numerous works of stone sculpture in their style. This makes it possible to recognize local workshops and local styles and to distinguish among the slender island kouroi, the eastern characteristics of Ionian works, the stocky proportions of sculpture made in Peloponnesian centers (Argos, Laconia), and the well-proportioned figures made in Attic workshops. But it must be noted that in Greek art bronze was used for figures in the round and for the decorative arts and did not replace stone in architectural sculpture (pediments, friezes, metopes, or akroteria).

The wealth of finely made bronze vessels dedicated on the Acropolis of Athens and at other Attic sanctuaries shows that Attic bronze-working establishments were producing significant numbers of objects at the end of the sixth and early fifth centuries, yet little evidence for the manufacture of large-scale bronze statuary has survived. One example is the discovery of molds for a half-life-size kouros, c. 550 B.C., found in the excavations of the Athenian Agora. The Athenian polis encouraged theatrical and athletic contests (the Panathenaia) and promoted public works. The founding of the Athenian democracy in 509 B.C. undoubtedly gave a new impulse to architecture and the visual arts, as can be seen in the new buildings and in sculpture and decorative arts such as vase painting. The flourishing of the arts in Athens in the early fifth century was, fortunately, not arrested by the Persian invasions of 490 and 480. On the contrary, the Athenians who returned to their ravaged town in 480 demonstrated their creative activity with renewed vigor. In 477 the sculptor Kritios cast a bronze group, the *Tyrannicides*, to replace the group removed from Athens by the Persians. Around 465 the young sculptor Pheidias cast the colossal bronze *Athena Promachos*, which stood on the Acropolis. The most eminent bronze sculptor of post-Persian times, Myron, made a famous bronze cow that stood as a dedication on the Acropolis. Several other important works in bronze by Myron, his *Diskobolos* and *Athena with Marsyas*, for example, are mentioned by ancient writers. The original bronzes no longer exist, but copies of them in marble have been recognized. Some people attributed to the Athenian sculptor Kalamis the magnificent Zeus (or Poseidon) of about 460 B.C. found years ago off Artemiseion in the northern straits between Euboea and the mainland.

In composition a world of difference separates the *Peiraeus Kouros* and the Artemiseion god, though in time they are no more than fifty years apart. The artistic creativity exemplified by the Artemiseion god is exactly what justifies the characterization of the fifth century B.C. as the century of the "Greek miracle."

The Contribution of Greek Drama to the Political Life of Athens

Daniil I. Iakov

The origins of Greek drama remain unexplained up to this day because we lack any detailed and coherent information on the subject. This situation has given rise to a variety of conflicting theories about the birth of tragedy and comedy; what is beyond any reasonable doubt, however, is that Greek drama reached its culmination in fifth-century-B.C. democratic Athens. A large number of plays were produced by many poets during this period, but only a few of the most important works of four dramatists have survived intact. Forty-four complete dramas have come down to us: seven tragedies by Aischylos (525–456), seven tragedies by Sophokles (496–406), eighteen tragedies and one satyr play by Euripides (485–406), and eleven comedies by Aristophanes (c. 450–c. 385).

Greek drama was a multidimensional phenomenon with a variety of functions, one of the most important of which was sociopolitical influence. A Greek play was not performed repeatedly for entertaining an audience; rather it constituted a unique theatrical experience, presented only once within the religious setting of the annual festival of the Great Dionysia at Athens. Its performance was under the supervision of state officials charged with the selection of the competing poets and their plays. Furthermore, if we take into consideration that renowned politicians like Themistokles and Perikles served as *choregoi,* that is to say undertook the expense of staging plays, that Aristophanes considered the dramatist as educator of his people, and that Plato banned tragedy from his ideal state because he judged it harmful to society, we can better understand the great influence that was attributed to theatrical works by statesmen, poets, and philosophers.

Perikles, for example, sponsored the performance of a trilogy that contains the oldest preserved work of Aischylos, *The Persians* (472). The subject of the tragedy was a recent historical event with enormous political significance, the defeat of the Persian fleet at the naval Battle of Salamis in 480 B.C. The poet, however, in spite of the pride he felt for his city and its political system, did not compose a drama to serve ephemeral chauvinistic or factional goals. He attributed the defeat of the Persians not to any human agency but to the youthful arrogance of their king, Xerxes, and his subsequent transgression of the moral code that bids, among other things, knowledge of human limits and respect for the temples and sanctuaries of the gods. Such a message knows no local or temporal limitations and may serve as a guide to political behavior in every country at any time.

Historical tragedy constitutes an exception to the usual subject matter on the classical Attic stage. The main source of tragic subjects was not contemporary reality but myth, that is to say events that took place in the distant heroic past. Myth acquired relevance to contemporary situations,

in spite of local and temporal distances, because of the way in which the poets treated the events of the past. For example, in *The Suppliants* (463?), Aischylos dealt with a question crucial for contemporary politics, the granting of asylum to a fugitive, by basing his play on mythical figures. The fifty daughters of Danaus, pursued by their fifty cousins, the sons of Aegyptus, flee to Argos in order to avoid being forced into unwelcome marriages. Argos' King Pelasgus is faced with the dilemma of whether to grant them asylum and therefore become embroiled in war with the persecutors and endanger the lives of his innocent subjects, or to transgress his sacred obligation to protect the suppliants and thus provoke the wrath of the guarantor of the suppliants' rights, Zeus himself. Faced with this impasse, the king decides to grant asylum, but he wishes his decision to be approved by the assembly of the people—obviously a political anachronism. The conclusion is twofold: the question of whether political advantage should be served or the rules of ethics observed is unequivocally answered in favor of the latter alternative; and the responsibility for taking decisions devolves on officials, but the people must have knowledge of these decisions and be persuaded about their correctness, at any rate in a democratic country.

During the Peloponnesian War (431–404), Euripides dealt with the problem of asylum in two tragedies, *Herakleidai* and *Suppliants*. In these cases, too, moral principles triumph, and Athens is shown to be a Panhellenic bastion for the defenseless and persecuted, such as the children of Herakles in the former tragedy and, in the latter, the Argive mothers who beg King Theseus to intervene so that they be allowed to carry away and bury the bodies of their sons who fell in the war of the Seven against Thebes. Here Euripides made a distinction between democratic Athens and the oligarchic government of her opponent, pointing out the excellences of the democratic system without, however, concealing its weaknesses, in particular when the people possess uncontrolled power.

Aischylos' *Eumenides*, the third play of the Orestean trilogy (458), alludes to the political situation of the time. The democratic reforms of Ephialtes had been recently introduced four years earlier, whereby all political power was taken away from the aristocratic Council of Areopagus, which had, until then, exerted great influence in formulating foreign policy and had controlled internal affairs. The Council of Areopagus now had jurisdiction solely over cases of homicide—such as the murder of Clytemnaestra by her son Orestes. The verdict of the highest court in the *Eumenides*, namely the acquittal of Orestes, enrages his accusers, the Furies, the goddesses of punishment and revenge who threaten to call down catastrophe and civil war on Athens. Athena, however, succeeds in persuading the Furies to give

up their destructive role and to take a place of honor within the framework of a well-governed democratic society. In proposing a balanced distribution of powers, Athena turns the Furies into beneficent spirits called Eumenides, the "Gracious Ones."

Sophokles' tragedy *Ajax* demonstrates that those who govern and those who are governed, especially within the framework of democratic institutions, have need of harmonious cooperation and mutual assistance rather than of strife and antagonism; there is no such thing as being a law unto oneself based on unyielding positions (the same truth is shared also by the *Prometheus Bound* of Aischylos and the *Antigone* of Sophokles). In *Ajax* the hero commits suicide because he is unsuccessful in his attempt to revenge himself on the sons of Atreus, who have awarded the arms of the dead Achilles to Odysseus rather than to himself. The sons of Atreus decide to punish the dead Ajax by forbidding the hero's burial, but Odysseus, the great opponent of Ajax while both were alive, succeeds in overturning the decision, recognizing the fragility of a human being.

Greek tragedies do not contain solely timeless messages. Occasionally they serve short-term political aims, for example the promotion of Athens' alliance with Argos (Aischylos' *Eumenides*), or a caricature of the opponents of the Athenians in the Peloponnesian War, the Spartans, by making fun of their mythical king Menelaus (Euripides' *Andromache*).

Whereas tragedy employs various devices such as anachronism or analogy between past and present situations in order to transplant current historical reality into the realm of myth, the comedy of Aristophanes draws mostly on everyday political events and satirizes all holders of power, who are sometimes mentioned by name and sometimes given a transparent pseudonym or referred to in a symbolic or an allegorical manner. The comic poet was merciless in scrutinizing political affairs and thus contributed to the good function of the democratic system. The demagogue Kleon was so exasperated by Aristophanes' criticism that he took the poet into court.

One might well maintain that comedy is a witty way of handing out advice on stage to the city and its politicians. During the troubled years of the Peloponnesian War, the poet's constant concern was to propagate the message of peace and to brand the indecencies of public life. Suffice it to observe that in *Ploutos* the poet abandoned political satire, since it no longer had any point in a city waning after its decisive defeat in 404. Thus we see the disappearance of a form of drama, the comedy with strong political interests, along with the decline of the city. This more than anything else vividly demonstrates the significant social role that comedy played in Athens of the fifth century.

One thing is certain: Greek drama, whether in serious or playful form, was always designed to transmit a political message of the highest significance, a message that aimed at consolidating, criticizing, and improving the democratic institutions and the public conduct of the citizens, both the governing and the governed.

Reflections from the Golden Age
Robertson Davies

One of the most deeply rooted notions of civilized man is that there existed, at some time in the remote past, an era when humanity reached a glory from which it has been in decline ever since. This is the belief in the Golden Age. The Greeks dreamed of a Golden Age

> *When Saturn did reign, there lived no poor,*
> *The King and the beggar on roots did dine.*

But when we think of a Golden Age we think most often of that classical period in ancient Greece, roughly defined as the fifth century B.C., distinguished for art of a serene and restrained majesty, an ideal beauty of proportion, form, and expression, to which we have never again attained.

It was not always so. Greek art was little understood in the Western world until the middle of the eighteenth century, although examples of it were to be seen in great collections. It was the art historian Johann Joachim Winckelmann who spent a life discussing, cataloguing, and praising what was known and what was newly discovered for its serenity and noble simplicity. He may be said to have brought about neoclassicism in Europe, and his influence persists. It was he who brought into focus the Golden Age of Greece.

Not that the Greek heritage was unknown until its art came into vogue. During the Dark Ages manuscripts of Greek literature lingered in the libraries of monasteries, often neglected and little studied but not wholly forgotten. In an era committed to the learning and culture of the Christian church, however, such stuff had always a dubious reputation, for it was rooted in paganism. It was not until the Renaissance of the fourteenth and fifteenth centuries that such manuscripts were dusted off and eagerly acclaimed as wondrous revelations of an intellectual splendor that had existed before the Church was dreamed of.

This knowledge of the literary and philosophical riches of ancient Greece spread and dominated European culture, especially after the Reformation had put an end to the overwhelming psychological domination of the church of Rome. Schoolboys and ripe scholars who had never beheld a Greek sculpture or even a Greek vase were nevertheless deep in Greek literature which, in company with that of Rome, dominated European education for at least four centuries. Scholars of renown, and scholars who were merely competent, and schoolboys who were never likely to become competent all knew the heroes of Homer, but could not have formed any idea of what those heroes may have looked like. The more they knew the more adroit they

became in managing Greek meter, and would no more have confused a choliambic with a trochaic tetrameter catalectic than they would forgo their college fellowships; but of the actual manner of performance of a Greek play they knew nothing whatever. Greece was, for them, a literary rather than a sensuous concept.

We find evidence of this in their translations from the Greek and their imitations of Greek drama. Chapman's version of Homer is remembered now chiefly because Keats asserted in a famous sonnet that he owed his classical enthusiasm to it. But when we read it—and many readers do not persist to the end of *The Whole Works of Homer: Prince of Poets* (1616) because to the irreverent it seems often like riding over cobblestones in an unsprung cart—the flavor that rises to us from the pages is Elizabethan rather than Hellenic. The best plays of the golden age of English drama that deal with Greek themes, such as Shakespeare's *Troilus and Cressida,* are wholly Jacobean, and the arguments of the wise Ulysses on order and degree, excellent in themselves, would have been unlikely to occur to a Greek dramatist.

Nor have any of the tragedies written in Europe during the three centuries following the Renaissance much about them that speaks to us of Greece. The works of Corneille and Racine owe something of structure but little of spirit to the Greek drama from which they have drawn inspiration. But these are the works of poets great in themselves. To understand the icy grip that Greek drama had on the imagination of the learned and the merely educated world of the seventeenth and eighteenth centuries one must read a few of the countless tragedies written by earnest clergymen, armed only with ambition and a grounding in Greek, that were offered to the theater and appear now as precisely what they were—talentless and imperceptive imitations.

When they showed some dramatic flair they were even less Greek in feeling. Consider a play that held the stage for fifty years and provided a role splendidly acted by the great Mrs. Siddons, *The Grecian Daughter* (1772) by Arthur Murphy. In it Euphrasia saves the life of her father Evander who is in prison but starves on the prison diet; Euphrasia visits him and suckles him at her flowing breasts. In classical style this is not shown on the stage but is described by a guard, something of a Peeping Tom, who spies on it and relates what he sees to the audience, with moral gloating. It is not easy for Euphrasia to surpass this purely feminine exploit, but she does so by employing "a daughter's arm" to stab the tyrant, whereat her father cries

My child! my daughter! sav'd again by thee!

This is the voice, not of the Golden Age of Athens, but of the Age of Sentiment.

After the Renaissance, every age invented its own Greece. In seventeenth-century Florence a form of monodic music drama was thought to imitate the sung drama of the Greeks, and from it modern opera evolved. Alexander Pope produced (1715–1726) a splendid Homer, but as the critic Richard Bentley said, "It is a pretty poem Mr. Pope, but you must not call it Homer." There were many translations, and it is instructive to compare some of them and to wonder that one original could inspire so many disparate versions. But if we talk of the marvels of translation, let us turn, not to Homer, who was not of the fifth century, but to Sophokles, who was. Here is what a sober modern scholar, R. C. Jebb, offers as the conclusion of the final chorus of *Oedipus the King*:

> *Therefore, while our eyes wait to see the destined final*
> *day, we must call no one happy who is of mortal race*
> *until he hath crossed life's border, free from pain.*

Now hear a great poet, W. B. Yeats:

> *Call no man fortunate that is not dead,*
> *The dead are free from pain.*

And here is the romantic, Swinburnian version of a notable classicist, Gilbert Murray:

> *Therefore, O man, beware, and look toward the end*
> *of things that be,*
> *The last of sights, the last of days; and no man's*
> *life account as gain*
> *Ere the full tale be finished and the darkness*
> *find him without pain.*

All three obviously stem from the same source, but they are sufficiently different to make us wonder what we, if we had been Greeks, would have heard and understood had we been among the seventeen thousand Athenians who first heard the words spoken in the great theater of Dionysos. What would the tone have been? What shade of emotion would have been aroused? Even if we are fully proficient in Greek today, how much can we recapture of the savor of ancient Greece?

For us it has become a Golden Age, and perhaps it is best if we do not understand it too well. Consider, for instance, the matter of democracy. At its peak, the population of Athens was about 180,000; a conservative

estimate puts the slave population at 20,000 and these had no voice in government; women had no voice in affairs and they probably numbered about 70,000 at a guess. The voting population is estimated as less than 50,000. The Athenians were not trustful of elected persons, and offices were assigned by lot, rather than by simple vote, to control peculation. Nor was truth and the sanctity of the given word highly regarded (it was assumed in the courts that slaves never spoke truth except under torture), and public officials were kept in check by a number of controls. Privileged birth and outstanding wealth also played their part in government. The freedoms of Athenian democracy were by no means limitless, and when we refer to it as a model for our own democratic governments we do well to preserve a certain vagueness.

We are on firmer ground when we consider our artistic and literary legacy from Greece, but even here we must take heed of our posture as observers 2,500 years after the fact, and of the presuppositions we bring to our appreciation of the Greek heritage. In particular we must beware of mingling our Christian-Judaic ideas about mankind and society with what we can discern of Greek attitudes. When Elizabeth Barrett Browning wrote of

> *Our Euripides, the human,*
> *With his droppings of warm tears,*

she created a Euripides in her own image, as well as perpetrating an unintentional, ludicrous portrait. The Greeks were not ourselves in fancy dress, and to discover who and what they were with greater precision requires careful, undeluded study, which may well begin with Greek religion.

The rediscovery of Greek belief at the time of the Renaissance let a wonderful breath of fresh air into the European imagination. That imagination had been for a thousand years or more dominated by the Christian church, which made available to the people what portions of the Christian faith were thought to be good for them and made it amply clear that there was no salvation for their souls outside its walls. Though Christianity was a sophisticated belief with a coherent philosophy, it never wholly shook off its Oriental origins and its powerful Hebrew foundations. It was not a religion that encouraged free speculation and it regarded art as a handmaid rather than a creature of priestly authority. Its attitude toward women bespoke its Oriental associations and, although the Blessed Virgin was accorded high honors, it was as a mother, and never as a lover, that she was adored. There was no female figure in the Trinity, and the women of the New Testament were

virtually all servitors or penitents. Love, in so far as it was considered, was an adjunct of faith. Such teaching flew in the face of reality, as it could be observed by the more intelligent part of the populace, and the revival of Greek learning brought a splendid release. Until Winckelmann's time, however, it was chiefly literary in its influence.

It was a rediscovery of the Greek pantheon, a consideration of gods long forgotten, which, to spirits in chains, gave a psychological freedom that blew through orthodox Christianity like a frolic wind, and its influence in the subsequent Reformation has not been widely considered. Here was a religion that had a god who was in charge, so to speak, of every aspect of human life, a religion that considered nothing human alien to it and encouraged and venerated freely speculative thought. It embraced womanhood (though not of course as voters) and thought love not merely important but in the center of human concern. Here was a religion exalting rather than deriding the human form, adoring beauty, and thinking that, upon the whole, men were as beautiful or even more beautiful than women. Much later, in the Greek-obsessed nineteenth century, Swinburne was to write

Thou hast conquered, O pale Galilean;
the world has grown grey from Thy breath.

But he wrote of an earlier age than the Renaissance, when the pale Galilean, or perhaps it is fairer to say His interpreters, were sharply rocked back on their heels. The old gods had returned, and they are still with us.

Something of their spirit, that is to say, is still with us, but the man in the street is not likely to be able to name more than two or three. Zeus, the father of the gods, the cloud bearer and the hurler of thunderbolts, is still well remembered, even if it is only in Offenbach's *Orphée aux Enfers,* where Zeus dances a minuet and then leads the Olympians in the most famous of all cancans.

Zeus, with his horde of divine and mortal children and his appetite for pretty girls, is in sharp contrast to the God of Christianity, the monolith Creator of a monotheistic faith.

Zeus even had a wife, a consort and a powerful one. She was Hera, and her sphere of influence was in marriage and affairs of family and childbirth. She knew jealousy, rage, and revenge, and she was certainly no benign mother goddess.

We might be inclined to think that Athena was a more pacific figure, for her concern was with arts and crafts and wisdom, and she is well known in the modern world; her image adorns the cornice and also the main staircase of one of London's most celebrated clubs, known for its association with literature, and the owl of Athena (she was herself sometimes called *glaukopis,* which may mean owl-faced or perhaps bright-eyed) is to be seen in the insignia of scores of educational institutions, including the regalia of Washington's own Smithsonian. But we would be wrong: Athena was first of all a war goddess, though hers were the nobler aspects of conflict. It was Ares who was the god of the terrors and horrors of war and, like Poseidon, who ruled over earthquakes and the sea, he was a god more feared than loved.

If Athena ruled wisdom and literature, Apollo ruled prophecy. He was the god of male beauty, which he combined, some-what astonishingly to the Christian mind, with moral excellence. Apollo was beneficent; he had virtually no shadow, nor had his twin sister Artemis, who was goddess of fertility and shared the cares of childbirth with Hera, showing herself more beneficent as she did so. But she was no Blessed Virgin; motherhood and all the sentimentality that goes with Mother's Day was not congenial to the Greek mind. They were a remarkably unsentimental people; it would not have occurred to them to erect a vast temple to Mickey Mouse.

Aphrodite was the goddess of love, both intellectual and sensual, and to the Renaissance she brought a great expansion of spirit. Demeter was goddess of generation and rebirth; her grief-laden pursuit of her daughter Persephone, who was carried away to the underworld, might make us see her as a sentimental mother goddess if it were not for her trick of holding a child over a blazing fire to purge it of its mortality and thus make it immortal. The Greek gods were incalculable, and to our eyes sometimes barbarous.

A somewhat sinister figure was Hephaistos, god of fire, of metalwork, and of crafts; lame from birth and of a cankered nature, his temper was not improved by the love affair between his wife Aphrodite and the disagreeable Ares; he trapped them in a net and exhibited them in their confusion to the other gods, who laughed heartily. Neither the Greeks nor their gods were notably tender toward human folly. To catch

someone with his, or her, pants down—so to speak—was their idea of a really good joke.

Two dark gods remain whose influence was great but whose nature remains incalculable. The first of these, Hermes, was the herald of the gods and as such a great tattler and tale teller, which may be why he invades Athena's realm of literature or at least of journalism. He was god of thieves, of finance, and of merchants, for he was the god of luck and whatever is shadowy and chancy. He was the god of sleep and dreams, and thus associated with the modern art of psychoanalysis. Anthropologists will recognize him at once as the trickster of the gods. The other dark god was Dionysos, whose realm was all that is irrational, drunken, and possessed. Much crime of the passionate sort is ruled by Dionysos, the god of the drug taker, the serial murderer, and the child abuser: god of ecstasy, which has two faces, one inspired and the other demonic.

These are the mighty twelve of Olympus. There are more than twenty lesser gods, of whom Asklepios, the god of healing, Hekate, associated with ghosts and demons and black magic, and of course the nine Muses, who had special care of artists of all kinds, are immediately familiar. Thus it may be seen that every Greek had several deities who could be appealed to at necessity.

We must not forget that, although these gods have come down to us as fantastic figures shorn of their divinity, they were cloaked for the Greeks in their *thambos,* the reverential awe that surrounds the supernatural. The artistic or literary significance they have for us too easily shrugs off the prayers and rituals by which they were invoked, and we are left with only the iconic, the representational portion of their godhead. Splendid as it is, we must never mistake it for the whole.

Unless we give some understanding to Greek religion, we shall not come close to understanding Greek art. It is, however, a religion unlike any we know. It was rooted in no revelation; it possessed no prophet and no holy book; it was not codified or dogmatic, and it was defined in no creed. But it arose from a great body of myth.

Dispute about the nature of myth is unending, and ranges from Robert Graves' determination that myths embody versions of historical and political realities to the equally strongly asserted opinion of the psychoanalytical thinkers who declare that myths shadow forth in narrative the condition of the human soul. It is not impossible, of course, that myth is both these things, for history and politics must surely arise from the depths of human consciousness. But we must not suppose that the Greeks of the Golden Age bothered their heads about such matters;

myth was, for them, part of the atmosphere in which they lived, and when they went to the theater they went for a religious rather than a secular edification, and the stories of the great tragedies were fully familiar to them; their pleasure was found in the poetic splendor in which their poets enfolded what was already known.

Here we meet with a fact that is puzzling to the modern mind: the Greek theater was religious in intent, and the tragedies were based upon religiously accepted myths; but with these profound, solemn, and numinous dramas appeared also comedies of such astonishing bawdry that we have trouble in comprehending them. Who has not grubbed among the footnotes of a comedy by Aristophanes to try to find what he is being dirty about? For dirty these comedies are, not simply free-spoken and uninhibited. As Professor Eugene O'Neill writes: "There is no escaping the fact that Aristophanes wrote just as obscenely as he could on every possible occasion," and speaks of such writing as "the very part of his work which the poet clearly took the greatest delight in composing." These comedies make rapid leaps from dirty dialogue to odes of haunting beauty, and we marvel at the comprehensive taste that enjoyed both.

Many people today may gain a more immediate and fuller sense of the Greek world from the contemplation of Greek art than from any amount of studying translations of Greek literature. Some knowledge of Greek, once the hallmark of a gentleman's education, is now a rarity. George IV said that a gentleman was a fellow who had some Greek and did not part his coattails when he sat down; Greek art has supplanted Greek language as our peephole to Greek culture, and we no longer wear coats whose tails must be elegantly flipped to the rear so as not to expose our bottoms. We have outlived the era when Thorvaldsen's imitation Greek sculptures or such comic productions as Hiram Powers' *Greek Slave* carry any conviction to our hearts. We must have that part of the real thing that remains to us and make of it what we can.

In doing that, we must not forget that Greek sculpture, familiar to us since the Renaissance in monochrome marble, was originally brightly colored to imitate and improve on nature; eyes and lips glowed, nipples were rosy, hair might be bound with circlets of precious metal, even eyelashes of fine wire might be affixed. The effect, to the austere eye of modernity, might seem vulgar, but it glowed with life and it was authentically Greek as the graveyard tones of what remains to us is not.

We shall make little of what we see of our heritage from the Golden Age if we do not attempt in some measure, and however incompletely, to comprehend the psychological atmosphere that brought this art into being.

CATALOGUE

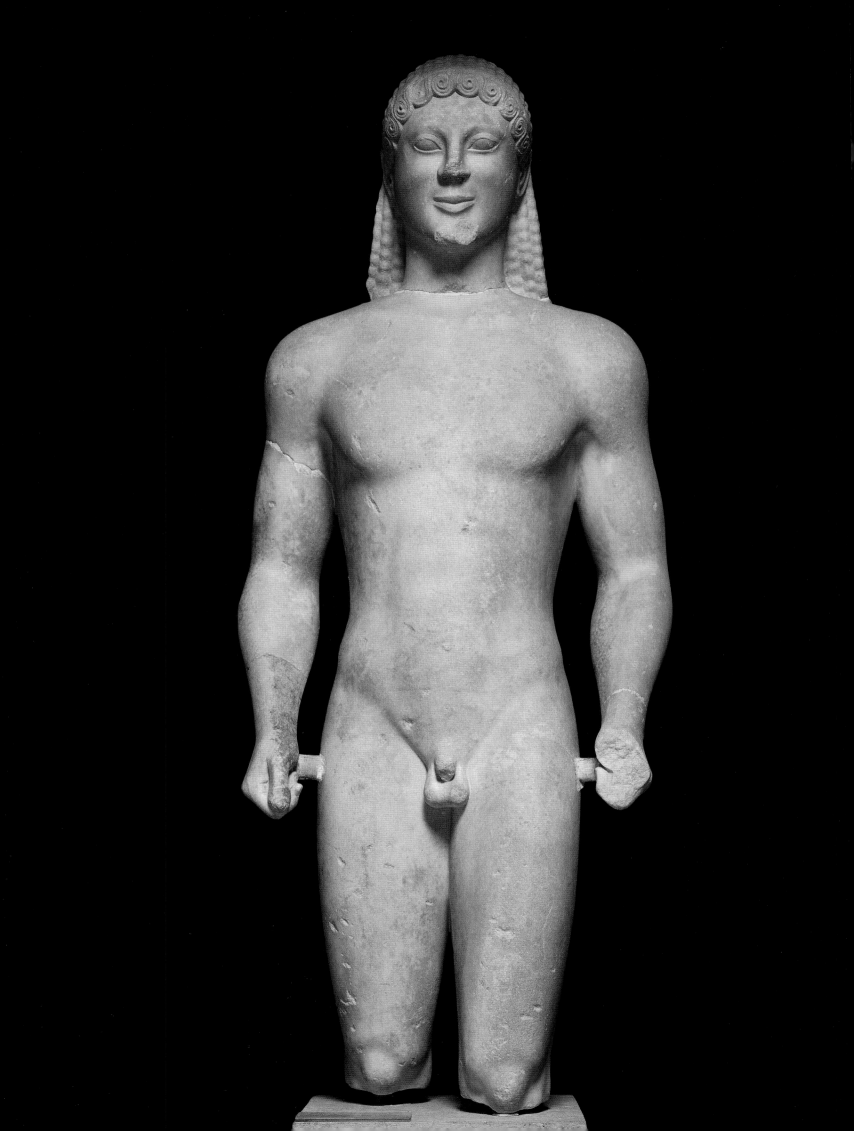

1
Statue of a Youth: Kouros
marble, 530–520 B.C.
height 1.6 m (63 in.)
National Archaeological Museum, Athens, 12

Throughout the sixth century B.C., Greek artists struggled to represent the human figure in an increasingly naturalistic way. The discoveries they made about the structure of the body helped set the stage for the achievement of the classical style in the next century. Statues of youths, known as kouroi, were a primary vehicle for exploring the depiction of the human body.

In the remote Sanctuary of Apollo on Mount Ptoön in Boeotia, some seventy-five miles northwest of Athens, archaeologists have excavated more than a dozen such kouroi. This example, discovered in pieces between 1885 and 1905, stands in the pose that had become canonical in the sixth century B.C.: facing front, arms at the sides, left leg forward, weight evenly distributed on both legs. In the archaic tradition, a smile animates his face. The well-developed musculature and vigorous energy of the figure place it close to the end of the century.

Some kouroi commemorated or were representations of deceased persons either in cemeteries or in sanctuaries. Others, such as this one dedicated in a sanctuary, may instead have been intended to represent the deity himself, in this case Apollo, who was charged with the flowering of youth into manhood. The lower legs of the statue are missing but the oval base, with the left foot advanced in front of the right, is preserved though not shown here. Athenians and Boeotians are known from inscriptions to have dedicated statues in the Ptoan sanctuary, although no dedication indicative of sponsorship accompanies this statue.

2
Statue of a Running Girl
marble, 490–480 B.C.
height 0.65 m (25⁹⁄₁₆ in.)
Archaeological Museum, Eleusis

This figure of a girl is a charming and accomplished study in motion and surface decoration. The treatment of the drapery combines an archaic delight in calligraphic patterns with a real sense of the moving body. The archaic style is evident in the sweeping linear folds that define the surface of the clothing as they reflect the girl's activity. Rows of tight curls across the forehead and the slight smile also recall the archaic tradition. However, the sinuous manner in which the artist has sought to show the figure running, as well as the feeling of young-girl chubbiness in the face and upper body, look forward to early classical innovations. The mantle, fallen from the shoulders, is visible on the back and upper right arm, and must once have been draped over the left arm as well. Hair shows beneath a diadem; more curls were once attached to a line of five holes at the back of the neck.

The two-dimensional concept and unfinished back suggest that the sculpture was placed in an architectural setting, perhaps in the pediment of a temple. The identity of the figure remains a matter of conjecture. Her backward glance, implying action behind her, would be appropriate for the goddess Hekate, who lighted the way for Persephone to return from the underworld after having been abducted by Hades. A figure of Hekate would have held torches in each hand; traces that might be from the ends of such torches can be seen on the right thigh and left side.

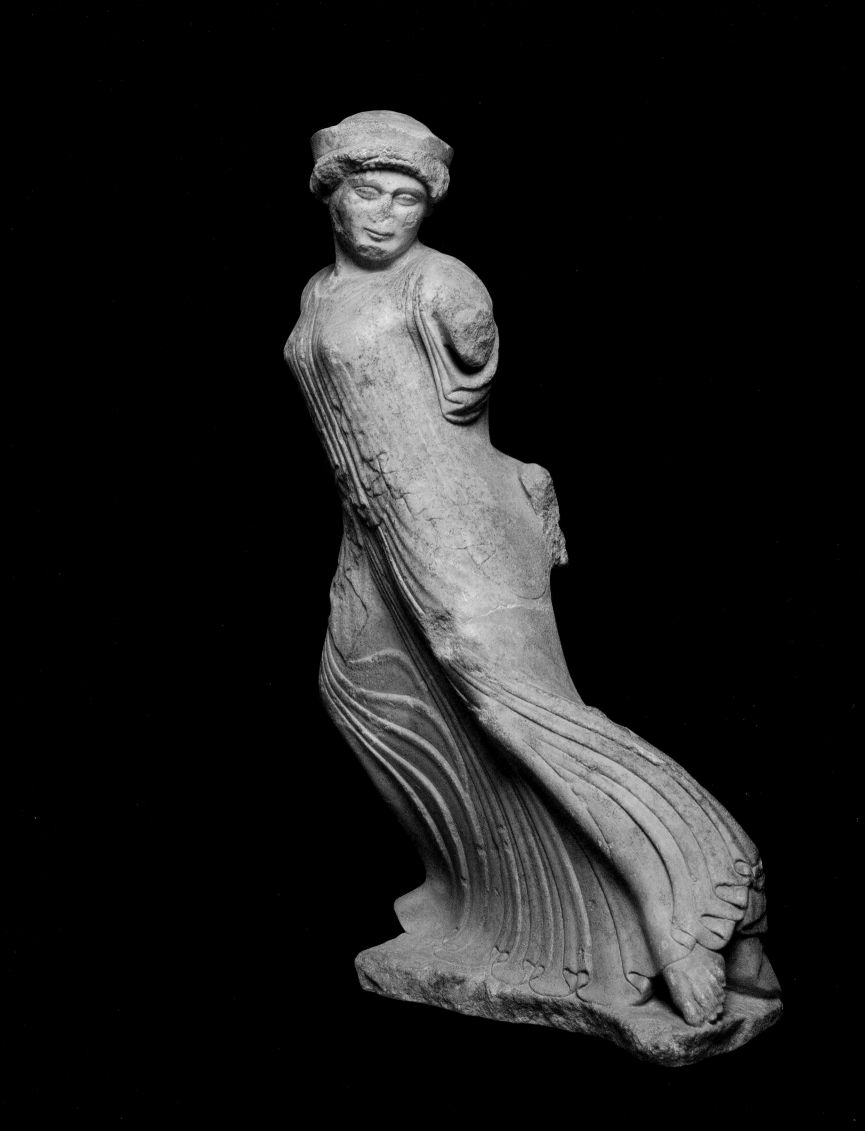

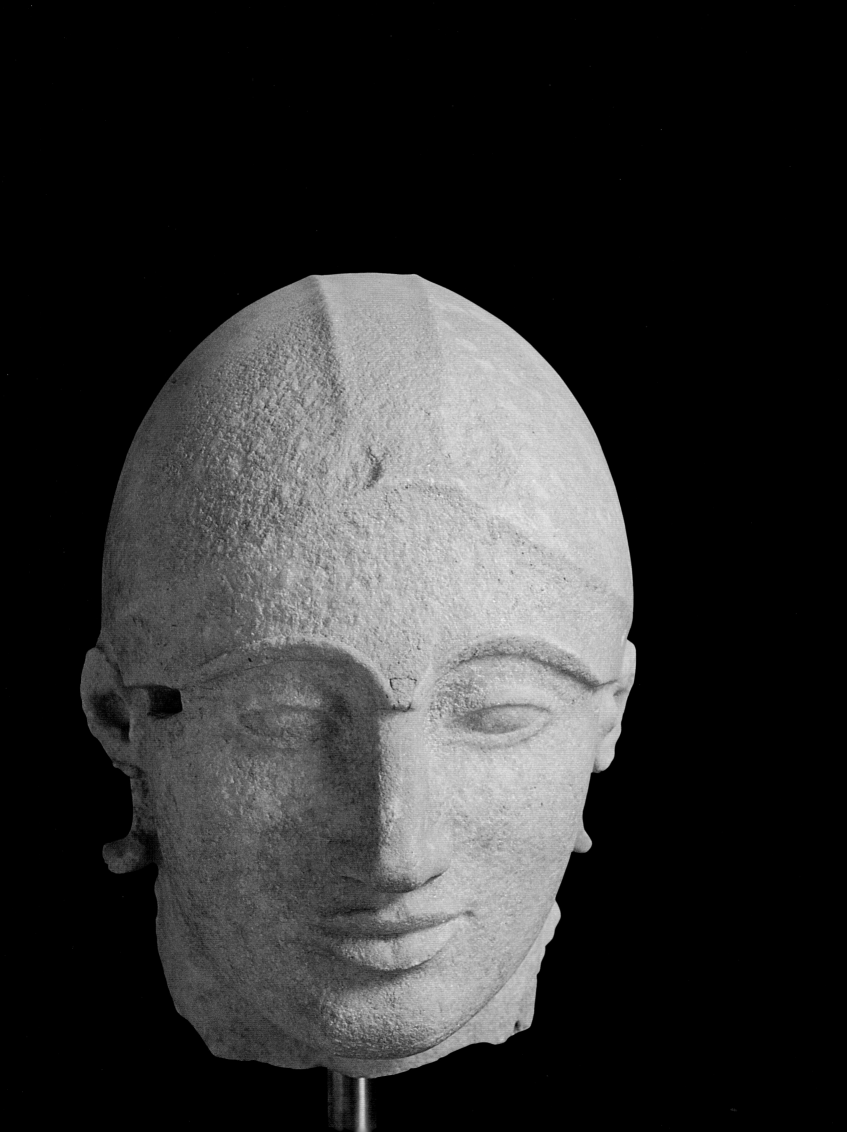

3
Head of a Warrior
marble, 485–480 B.C.
height 0.24 m (9⁵⁄₁₆ in.)
Staatliche Antikensammlungen und Glyptothek,
Munich, O.IX a

The head came from a figure once placed in the east pediment of the Temple of Aphaia at Aegina, an island power near Athens. The subject of the pediment was the legendary siege of Troy by the hero Herakles and by Telamon, son of the first king of Aegina and grandson of the nymph Aegina. This head may belong to the fragmentary remains of a Trojan warrior rushing to help a comrade ward off the attack of Telamon.

In its present condition the head lacks several of its original components. Missing from the helmet, which is pulled down over the forehead, is the nose guard. Also missing are the movable cheek pieces, made separately of marble, which were once attached in front of the ears where slots are visible. The helmet lacks a crest, which may have been made of some other material; traces of a painted net pattern are still evident on the helmet itself. The holes under the neck guard of the helmet were for the attachment of lead hair, probably also painted.

The head retains traces of the archaic style in the slight curve of the lips and the gentle bulge of the eyeballs; but the broad, simple planes of face and helmet, the emphatic projection of the eyelids, and the suggestion of intense concentration in the expression are harbingers of the early classical style.

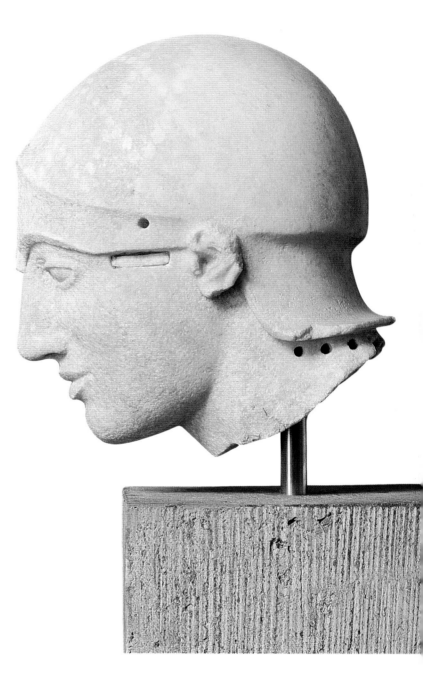

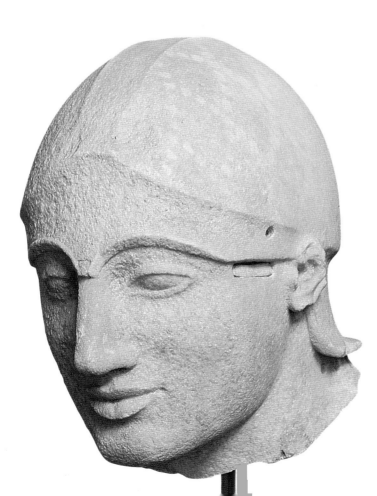

4
Head of a Warrior
bronze, 490–480 B.C.
height 0.29 m (11⁷⁄₁₆ in.)
National Archaeological Museum, Athens, 6446

This head was part of a life-size statue of a warrior, per-
haps a mythological hero, that was a votive offering on the
Athenian Acropolis, where the head was found. The lack
of detail in the hair suggests that the figure wore a helmet
arranged to reveal only the fringes of hair across the fore-
head and at the nape of the neck. The eyes retain some of
a white substance that formed an inlay, but the iris and
pupils are gone.

Scholars have often associated this head with the marble
sculpture from the east pediment of the Temple of Aphaia
at Aegina (compare cat. 3). The taut lines and angular pro-
files are similar, and both this head and the sculptures
from Aegina show the same transitional style in which
archaic elements—for instance the stylized hair and
beard—are combined with early classical details such as
the emphatic projection of the eyelids. The gravity of
expression, which gives the sense that these warriors are
aware of their actions and take responsibility for them,
points the way to the early classical period.

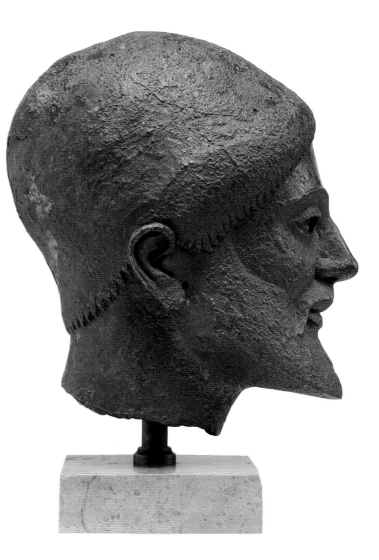

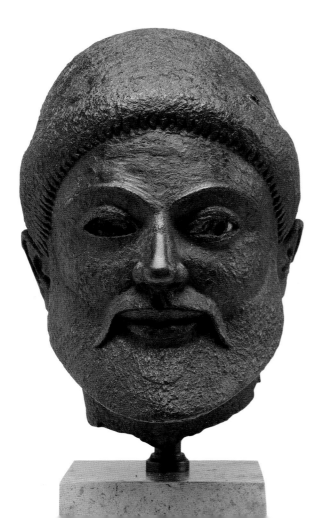

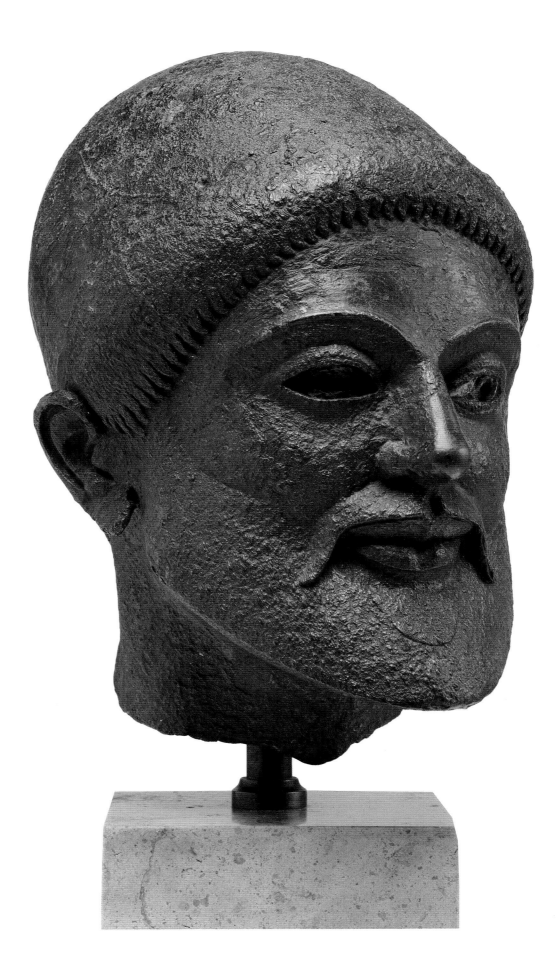

85

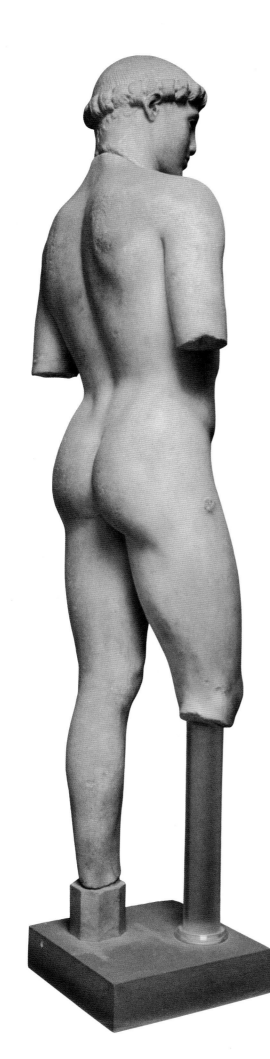

5
Statue of a Youth: The Kritios Boy
marble, 480–470 B.C.
height 1.167 m (46 in.)
Acropolis Museum, Athens, 698

Although still in the kouros tradition, the *Kritios Boy* makes a dramatic break from the canon. The figure is no longer entirely frontal with weight evenly distributed upon the legs; weight now rests primarily on the left leg, leaving the right leg free. The weight shift is reflected in the angle of the hips and shoulders, in the curve of the spine and tilt of the head. Although the boy is in a resting position, his potential for movement is clear. These changes from the archaic canon constitute a major advance in the direction of naturalistic representation. The eyes were once inlaid with glass or stone that would have contributed to the lifelike appearance. The archaic smile is gone, and the result is a more introspective, serious expression:

> *He keeps measure in his thoughts,*
> *And measure in his doings.*
> (Pindar, *Isthmian Ode* VI, 71–72, tr. C. M. Bowra)

The statue, found on the Athenian Acropolis, may represent the Athenian hero Theseus standing as a dedication to the goddess Athena. It is called the *Kritios Boy* because it resembles the head of Harmodios in the famous group known as the *Tyrannicides* by the bronze sculptors Kritios and Nesiotes, a work known today only in Roman copies. Certain details such as the low-relief wisps of hair clinging to the neck, the eyes that were once inlaid, and the polished surfaces of the flesh might point to a sculptor who also worked in bronze.

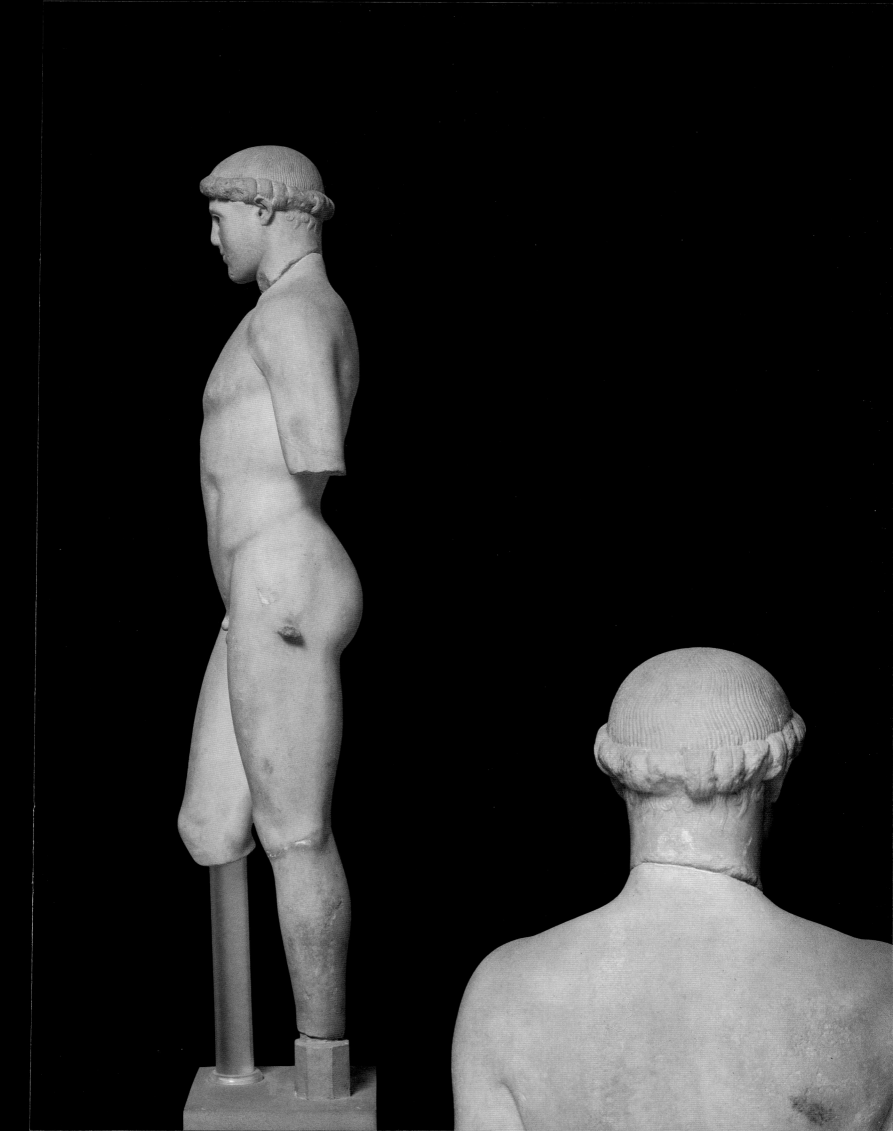

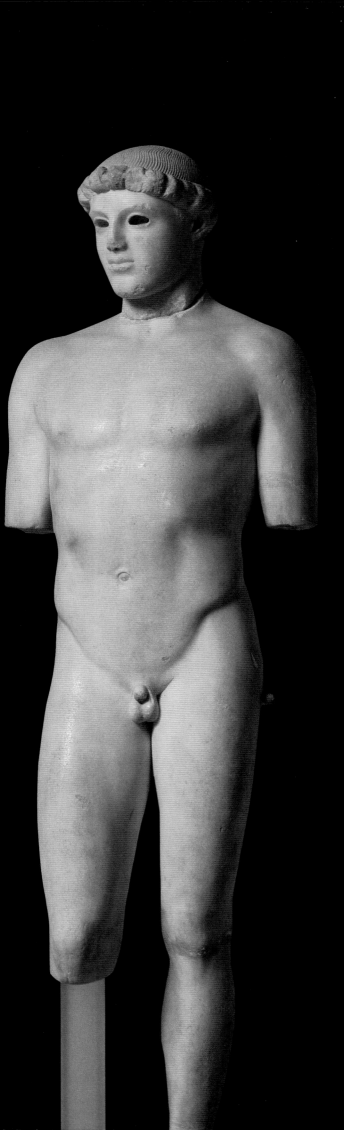

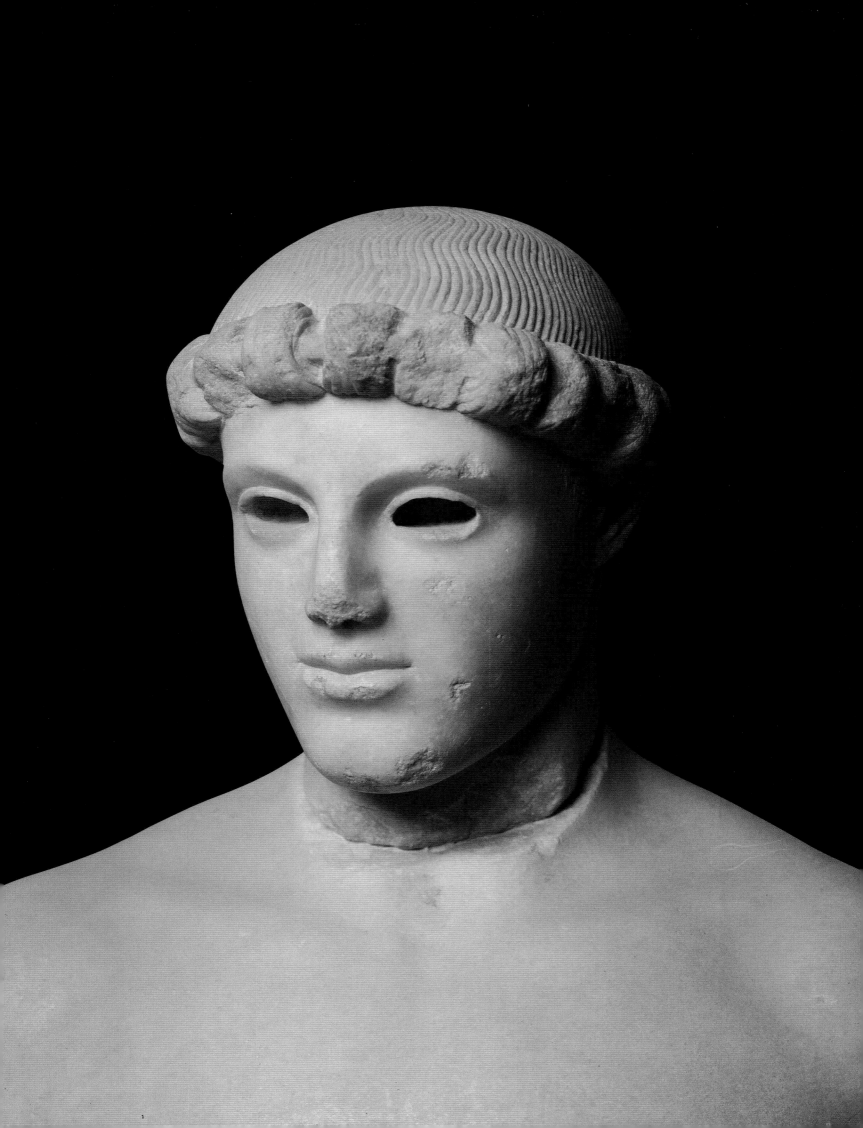

6

Head of a Youth

bronze, 480–470 B.C.
height 0.11 m (4⁵⁄₁₆ in.)
National Archaeological Museum, Athens, 6590

This head came from a small statue of a youth which, like the *Kritios Boy*, stood as a dedication to Athena on the Athenian Acropolis where it was found. The artist modeled the head with great attention to symmetry and has successfully exploited the bronze medium by contrasting the fine lines of the locks of hair with the smooth, gleaming surfaces of the face. The eyes, once inlaid with white and colored glass, together with the copper lips and separately made copper eyebrows, give warmth and color to the face. The expression is serious and controlled. A small part of the neck is preserved, showing that the head was slightly tilted. The unusual hair style with the roll of hair over the forehead relates this head to the *Kritios Boy* (cat. 5). Here the roll of hair has been parted in the middle and the back hair has been gathered in a bun, whereas on the *Kritios Boy* the hair is rolled in clumps all around the head. On both statues, small tufts of hair are incised on the skin below the thicker mass of hair; here they appear on the cheeks in front of the ears.

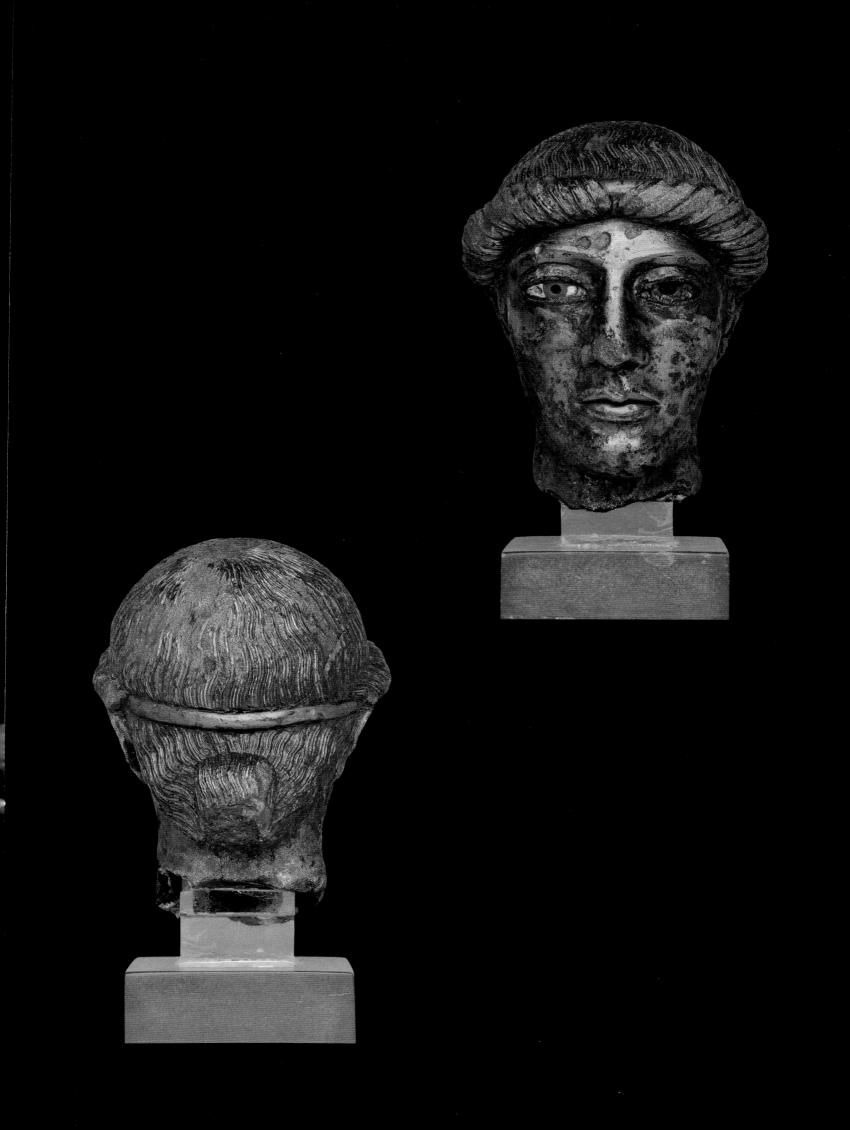

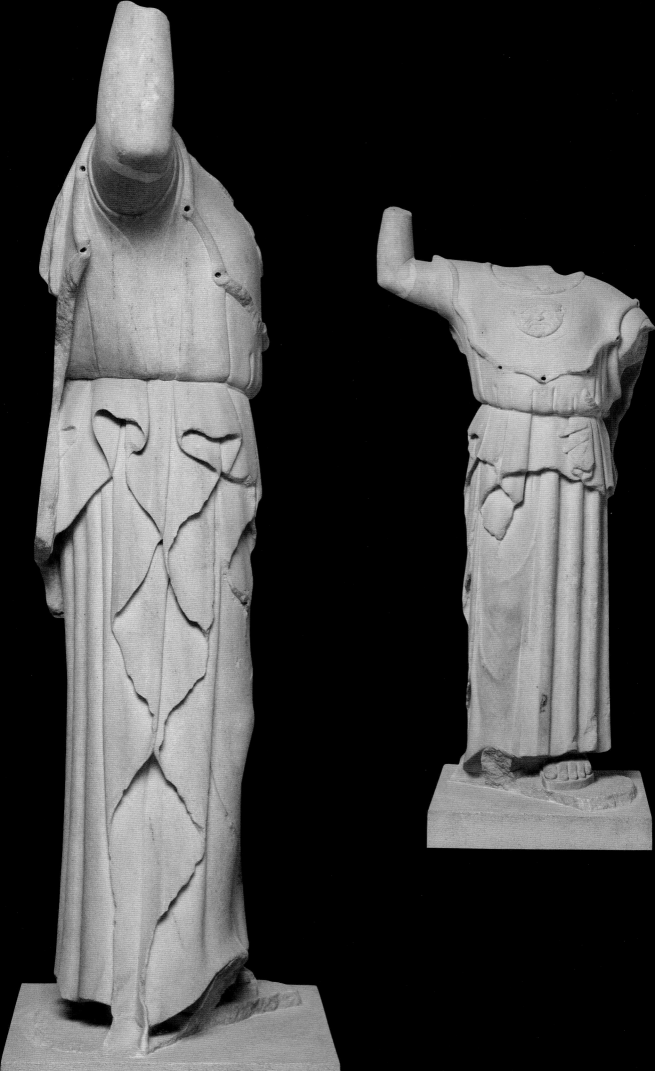

7
Statue of Athena
marble, shortly after 480 B.C.
height 0.895 m (35¼ in.)
Acropolis Museum, Athens, 140

Athena stands in a majestic pose appropriate for a goddess, her right arm raised, probably holding a spear, and her left hand on her hip. An aegis, a kind of protective animal skin, covers her shoulders, back, and breast and is ornamented with a gorgon head and with snakes whose heads were once fitted into holes on its edge. Beneath the aegis Athena wears a thick peplos, a one-piece woolen garment belted at the waist. The figure demonstrates a concern of Greek sculptors in the classical period: how to use drapery to reflect the stance and motion of the body within; for unlike men, women were not represented nude. The horizontal line of the waist tilts slightly, reflecting the raised right arm. From the front, the thick folds of the skirt hang straight over her left leg on which she stands, with the form of the right leg, bent slightly at the knee, showing through the material. From the back, it is the left leg that shows through the drapery while the right is hidden. The resulting contrast between heavy cloth concealing the body and the suggestion of the shape of the leg showing through became an effect frequently sought by Greek sculptors. This statue, from the Acropolis in Athens, once stood on a column inscribed with the signature of the sculptor, Euenor, and the name of the donor, Angelitos.

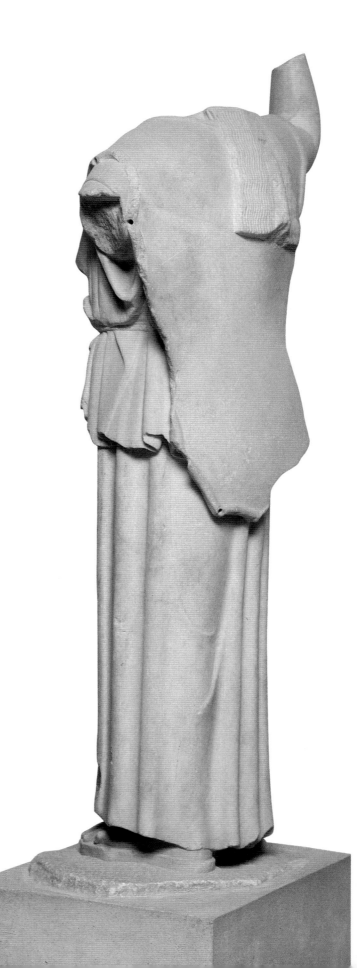

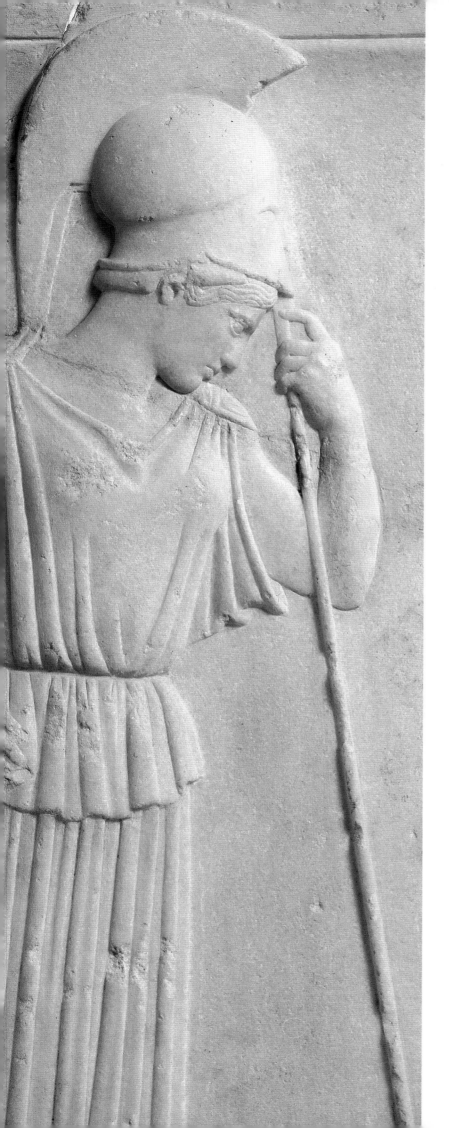

8
Relief with Athena: The Contemplative Athena
marble, 470–460 B.C.
height 0.54 m (21¼ in.)
Acropolis Museum, Athens, 695

Here Athena, head bent forward, stands before a stele, gazing intently at it as she leans on her spear. She wears a crested helmet pushed up on her head and a long woolen peplos similar to the garment worn by Euenor's *Athena* (cat. 7). Its long folds follow her stance rather than falling vertically as gravity demands. The raised heel of the left foot causes the skirt to form a lovely pattern of folds over the heel, a subtle clue to the fact that she stands with her weight on one leg like the *Kritios Boy* and Euenor's *Athena*.

The subject of the relief has been interpreted in several ways. Athena contemplating a stele might be the dedication of a victorious athlete or perhaps the dedication of the stone masons who completed the fortification of the Acropolis under Kimon in the late 460s. The stele could also have served as a boundary marker for Athena's sanctuary on the Acropolis, where the relief was found. In a more abstract interpretation, the stele might represent the power of the written word or the power of the decree of Athens, the state the goddess protects.

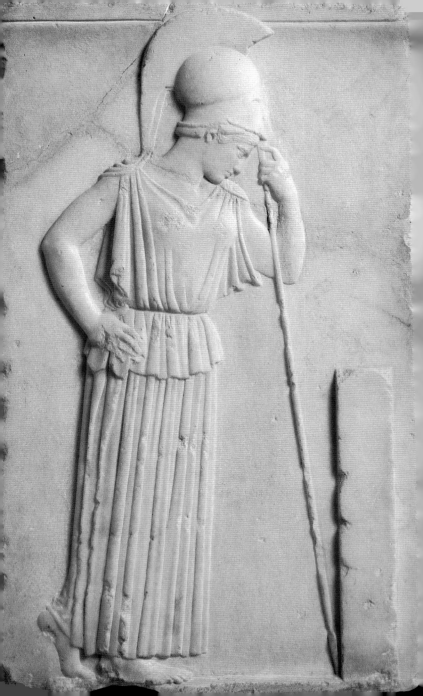

9

Herakles Receiving the Golden Apples of the Hesperides
marble relief, c. 460 B.C.
height 1.60 m (63 in.)
Archaeological Museum, Olympia

The sculpture adorning the Temple of Zeus at Olympia is considered to be one of the finest expressions of the early classical style. In addition to a complex of figures in the two pediments, the sculptural program included twelve metopes, six over the entrance on the east and six over the west end. The subject of the metopes was the twelve labors of Herakles, son of Zeus and legendary founder of the Olympic Games.

This relief, a metope placed on the east end of the temple, represents the last of Herakles' labors: obtaining the golden apples of immortality. The hero stands in the center holding up the heavens with the help of his patron goddess Athena. The giant Atlas, who normally supported the

skies, had been persuaded to fetch the golden apples from a tree in the garden of the Hesperides, where they were guarded by a dragon, and now he has returned and is presenting them to Herakles. Only Atlas knew the location of the garden, which was popularly imagined to have been in the far west of the known world, beyond the Atlas mountains in North Africa, as the names Hesperides and Atlas suggest.

The composition draws attention to the apples by contrasting the three verticals of the figures with the horizontal of the outstretched arms of Atlas. The rigid verticals of Athena and Herakles emphasize the weight of the heavens, which is enhanced by the folded cushion Herakles uses to help distribute the load. The cushion also brings the figure of the hero level with the goddess and the giant.

Successful completion of the twelve labors was to bring immortality to the mortal hero Herakles as the symbolism here makes clear, for the golden apples were apples from the tree of life.

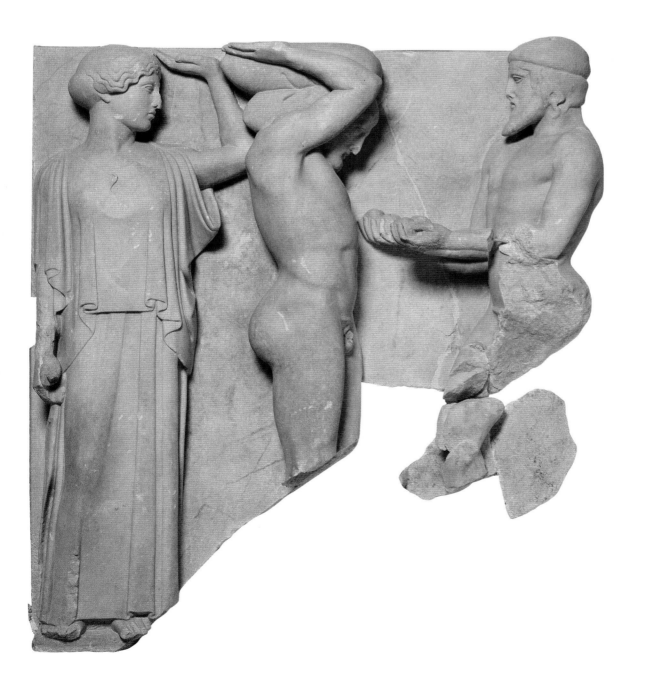

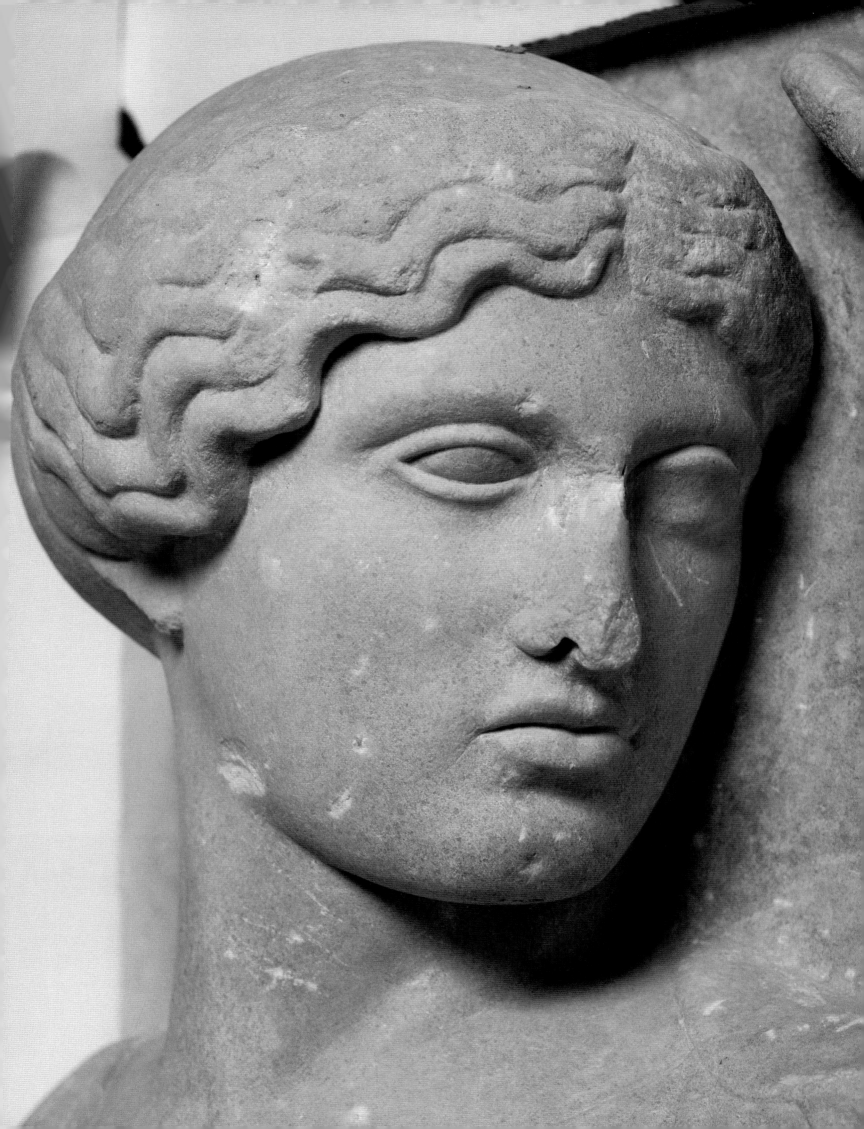

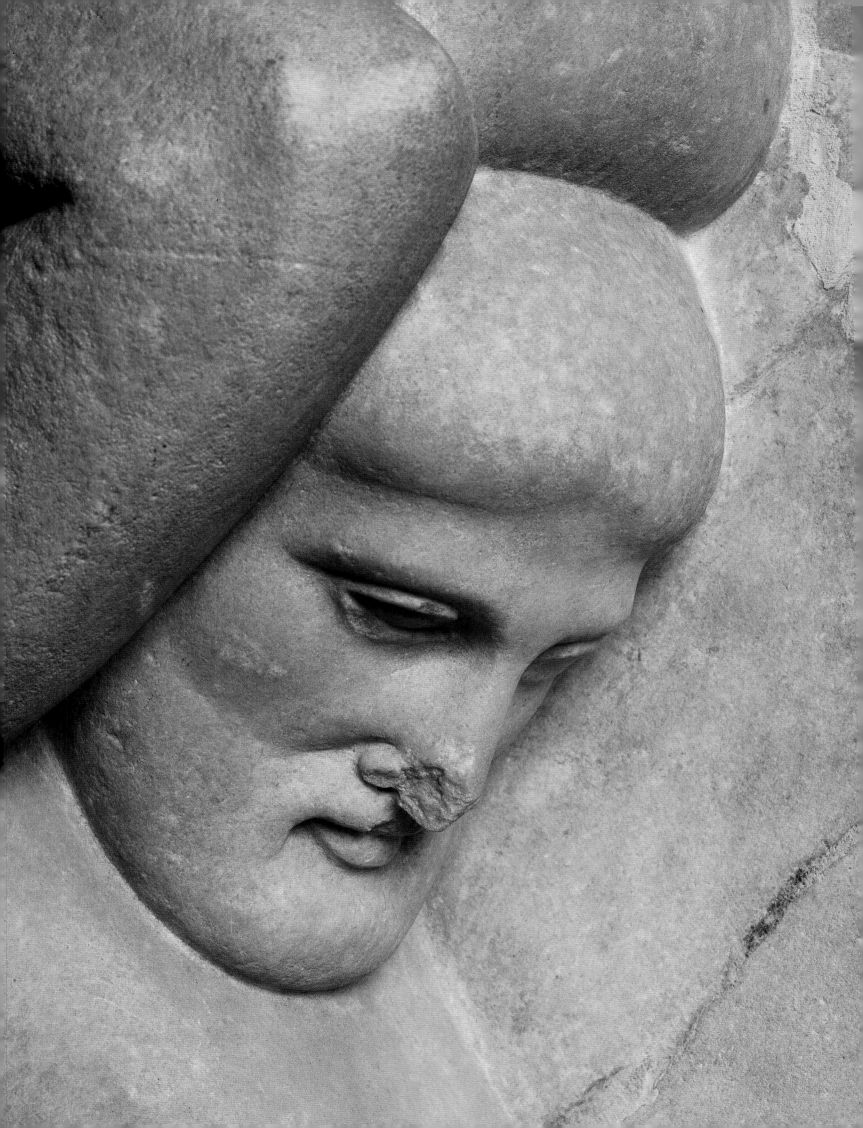

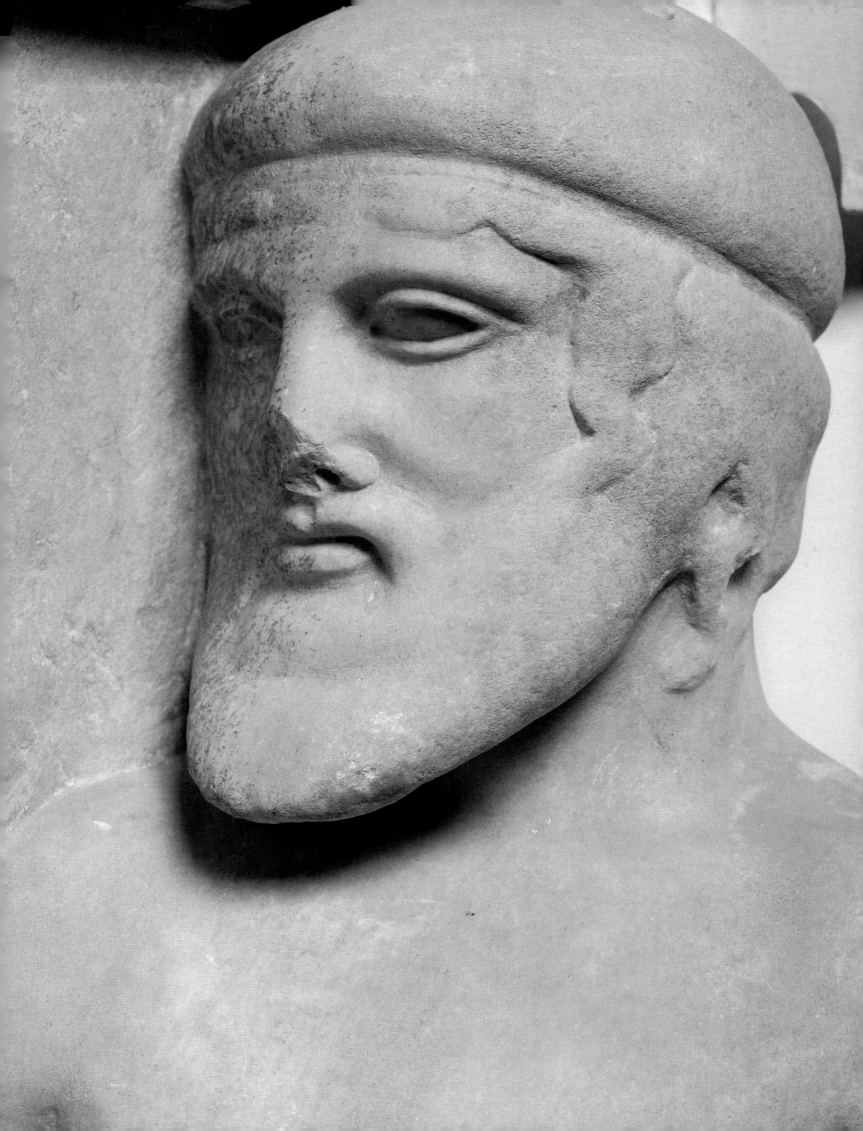

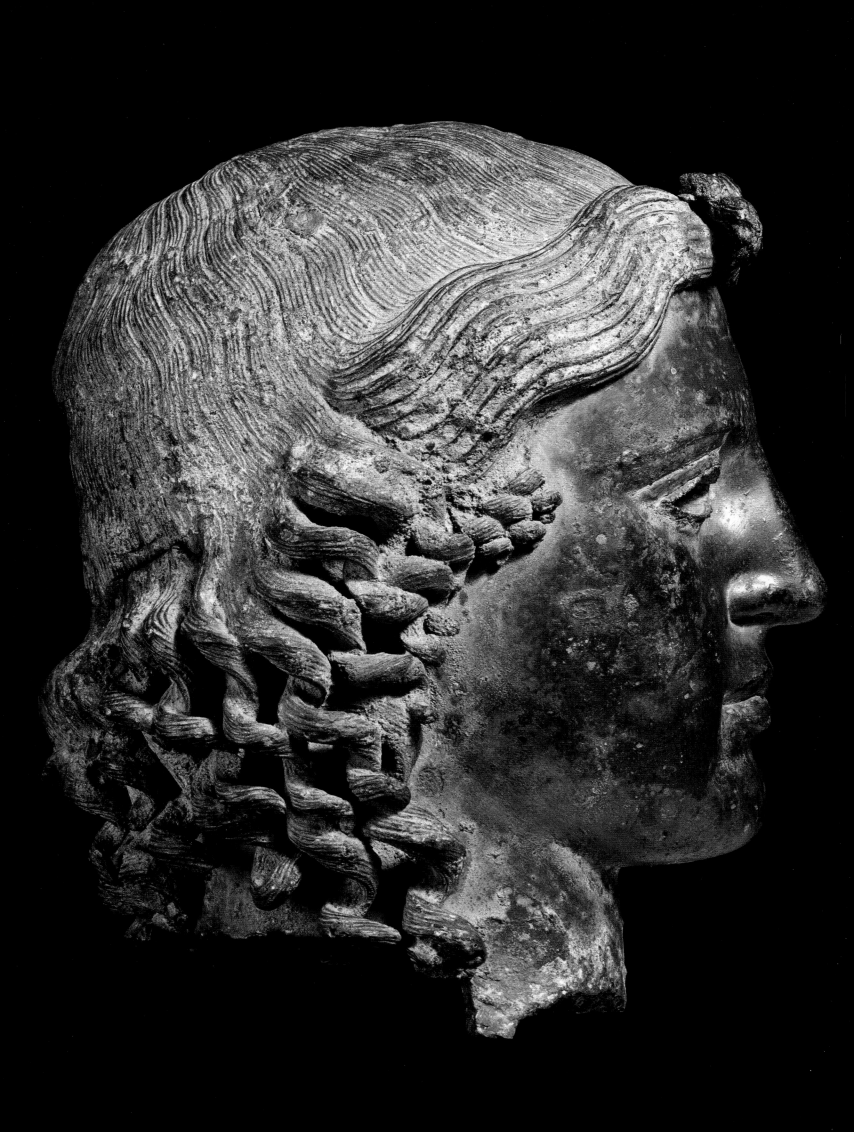

10

Head of a Youth or God: The Chatsworth Apollo
bronze, 460–450 B.C.
height 0.314 m (12⅜ in.)
The Trustees of the British Museum, London, 1958.4-18.1

In 1836, peasants digging for water in a dry riverbed near
Tamassos in central Cyprus found a complete life-size
bronze statue of a youth. When they carted the piece away,
it fell apart. The head made its way into the Chatsworth
collection and then to the British Museum, but the rest of
the figure has been lost with the possible exception of a leg,
made of the same bronze alloy, that is now in the Louvre.

The beardless youth has clumps of long curls cast sepa-
rately and attached at the level of the ears. Curls that cov-
ered the left ear are missing, so that the ear, originally hid-
den, is now visible. Two thick locks of hair have been
drawn forward and knotted above the forehead. The eyes
were once inlaid with colored glass or stone, the right eye
retaining the metal casing that was cut to represent lashes.
The reddish hue of the original copper lips would have
contrasted with the golden sheen of the bronze. The regular
symmetrical features, smooth planes of the face, and seri-
ous though serene expression are typical of the early clas-
sical style.

A life-size figure of a beardless young man with long
hair could well represent the god Apollo; one of his many
sanctuaries was situated at Tamassos close to where this
figure was found.

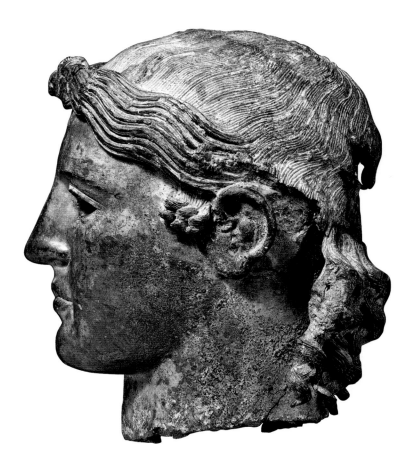

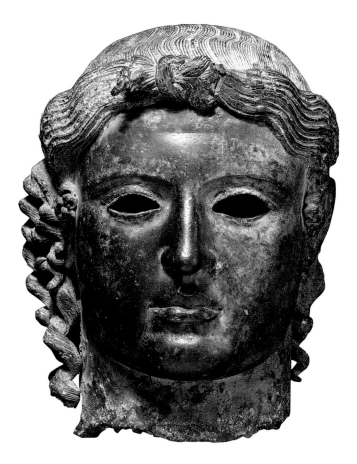

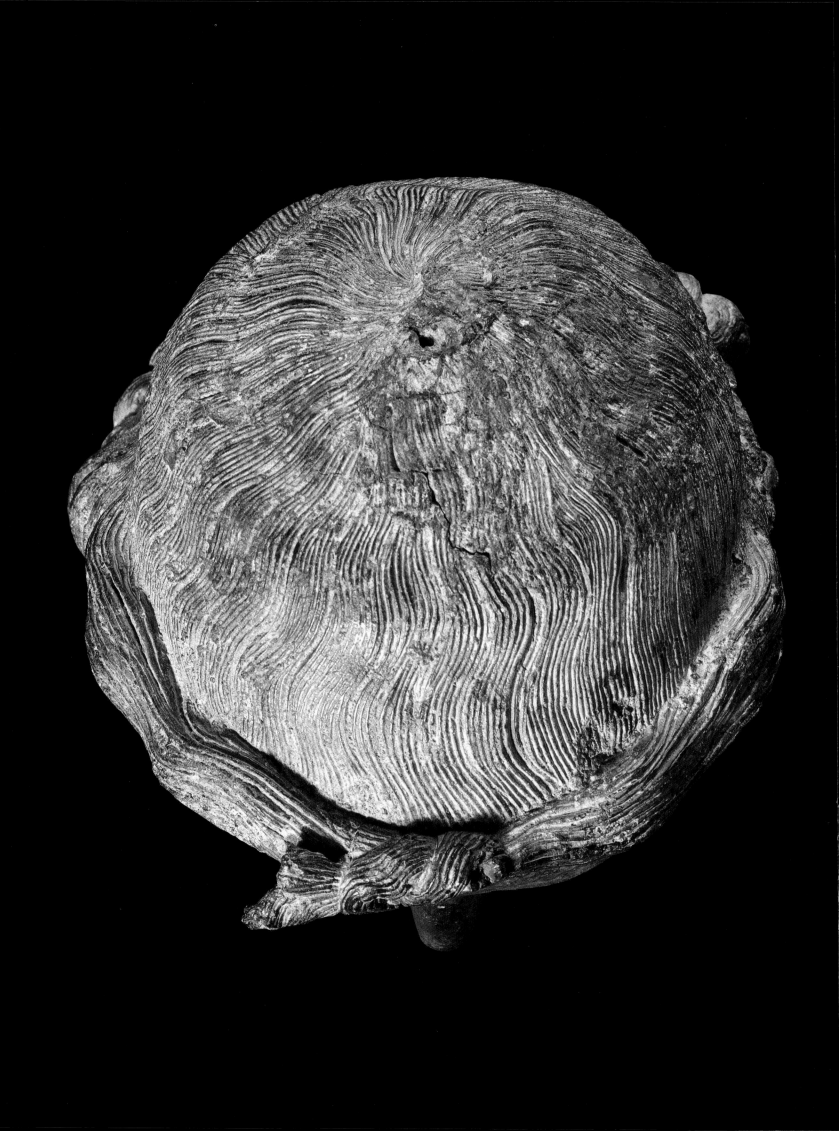

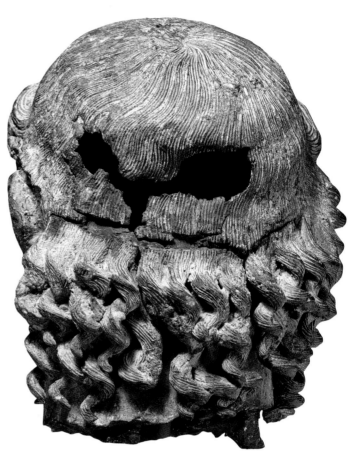

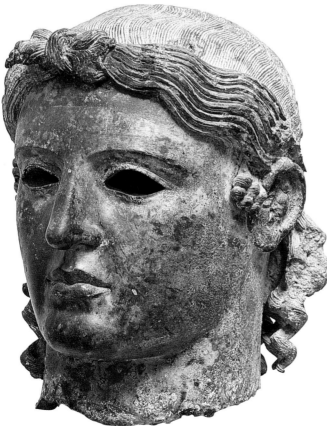

11
Statue of a Horse
bronze, 470–460 B.C.
height 0.228 m (9 in.)
Archaeological Museum, Olympia, B 1000

This stallion, from the Sanctuary of Zeus at Olympia, was originally one of four horses drawing a chariot. The complete group would have included, in addition to the horses, the chariot and charioteer. The famous bronze figure known as the *Charioteer of Delphi*, dedicated by the winner at the Pythian Games held at Delphi, came from a life-size group of this same type. Like the Delphi dedication, this horse was probably from a votive gift dedicated by the winner of a chariot race, the most spectacular and most costly event in the ancient Olympic Games. Winning chariot teams were also celebrated in song; many odes by the poet Pindar were written for victors in this race:

> *An Olympian victory song, the choicest honor*
> *For his horses whose hooves never weary.*
> Pindar, *Olympian Ode* III, 5–6 (tr. C. M. Bowra)

The details of this animal's left side suggests that he was the left-most horse of the chariot team. He wears a breast collar decorated with a rosette on the front, to which is attached a snug bellyband fastened with a quick-release knot visible on the horse's left side. The upright ring in the middle of the back, probably used to thread the reins, does not seem to be attached to any part of the harness. The bridle consists of a bit held in place by crescent-shaped cheek pieces attached to straps that meet at a ring and connect there with the noseband, and with the cheek strap that runs up behind the horse's ears. The throatlatch, running under the horse's head, has another quick-release knot.

The horse is anatomically similar to the horses on the Parthenon frieze (compare cat. 22). They are built differently from modern horses, the angle of the shoulder, neck, and head being more upright than in race horses bred today.

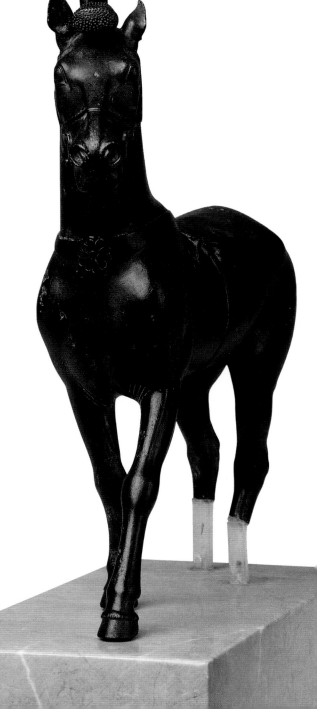

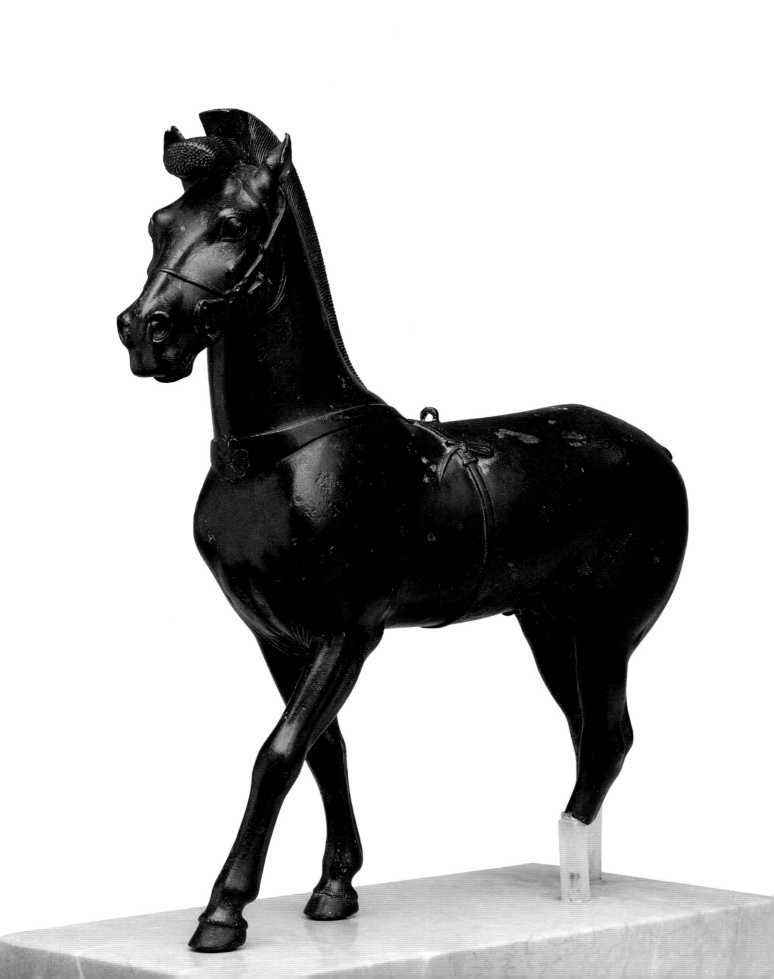

12
Statuette of a Diskos Thrower
bronze, 480–460 B.C.
height 0.245 m (9⅝ in.)
The Metropolitan Museum of Art, New York, Rogers
Fund, 1907, 07.286.87

The Greek emphasis on competitive sports brought forth a
host of images of athletes in marble and bronze, both large
and small, that were dedicated in sanctuaries to commemo-
rate victories. Because Greek athletes competed nude,
such dedications afforded sculptors of marble and casters
of bronze a natural opportunity to depict the human body
in all its strength and vitality; and because the competitions
were spectator events, what the artists made were at once
recognizable by the admiring public. Diskos throwing was
one of the events of the Pentathlon, a five-part test for all-
round athletes instituted at the Olympic Games as early as
the late eighth century B.C. and taken up in athletic festi-
vals held in other Greek cities.

In this work, said to come from the Peloponnesos, an
athlete is going through the first of several motions leading
to the actual throwing of the diskos. No evidence exists to
suggest that ancient diskos throwers spun around two and
a half times as modern athletes do. The figure's concentra-
tion is conveyed by taut muscles and by the facial expres-
sion that is given intensity by the downward turn of the
corners of the mouth and the darkness of the pupils empty
of inlay. The manner in which the toes of the preserved
foot seem to grip the soil gives a feeling of coiled energy.

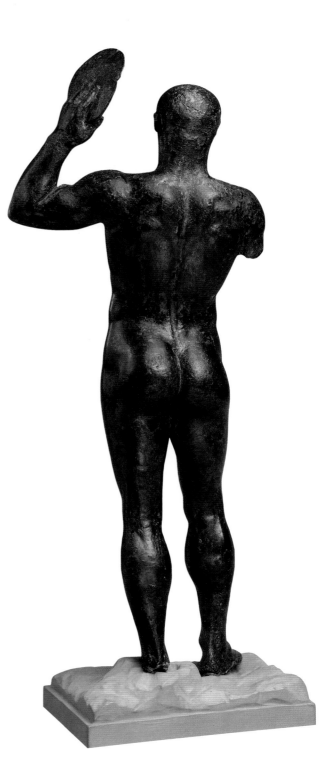

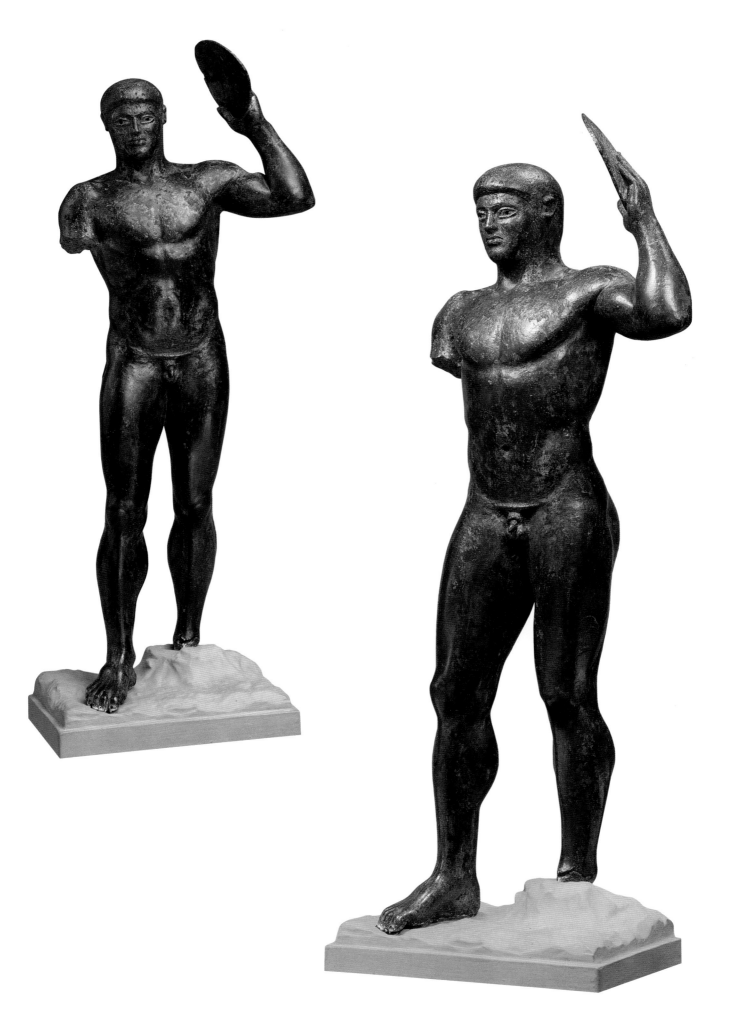

13
Statuette of an Athlete Making a Libation
bronze, c. 460 B.C.
height of figure 0.264 m (10⅜ in.)
Musée du Louvre, Paris, Département des Antiquités grecques, étrusques et romaines, BR 4236

This youth wears a headband adorned in the center with a small leaf, a sign that the figure represents a victorious athlete. He may once have held a libation bowl in his outstretched arm, suggesting that the statuette represents an act of thanksgiving for victory in an athletic contest. The strong musculature of the legs and arms is appropriate for an athlete.

> Yet that man is happy and poets sing of him,
> Who conquers with hand or swift foot
> And wins the greatest of prizes
> By steadfastness and strength.
> (Pindar, *Pythian* X, tr. C. M. Bowra)

The stance, with the left leg forward, recalls the long sixth-century tradition represented in kouroi (cat. 1), but here the subtle shift of weight apparent in the slightly raised left hip shows that the artist was aware of the innovations of the early classical style (compare cat. 5). This figure is best seen from the front; in the profile view his right leg appears shorter than his left leg.

After the bronze was cast, the hair was emphasized by incision and the nipples were inlaid with copper (compare cat. 14). The statuette was once attached to a base, and part of the struts for attachment are visible under his feet. The statuette is said to be from Phocis, in the region of Delphi.

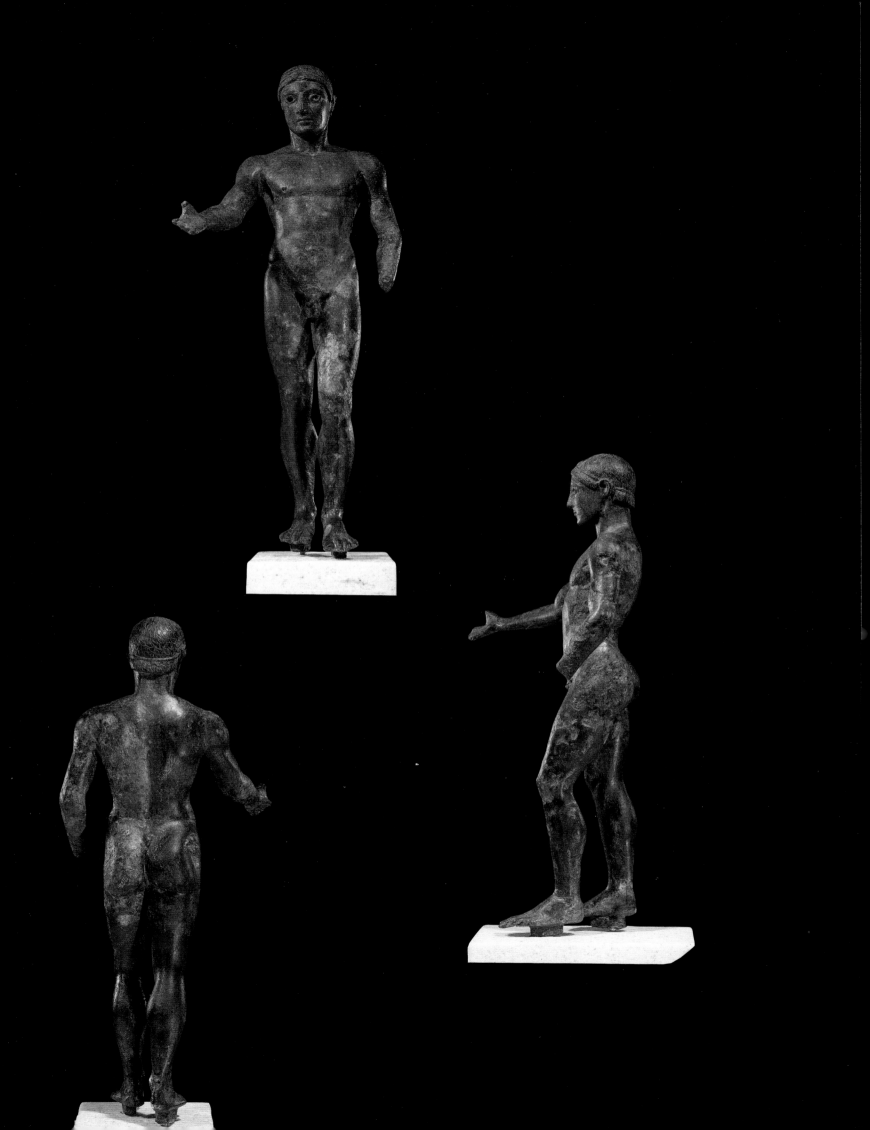

14
Statuette of Herakles
bronze, c. 460 B.C.
height 0.13 m (5⅛ in.)
Musée du Louvre, Paris, Département des Antiquités
grecques, étrusques et romaines, BR 4171

One of the more popular figures in Greek art was the hero
Herakles, often shown in bronze and marble sculpture and
in vase painting engaged in one of the celebrated twelve
labors (see cat. 9), or in the company of the gods, or simply
advancing against an unseen adversary. In this bronze,
said to be from Mantineia in Arcadia, the hero appears as
an isolated figure, his upraised right arm perhaps once
wielding a club, the outstretched left arm probably holding
a bow. The small size and narrow shape of the left foot
suggest that it was meant to be seen in profile. The pose is
similar to that of the larger-than-life-size bronze statue of
Zeus from Artemiseion, but is more three-dimensional.
Herakles turns in space, the three-quarter view of his torso
and head providing a transition from his frontal right leg
to his profile left leg.

The technique used to render the hair is unusual: the
curls were made in the wax model with a stamp and then
sharpened after casting. The style, with tight curls all over
the head, was typically used for Herakles on Greek vase
paintings of this period. The pupils were probably inten-
tionally left empty. The nipples are inlaid with copper, the
warm color of the pure metal suggesting an aureole (com-
pare cat. 13).

The heavy, short proportions and strong muscles of the
figure, while appropriate for Herakles, are also typical of
the Argive school of bronze casting that produced the
renowned sculptor of life-size statues, Polykleitos.

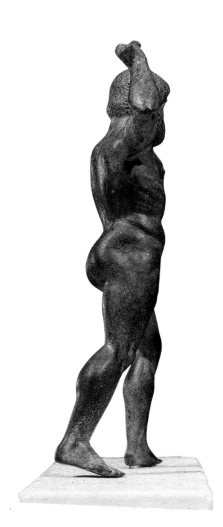

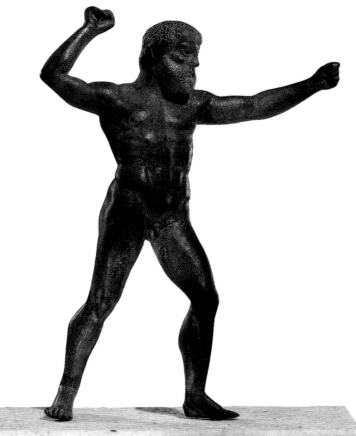

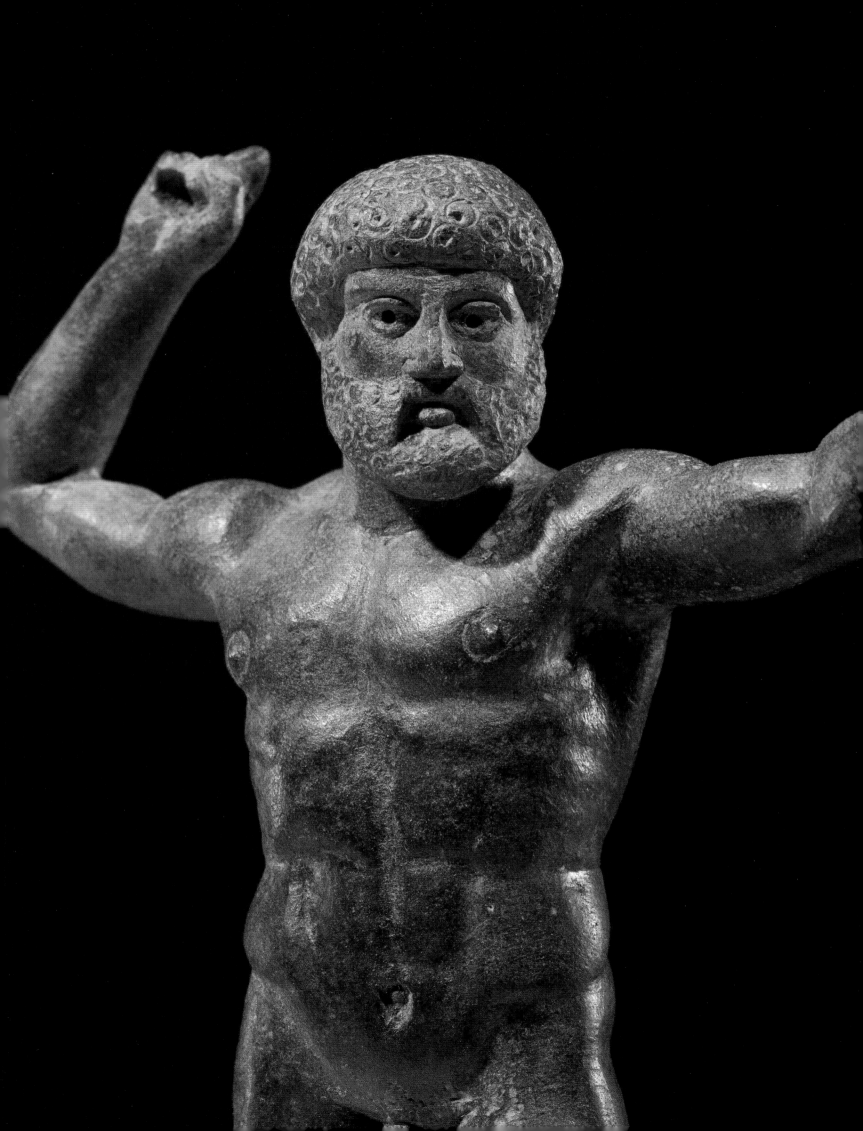

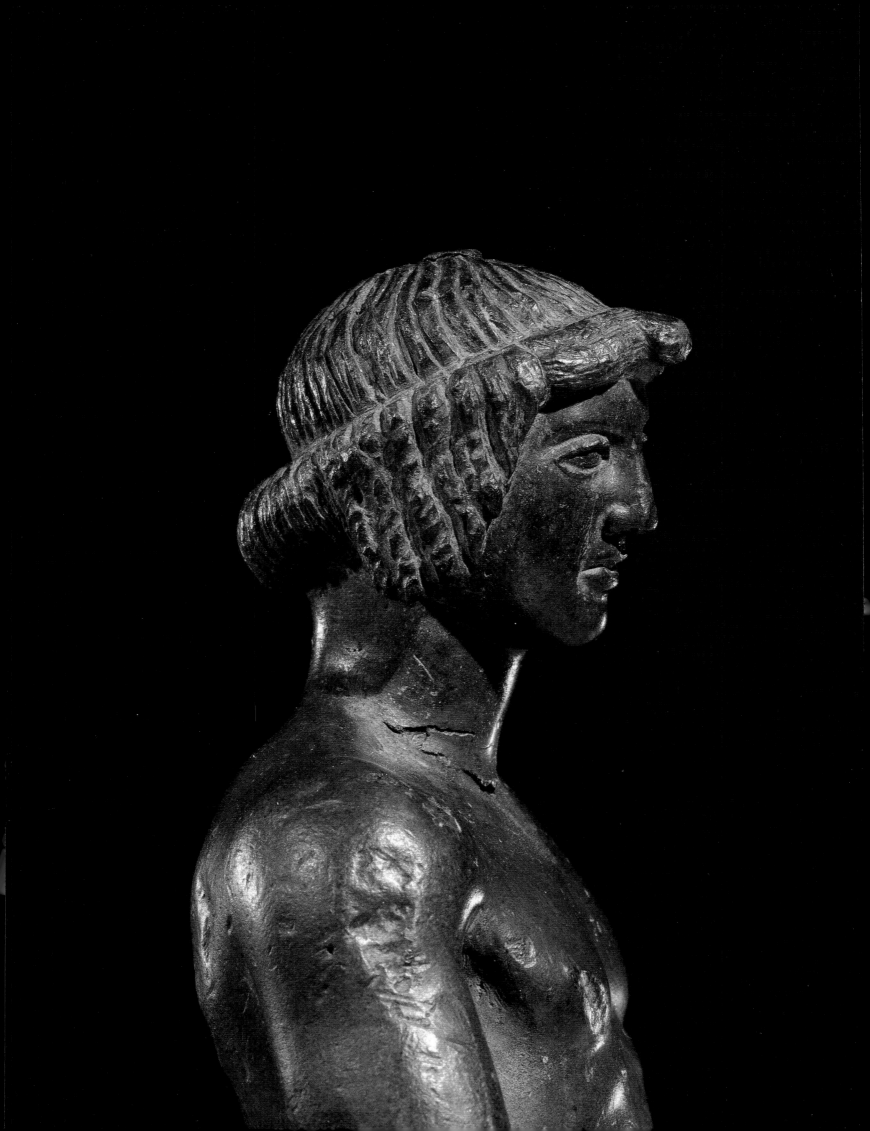

15

Statuette of a Male Figure, Perhaps Dionysos
bronze, c. 460 B.C.
height 0.24 m (8⅞ in.)
Musée du Louvre, Paris, Département des Antiquités
grecques, étrusques et romaines, BR 154

The figure has been identified as the god Dionysos who, by the middle of the fifth century, was often represented as a beardless youth. The unusual hair style, rolled in back and falling in long locks at the sides, is a foreign, almost effeminate coiffure that was associated with the god; so Pentheus, king of Thebes, describes him:

> *I am also told a foreigner has come to Thebes*
> *from Lydia, one of those charlatan magicians,*
> *with long yellow curls, smelling of perfumes.*
> (Euripides, *Bacchae*, 233–235, tr. William Arrowsmith)

The high, laced boots suggest a god who traveled far, and the holes on the figure's left shoulder and hip were intended for the attachment of a separately made traveler's cloak. The rod preserved in his right hand might have been part of the handle of a *kantharos,* the drinking vessel associated with Dionysos.

The statuette, said to have been found in the Sanctuary of Zeus at Olympia, was a votive gift that could have been brought there from a number of places. It is most likely the product of a Peloponnesian bronze-casting school. The slim, elegant form and long proportions of the figure contrast with those of the Argive school (cat. 14).

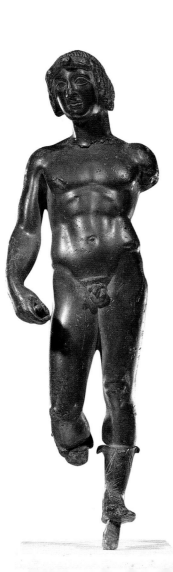
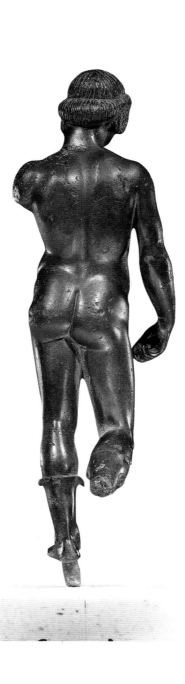
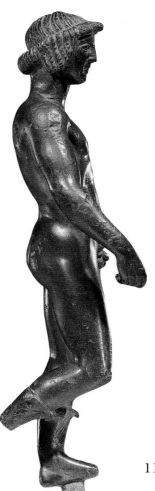

16
Statuette of a Female Figure
bronze, c. 460 B.C.
height 0.27 m (10⅝ in.)
National Archaeological Museum, Athens, K540

This figure of a woman may represent a votary, a priestess, or even a goddess. The dove she holds was an appropriate gift for Aphrodite, the goddess of love and beauty, who is often accompanied by doves in ancient art. According to some traditions, doves were also connected with Dione, Aphrodite's mother, who was closely associated with the Sanctuary of Zeus at Dodona, near the Pindos Mountains where this bronze was found. The figure might have held a flower in her other hand, also appropriate as a gift or attribute for either goddess.

In modeling the figure, the artist achieved an effective contrast between the tunic and outer garment. The thin crinkly tunic with embroidered hems and seams at the shoulders is rendered in wavy lines not unlike the lines of her hair; the heavy outer garment, a peplos, is done with bold folds. The peplos drops loosely off her shoulders, is belted at the waist (with the belt hidden), and hangs straight from the waist to the ankles.

The bronze was cast in more than one piece; the lower body fits into the upper and is pinned front and back. The feet of the statuette are fixed to a metal disk that in turn must have been pinned to a stone base, and in this fashion the statuette would have been displayed in a sanctuary.

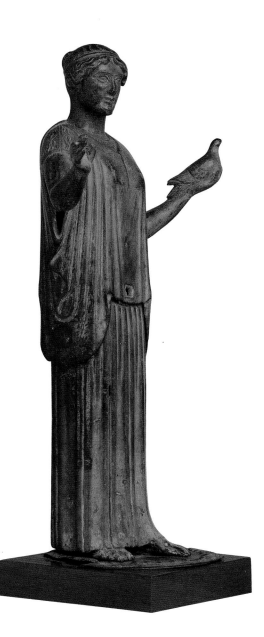

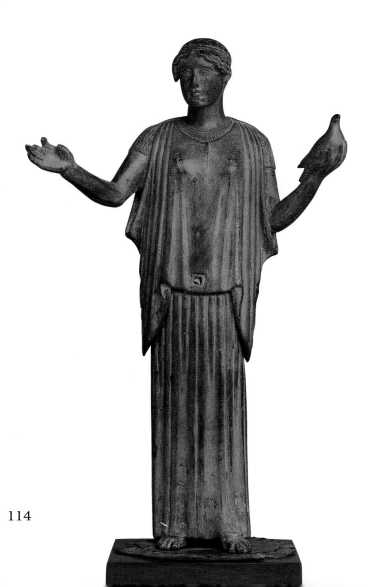

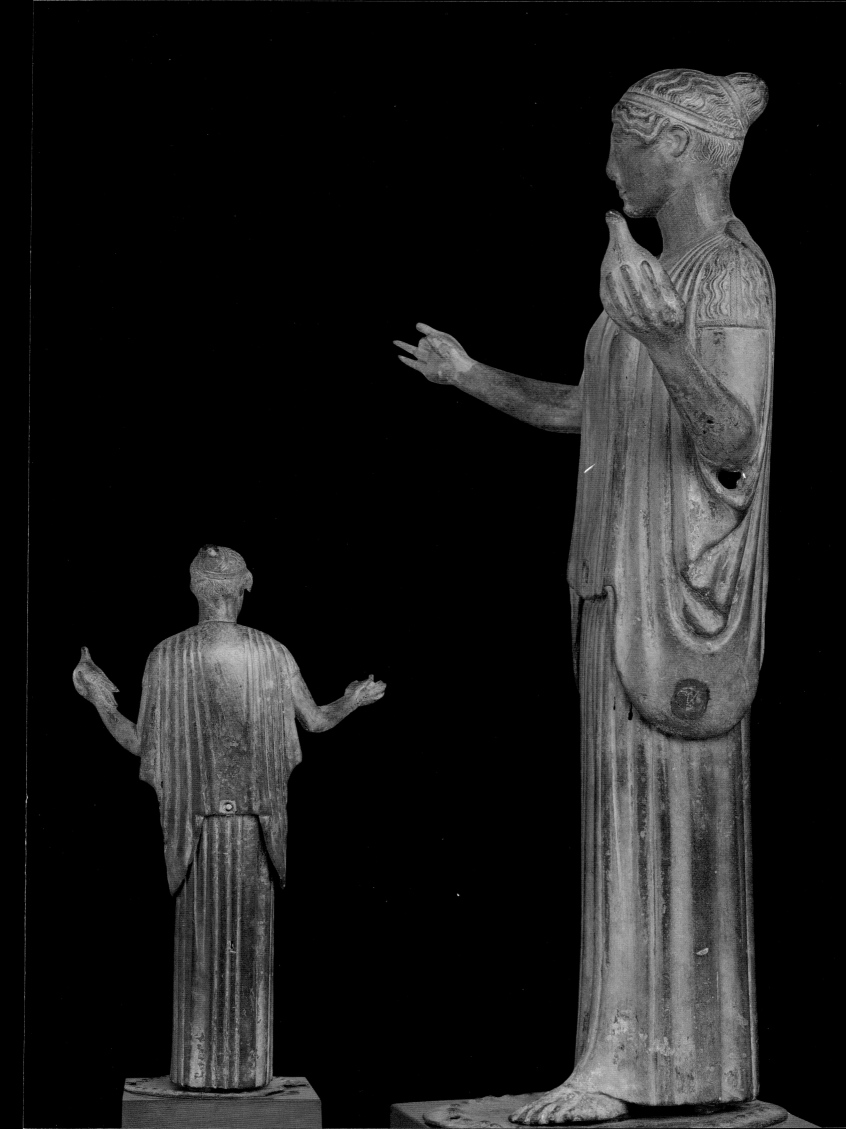

17
Statuette of a Young Woman

bronze, 460–450 B.C.
height 0.167 m (6⅝ in.)
Staatliche Museen zu Berlin,
Antikensammlung, 30082

The young woman turns her head slightly to the side as if
intent on something once held in her outstretched left
hand. Her gestures and statuesque pose have prompted
various interpretations of her activity. Is she praying to a
divinity, arms uplifted offering a flower or a branch? Is she
spinning, with a spindle in her left hand, the wool in the
other? Or was she performing her toilette, holding a mir-
ror in her left hand? Some have suggested in fact that she
was the support and handle of a real mirror, the round
reflecting disk being fastened to the top of her head where
the flattened surface indicates something was indeed once
attached (see cat. 18). If so, a mirror in her hand would
refer to the original function of the statuette.

The bronze is a wonderfully successful evocation of a
woman admiring herself. The folds of her garment help
suggest her slightly turning, almost preening pose: the
shape of her right leg shows through the garment while
long, straight folds emphasize the weight-bearing left leg.
The folds of the upper part of her dress are not entirely
symmetrical and suggest the slight displacement of the hips
that results from putting weight on one leg. The broad,
slightly raised right shoulder is another subtle indication of
the way her body turns so that she can see herself in the
mirror. The statuette, said to be from Olympia, stands on a
base that does not belong with the figure.

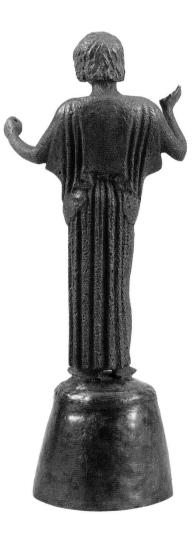

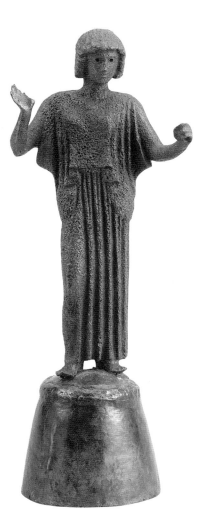

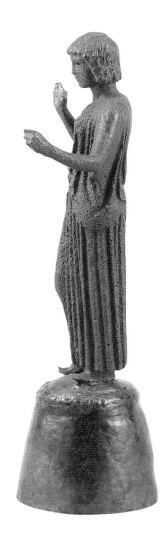

18
Mirror
bronze, 460–450 B.C.
height of figure, 0.15 m (5¹⁵⁄₁₆ in.);
of entire mirror, 0.388 (15⁵⁄₁₆)
National Archaeological Museum, Athens, 7579

Bronze mirrors were a standard item among the household effects of well-to-do women. A particularly fine class of more than a hundred mirrors features handles in the form of human figures, some male but the majority female. Those with draped female figures range from the mid-sixth century B.C. to the late fifth century, the stance and attitude of the women reflecting advances of sculptural style; and their clothes, the latest fashions of dress. Most of the figures stand on tripod bases that allowed the mirrors to rest upright on tables or in cupboards. The bronze women are brilliantly rendered, reduced versions of life-size sculptures. They retain their presence and dignity even though functioning as utensils.

This figure stands on a three-legged lion-paw base in a quiet but far from simple pose. Her right arm is on her hip, the left hand is extended as if offering something. The vertical folds of her garment emphasize the weight-bearing right leg, while the shape of the left leg, which is turned out, can be seen pushing through the material. The head and upper body twist subtly to follow the outward turn of the left leg. A pair of Erotes flutter about her as they do on many such mirrors, a good argument that the figure was intended as the goddess Aphrodite. The object once in the left hand could have been a bird or flower, also attributes of Aphrodite.

The mirror disc itself, once highly polished but now corroded, is cradled in an ornament attached to the woman's head. The circumference of the disk is embellished with animals and flowers: two cocks confront one another at the top while foxes chase hares up both sides.

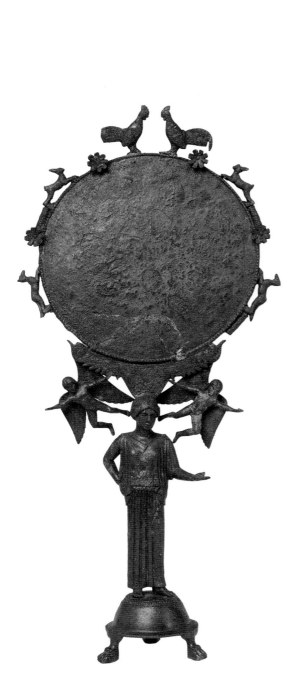

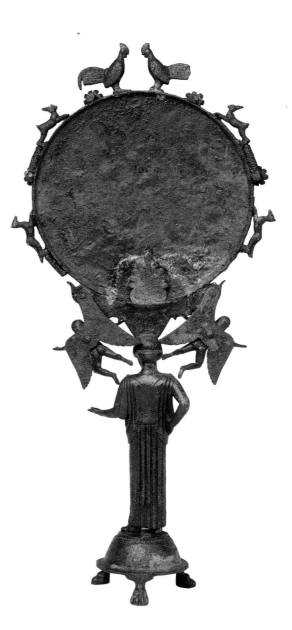

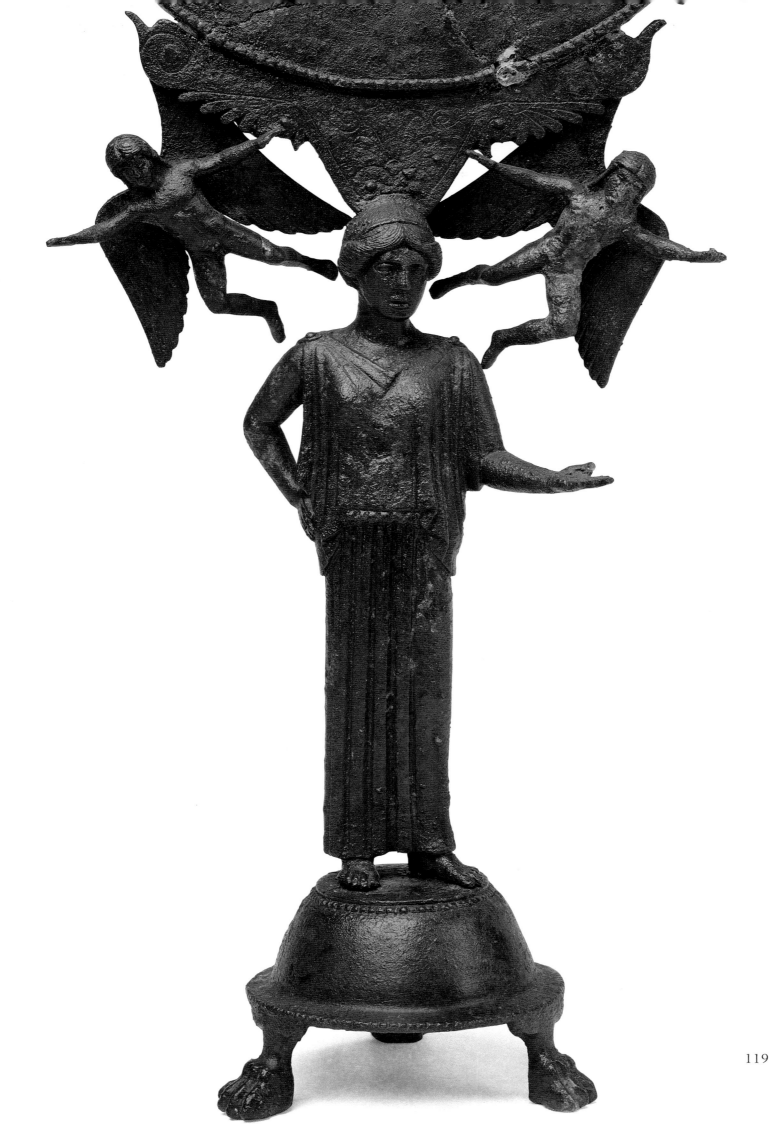

19
Statuette of a Youth with a Ball
bronze, c. 450 B.C.
height of figure 0.135 m (5⁵⁄₁₆ in.);
with base 0.15 (6)
Staatliche Museen zu Berlin,
Antikensammlung, 8089

The youth holds a ball in his left hand, and in his right he
may have held a stick of the sort used today in playing
hockey. The figure could thus be identified as a winner in
a game not attested in ancient literature but known from a
relief on a marble statue base of the archaic period in the
National Archaeological Museum in Athens. In the Athens
relief the artist represented what to modern eyes appears
to be a hockey game.

This figure, from Ligourio near Epidauros in the Argolid,
is another of the works thought to illustrate the bronzes of
the school in Argos that later produced the renowned
sculptor Polykleitos. The pose, with the weight on the left
leg and the right leg forward and turned outward slightly,
is balanced and projects rest but not without an implica-
tion of movement. The figure does not yet show the com-
plexity of rhythms typical of the work of Polykleitos, but
the compact structure and articulation of the body are typi-
cal of the Argive school (compare cat. 14). The statuette is
attached to a low, four-footed base that in turn may once
have been sunken into a larger support.

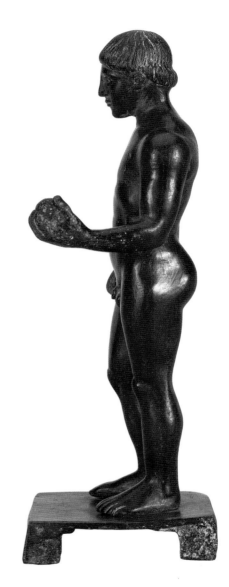

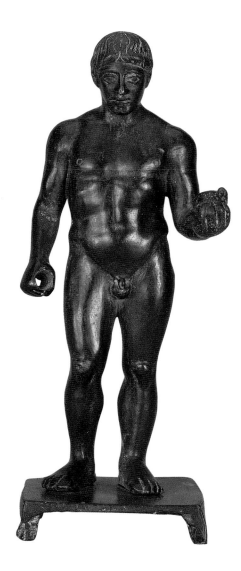

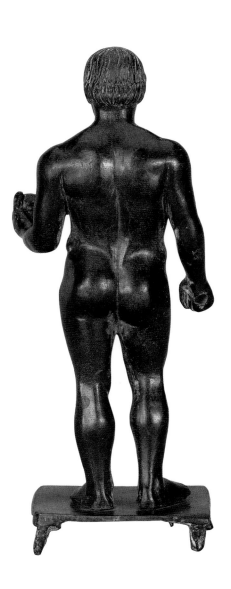

20
Statuette of Zeus

bronze, c. 450 B.C.
height 0.189 m (7⁷⁄₁₆ in.)
Musée du Louvre, Paris, Département des Antiquités grecques, étrusques et romaines, BR 158

Mature musculature and a full beard help identify this figure as Zeus. He raises both arms and seems about to hurl a thunderbolt with his right hand; his stance and the left arm stretched out for balance are appropriate for this action. The proportions of the figure differ from those of the bronze statuettes of the Argive school (cats. 14, 19): the head is larger, the neck shorter. The pose also differs from the more balanced stance of the Argive bronzes, as it sways to the right with hip raised and legs turned out slightly. The pupils of the eyes, perhaps left empty on purpose, give the face an intense expression.

The alleged source of the statuette, the Sanctuary and Oracle of Zeus at Dodona, was a cult center in northwestern Greece where a sacred oak tree "spoke" answers to the inquiries put to the oracle.

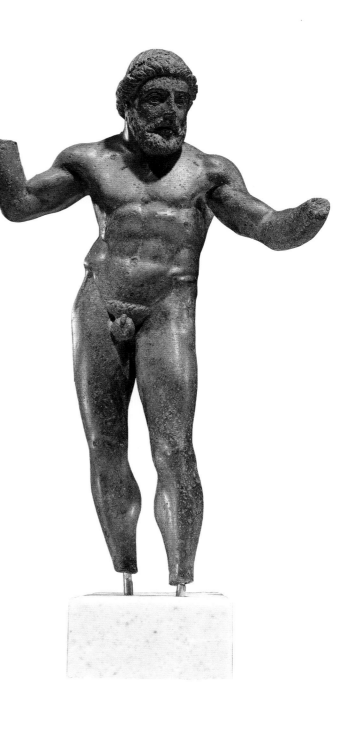

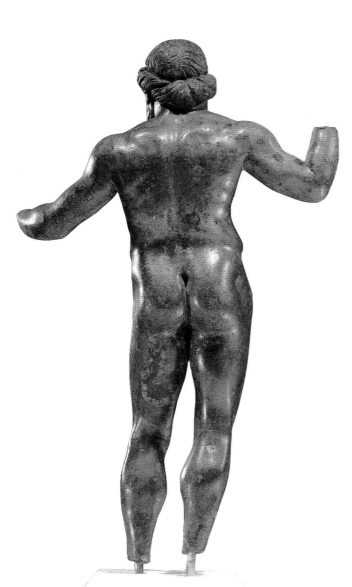

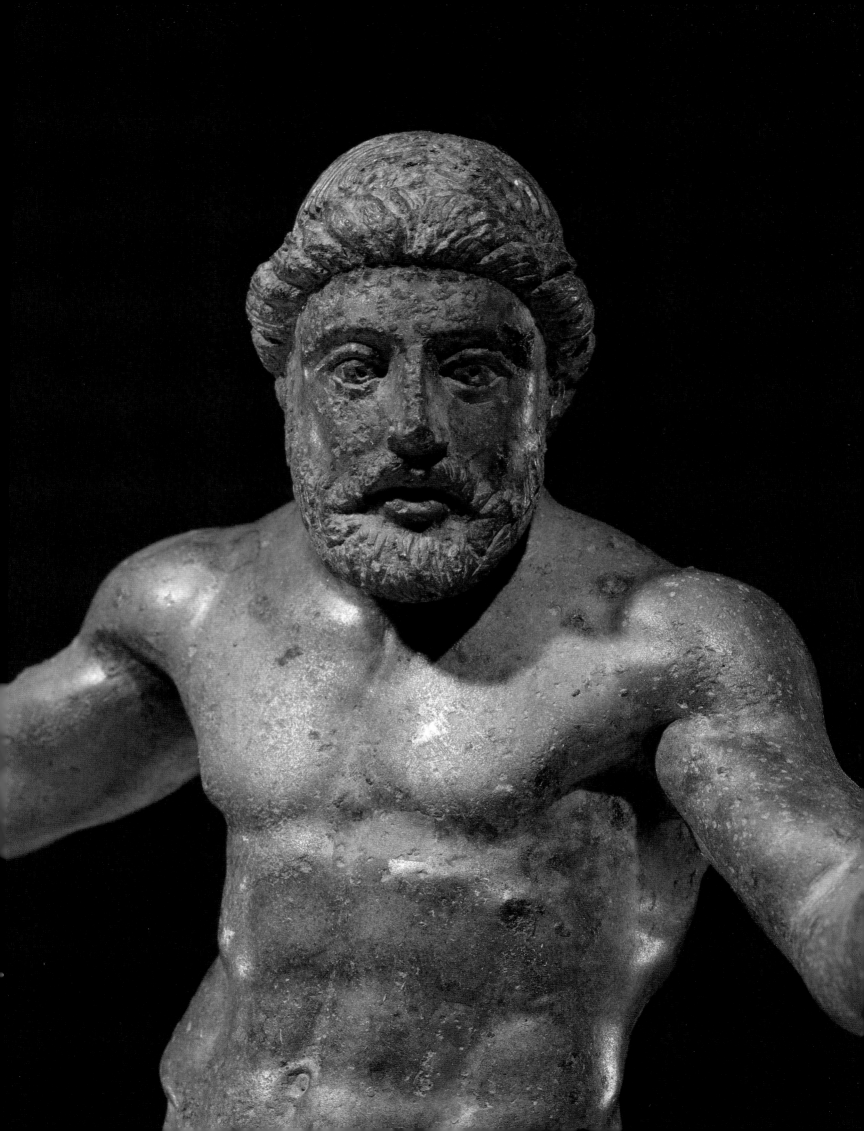

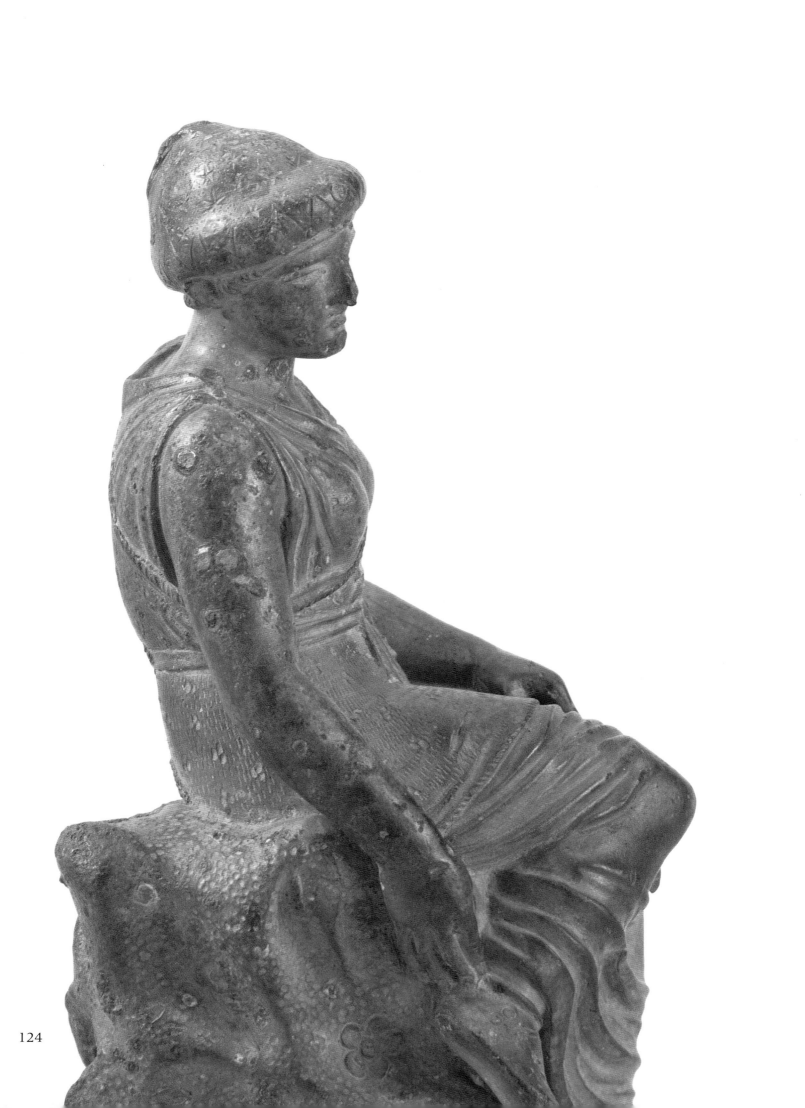

21
Statuette of a Resting Maenad
bronze, c. 450 B.C.
height 0.11 m (4⁵⁄₁₆ in.)
Staatliche Museen zu Berlin,
Antikensammlung, 10582

Just as marble sculpture was used to ornament temple
architecture, so were small bronzes of animals and human
figures used to decorate major bronze vessels, where they
were situated about the handles or perched on rims and
shoulders. The shape of the back of this figure suggests a
position on the shoulder of a large krater, a bowl for mix-
ing wine and water.

Over a finely pleated tunic the woman wears a second
garment, a feline animal skin to judge from the claw-foot-
ed clasp on her left shoulder and the finely engraved lines
indicating fur. This costume suggests that she is one of the
maenads, female companions of the wine god Dionysos
known for their ecstatic dancing and wild behavior. This
maenad, however, is not portrayed in the usual exuberant
pose, but sits back quietly on a rough-textured rock. Her
feet, in elegant shoes with lotus-patterned laces, are casu-
ally placed on the rocky outcrop. Her head, with hair
bound in a patterned headband, tilts to her right, her
expression relaxed and reflective. Is she listening to
music? It has been suggested that she was the pendant fig-
ure to a bronze statuette of a lyre player, perhaps Orpheus,
now in the Hermitage (St. Petersburg). The music of
Orpheus was said to have calmed all manner of creatures,
frenzied females as well as wild beasts. The musician
would have been situated near the maenad on the shoul-
der of the bronze vessel.

The maenad was found at the Sanctuary of Zeus at Dodona
where the statuette of Zeus (cat. 20) was also found. The
fine surface detail may be compared with the statuette of a
woman from the nearby Pindos mountains (cat. 16).

22
Cavalry from the Parthenon Frieze
marble, 442–438 B.C.
1.02 x 1.22 m (40⅛ x 48 in.)
Acropolis Museum, Athens, 862, north frieze XXXI

Look, their bridle irons flashing,
the cavalry of Athens thundering headlong on.
They honor Athena, reigning queen of horsemen—
(Sophokles, *Oedipus at Colonus* 1215–1217, tr.
Robert Fagles)

Four riders and the forelegs of a fifth horse appear on this slab from the frieze of the Parthenon. Placed high within the colonnade of the temple, the frieze was originally about 524 feet in length, of which 420 feet survive; old drawings record another 50 feet of relief now lost. One man, perhaps Pheidias, must have designed the work, though many different hands are discernible in its execution.

The depth of the carving of the relief is only 2¼ inches at its maximum, yet the artist has managed to place riders in three different planes overlapping one another. The rider in the foreground, looking out toward the viewer, sits easily astride his prancing horse. His right hand held reins separately made of bronze and attached at the holes visible on the horse's head. Two riders are in the second plane:

the first, only partly preserved, sits in profile, leaning forward slightly; the second, in more of a three-quarter view, raises his right hand to adjust his wreath. The rider in the third plane is also in profile but leans back slightly. A subtle but compelling rhythm of near repetition and slight variation unites the entire frieze and is especially clear in the section showing the cavalry.

Such a procession is thought to have formed part of the Panathenaia, a festival at which a new peplos was presented to Athena, patron goddess of the city. On the Parthenon freize, the cavalry was preceded in the procession by chariots and people on foot—groups of girls in the lead, followed by animals to be sacrificed (sheep and heifers), water carriers, musicians, and elders. No other classical Greek temple is adorned with a frieze representing a religious ceremony carried out by ordinary mortals; subjects drawn from mythology were the rule.

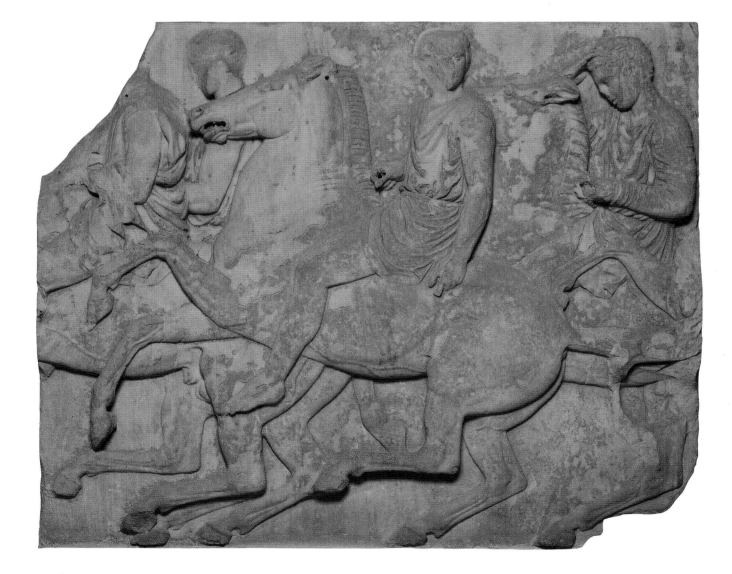

126

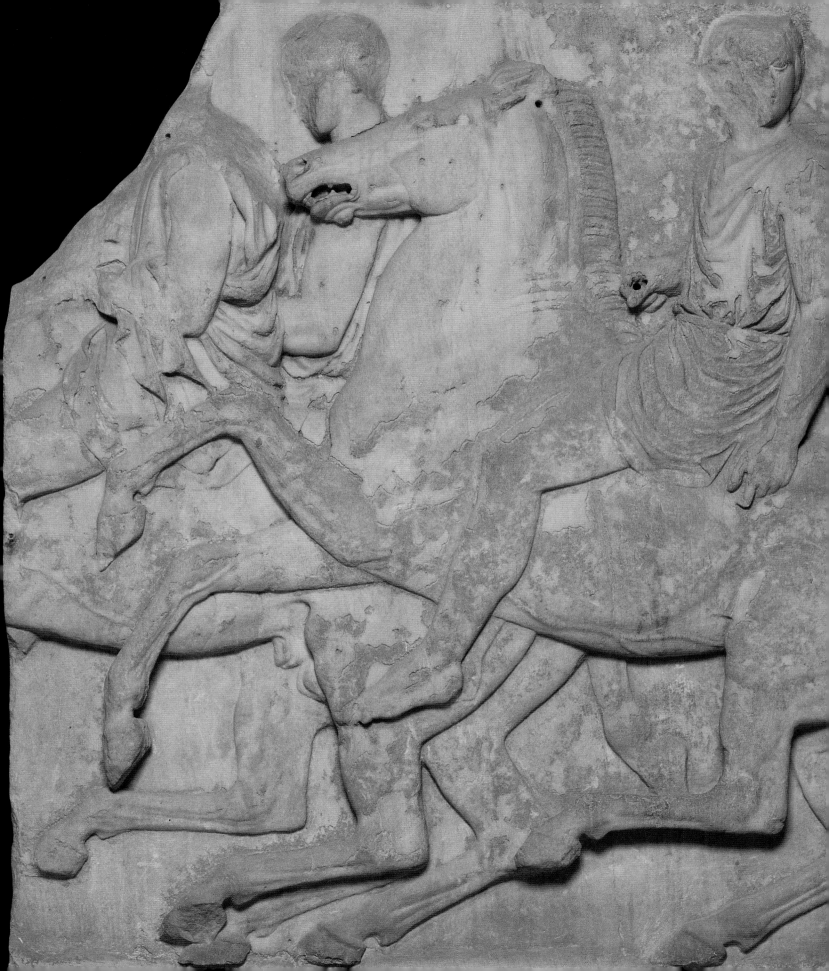

23

Statue of a Man, Perhaps Theseus
marble, 450–425 B.C.
height 1.37 m (54 in.)
Musei Capitolini e Monumenti Communali, Rome, 2768

The statue comes from a partially preserved temple pediment excavated in Rome in the 1930s. The pedimental sculptures showed a battle between the Greeks and the Amazons, the fierce warrior women recorded in Greek mythology as having inhabited the coast of the Black Sea. This figure, one of at least ten from the pediment, is a Greek. His extended left arm probably once held a shield, his right hand, a sword. His cloak is shown falling off his left thigh. The hairstyle is unusual: two long braids wound around the head with separately made flowing locks of bronze set in rectangular holes over the forehead and still preserved today. A headband and laurel wreath were pinned in rows of smaller, round holes circling the head.

The sculptural style belongs to fifth-century mainland Greece. The treatment of the drapery is similar to that on the Parthenon frieze (cat. 22), and the sharp line of the profile finds parallels on Parian gravestones of the third quarter of the fifth century B.C. (cat. 27).

The figure has been identified as the Athenian hero Theseus confronting an Amazon who was perhaps mounted on horseback. Among the other figures preserved from the pediment are Athena, Herakles, and Nike (Victory). Athena probably occupied the center of the pediment. Herakles was placed to her right facing one Amazon, and Theseus to her left with the Amazon on horseback. Nike probably hovered behind Theseus, about to place a victor's crown on his head, thus making him the real hero of the pediment. In mythology, both Herakles and Theseus fought the Amazons on separate occasions. Herakles' exploit, in which he sought to take the girdle of the Amazon queen Hippolyte, formed one of his twelve labors. On this pediment the two heroes are united against the Amazons, perhaps for political reasons.

It has been suggested that the sculptures were made originally for the pediment of a classical temple in Eretria, a city near Athens that was allied with Athens at various times, which would help to explain the presence of Theseus, the Athenian hero. The Persians had destroyed an earlier, late archaic temple at Eretria when they invaded Greece in 490 B.C. Pedimental sculpture from this earlier temple, still surviving, shows Theseus carrying off the Amazon queen Antiope. It would seem that the Eretrians rebuilt their temple in the fifth century and again commissioned sculpture with an Amazon theme. Much later, as has been suggested, the Romans removed the second sculptural group and reinstalled it on a temple of Apollo in Rome, perhaps early in the reign of the Emperor Augustus.

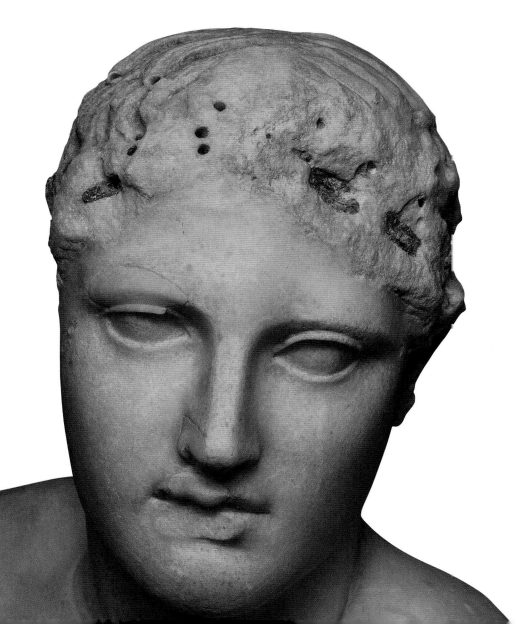

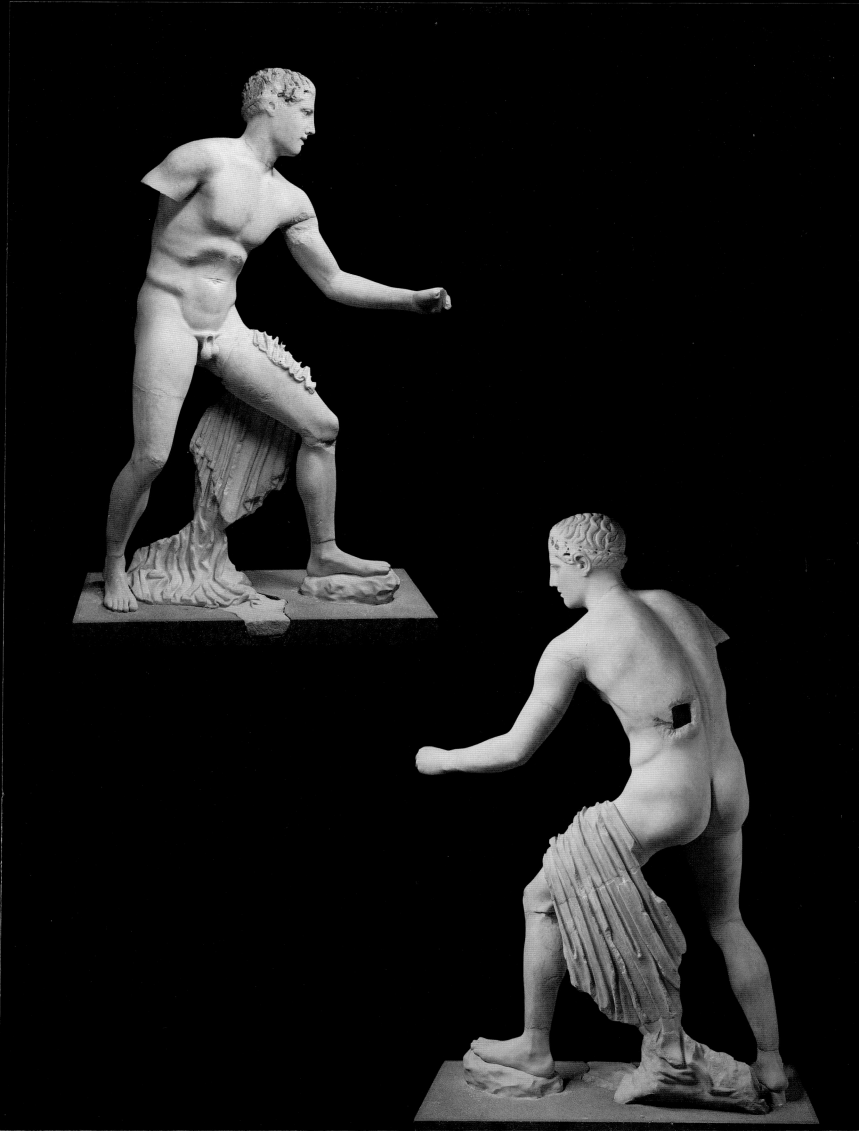

24
Head of Nike (Victory)
bronze, 425–415 B.C.
height 0.20 m (7⅞ in.)
Agora Museum, Athens, B30

This head, found in the Athenian Agora, was once fitted
into a draped female figure. Her hair was gathered at the
crown where a knob served for attaching a bunch of the
fluttering ends of her hair. The long narrow grooves at the
hairline and the sides of the neck once served to secure
sheets of silver overlaid with sheets of gold; traces of both
metals remain in the grooves. The neck, face, and hair of
this statue would thus have been golden, and likewise the
entire body.

The artist who made this statue must have known the
series of Golden Nikai. These images derived from the six-
foot-high statue of Nike shown alighting on the right hand
of the colossal statue of Athena Parthenos, Pheidias' gold
and ivory masterpiece that stood within the Parthenon.
The Golden Nikai also had removable gold surfaces, a
practical arrangement devised by Perikles by which the
precious metal served a temporary artistic purpose but
could easily be removed in time of financial need. We can
imagine that this complete statue looked something like
Athena's Nike, a flying figure coming in for a landing
whose fluttering drapery would have lent dramatic
impact.

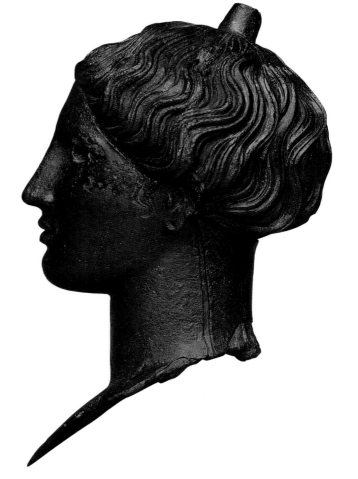

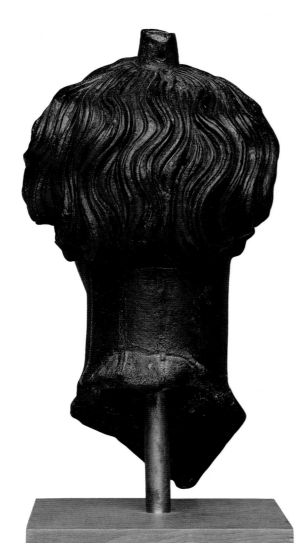

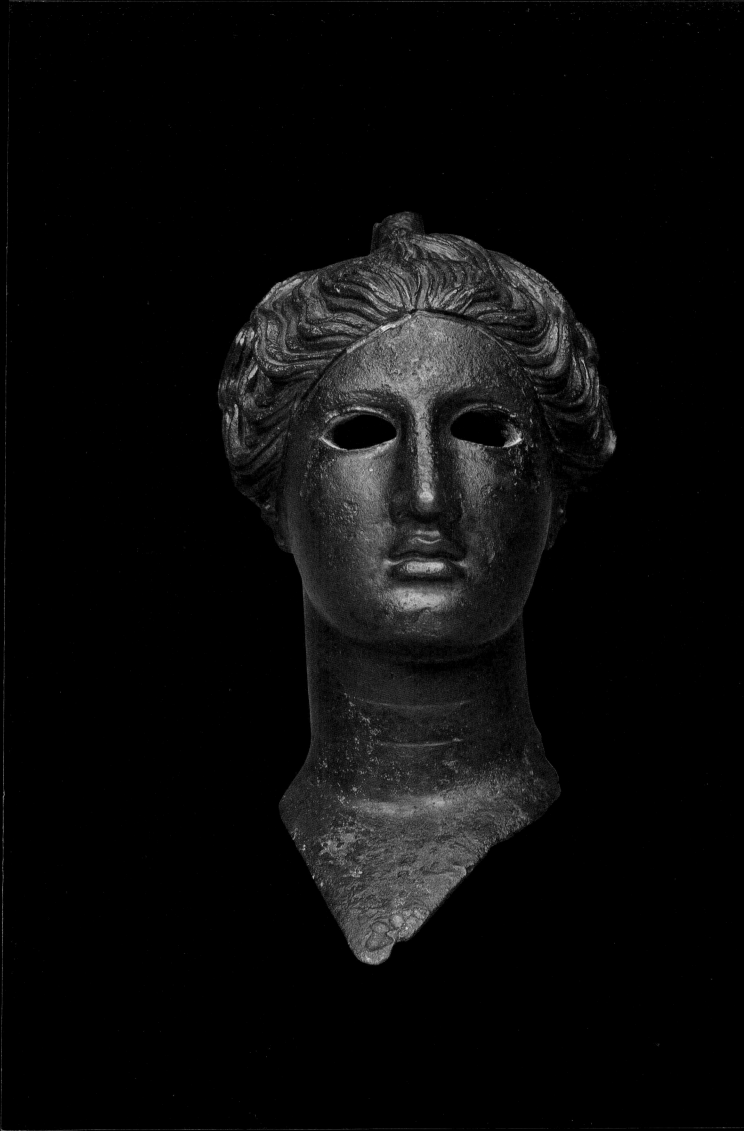

25
Nike (Victory) Unbinding Her Sandal
marble, c. 410 B.C.
height 1.40 m (55⅛ in.)
Acropolis Museum, Athens

As one approaches the entrance gates of the Athenian
Acropolis, one sees on the right a projecting bastion
crowned by the small temple of Athena Nike. Around
three sides of the temple, at the edge of the bastion, is a
balustrade decorated with a marble frieze. Victory was the
subject of the frieze, and on it many personifications of
victory, called Nikai, are shown in relief erecting trophies
of Persian armor or driving bulls to be sacrificed before
Athena. The entire frieze was probably designed by one
person, but the hands of several individual artists are evi-
dent in its execution.

This figure is poised to remove her sandal, perhaps
because she will walk on holy ground as she approaches
the goddess' sanctuary. She maintains her delicate balance
by furling her wings behind her. Her body shows through
the transparent drapery and, although the drapery does
little to express the volume of the body, the pattern of
folds harmonizes with it, helping to create the illusion of
balance. The fold lines are geometrically related: radiating
fanlike from the figure's left shoulder, hanging in *U*-
shaped curves from her raised knee to her left forearm,
and forming a strong vertical accent at the bottom.

The style of this sculptor, with his masterly rendering
of Nike's drapery and body, had a long-lasting impact on
Greek sculptors.

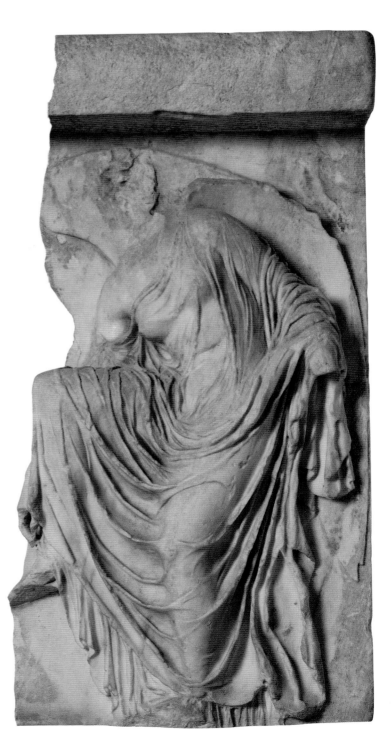

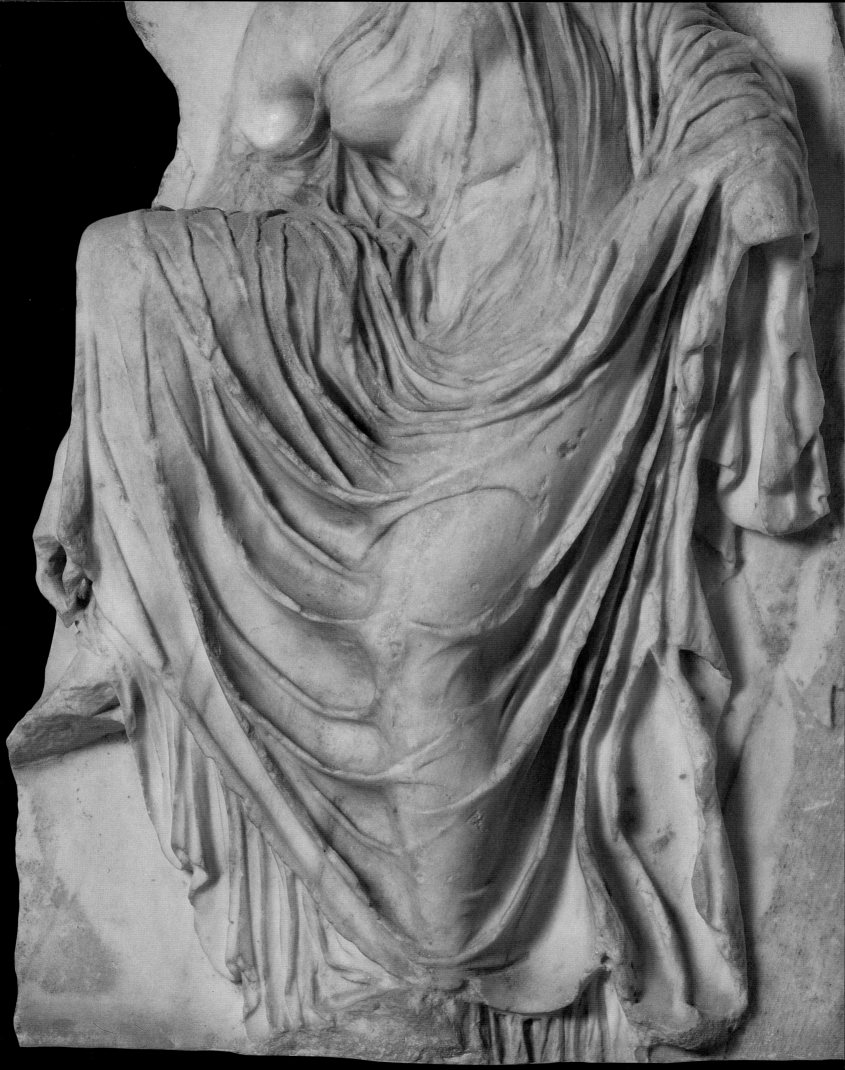

26
Votive Relief Dedicated to Hermes and the Nymphs
marble, 410–390 B.C.
height 0.65 m (26⅛ in.)
National Archaeological Museum, Athens, 1783

The relief on one face of this stone is a narrative with six standing figures. The woman at the left in a short chiton probably represents the goddess Artemis Munichia, the principal Artemis of the Peiraeus area. The female figure faces a bearded male figure, probably the hero Echelos. Behind him come Kephissos, the river god identified by the two horns on his forehead, and three nymphs. The compositional arrangement of the figures suggests that the goddess is receiving the hero, who presents to her the divinities of the area. On the molding over their heads is cut an inscription recording that Kephisodotos dedicated the stone.

The other side of the stone illustrates a little-known myth, the story of Iasile and Echelos, whose names appear in the molding over their heads. Echelos has abducted Iasile, holding her with one arm and the horses' reins (originally painted) with the other. Iasile clutches her blowing garments and limply hangs onto the chariot rail. Hermes leads the team of horses, the rising ground line suggesting that Echelos is driving uphill.

The relief was found along with others in the small Sanctuary of Kephissos near New Phaleron, situated near the long walls that connected Athens with Peiraeus.

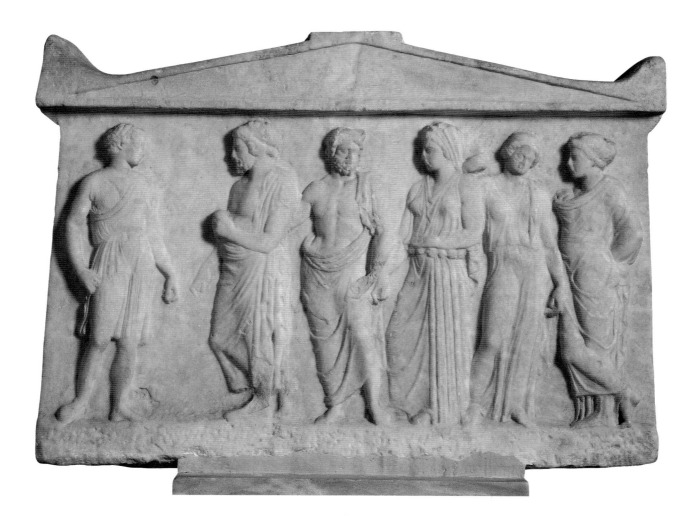

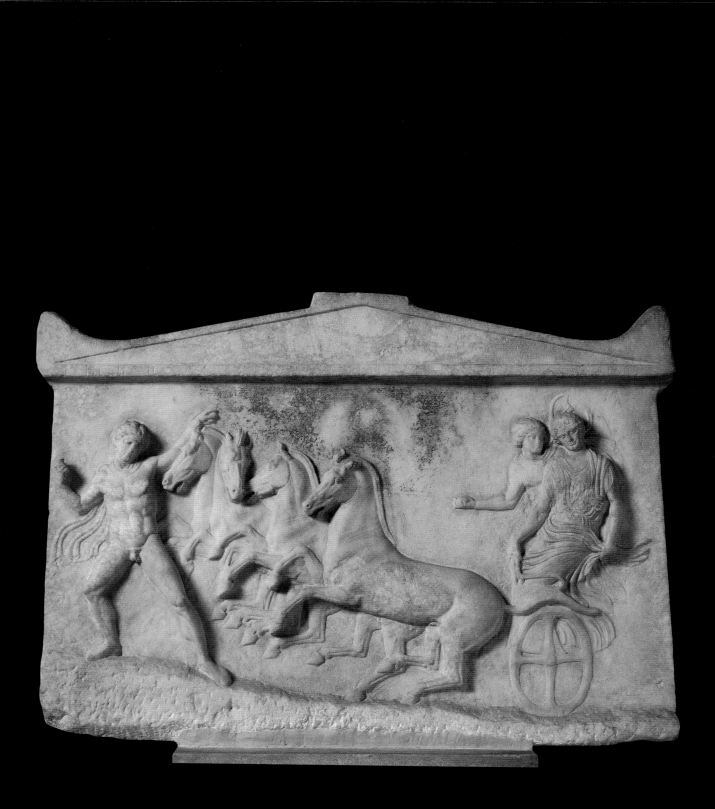

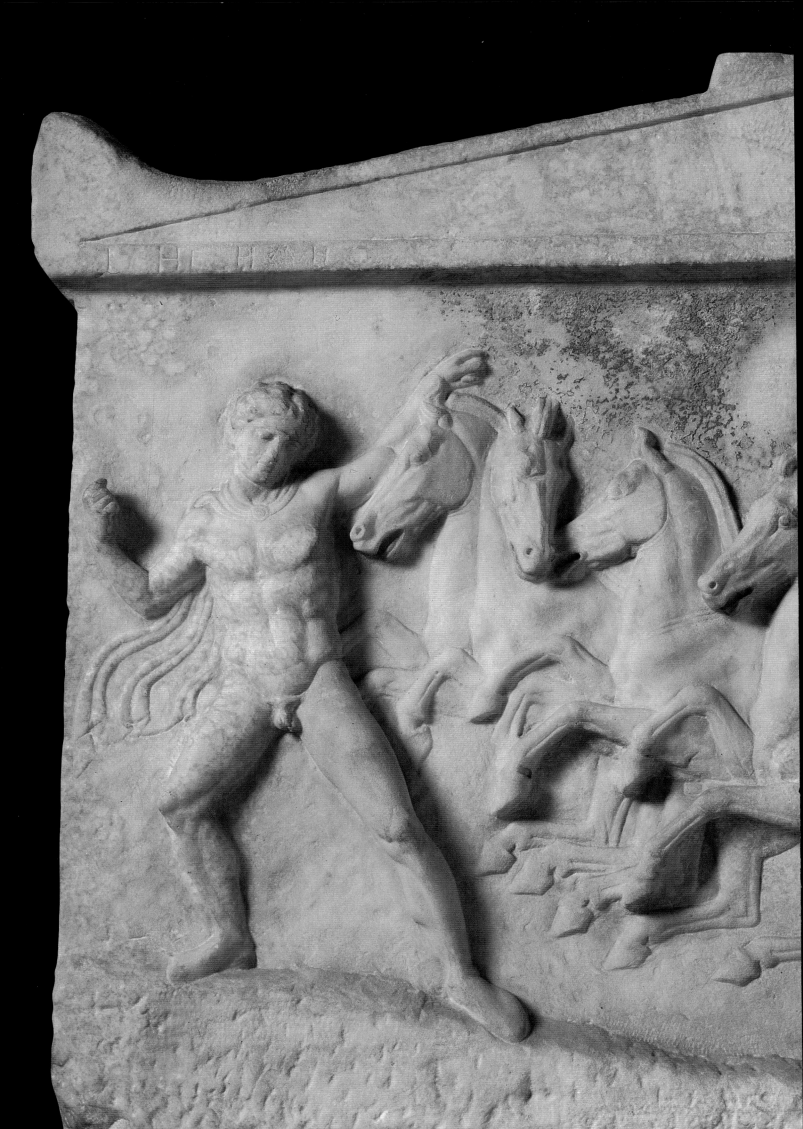

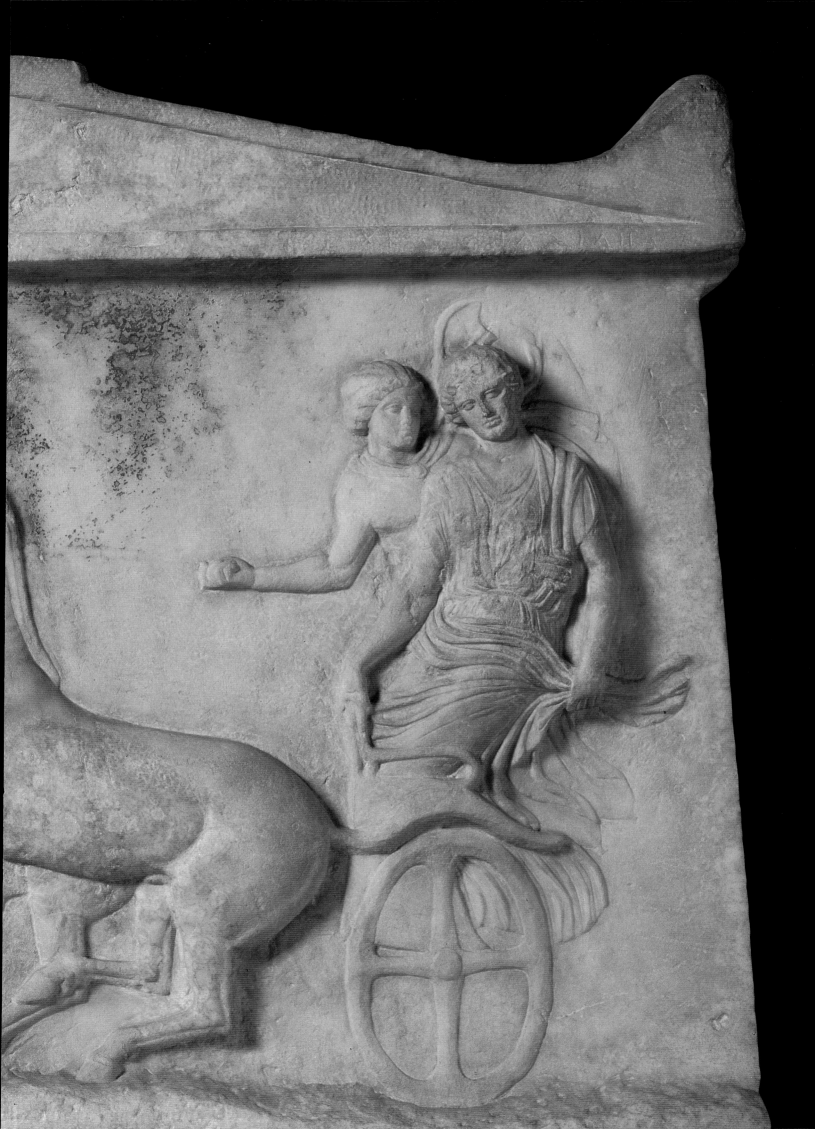

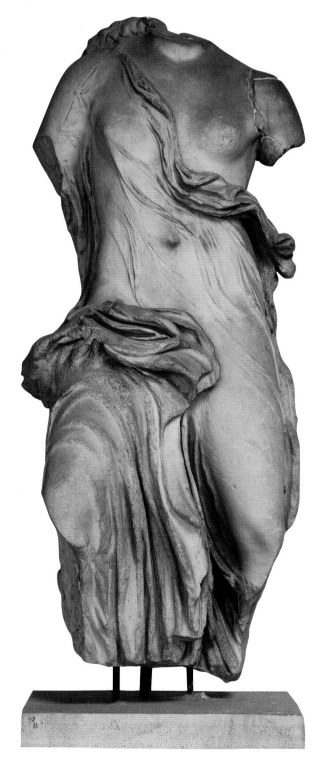

27
Statue of a Young Woman, Perhaps a Nereid
marble, c. 390 B.C.
height 1.25 m (49⅜ in.)
Agora Museum, Athens, S182

The front of the young woman's body is almost entirely revealed by her wind-blown transparent tunic, parts of which adhere to her body as if wet. The sensual effect is enhanced by the translucency of the Parian marble from which the figure is carved. She moves forward and slightly to the left while a subtle twist of her torso and head indicate that she is looking to the right. Part of her unbound hair is preserved behind the right shoulder. The cloak, of a heavier material, has fallen down around her hips and between her legs.

The running pose and wet, windblown drapery recall the later Nereids of the famous tomb monument in the British Museum from Xanthos, Lycia, in southwestern Turkey. Hence the suggestion that she may be a Nereid, one of the fifty daughters of the sea god Nereus. Such figures also occur as akroteria, the freestanding sculptures that served as roof ornaments on the peaks or corners of temple pediments. However, this figure seems too big to be an akroterion on any temple discovered so far in the Athenian Agora, where the statue was found. The back of the figure is less carefully rendered, giving it an unfinished look, as if it were meant to stand against a wall. Perhaps she was instead part of a votive monument in one of the Agora's sanctuaries.

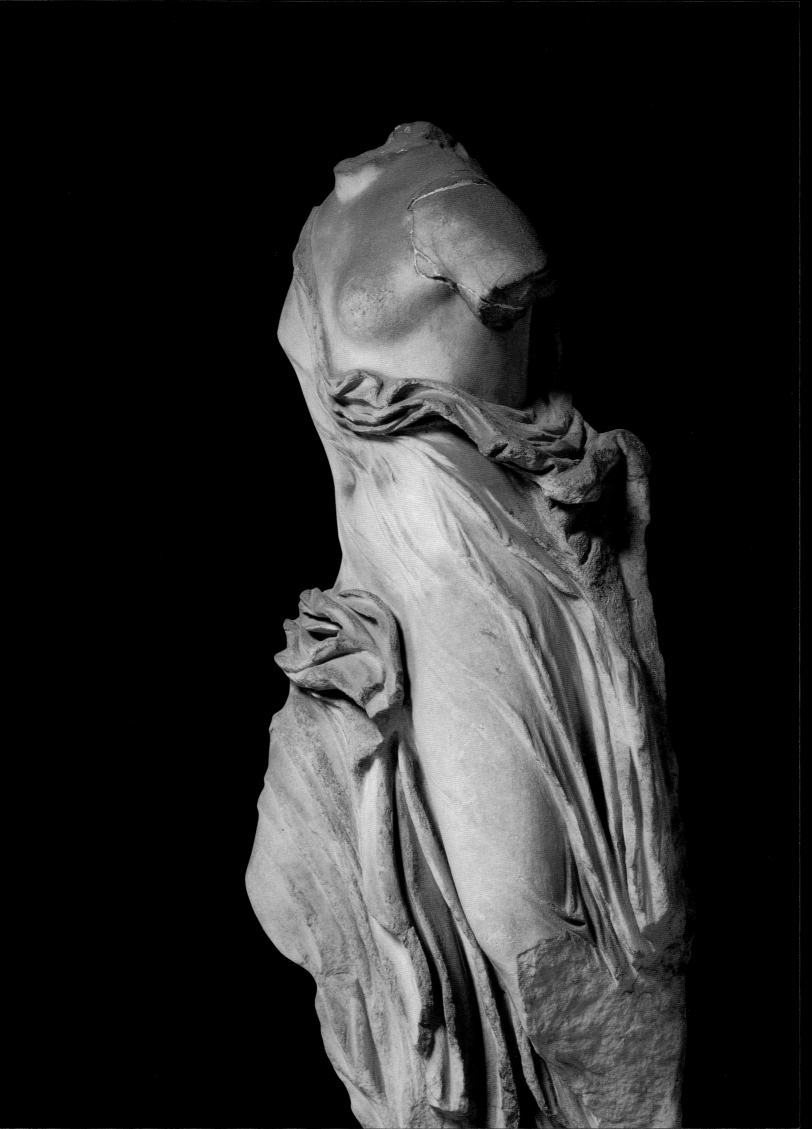

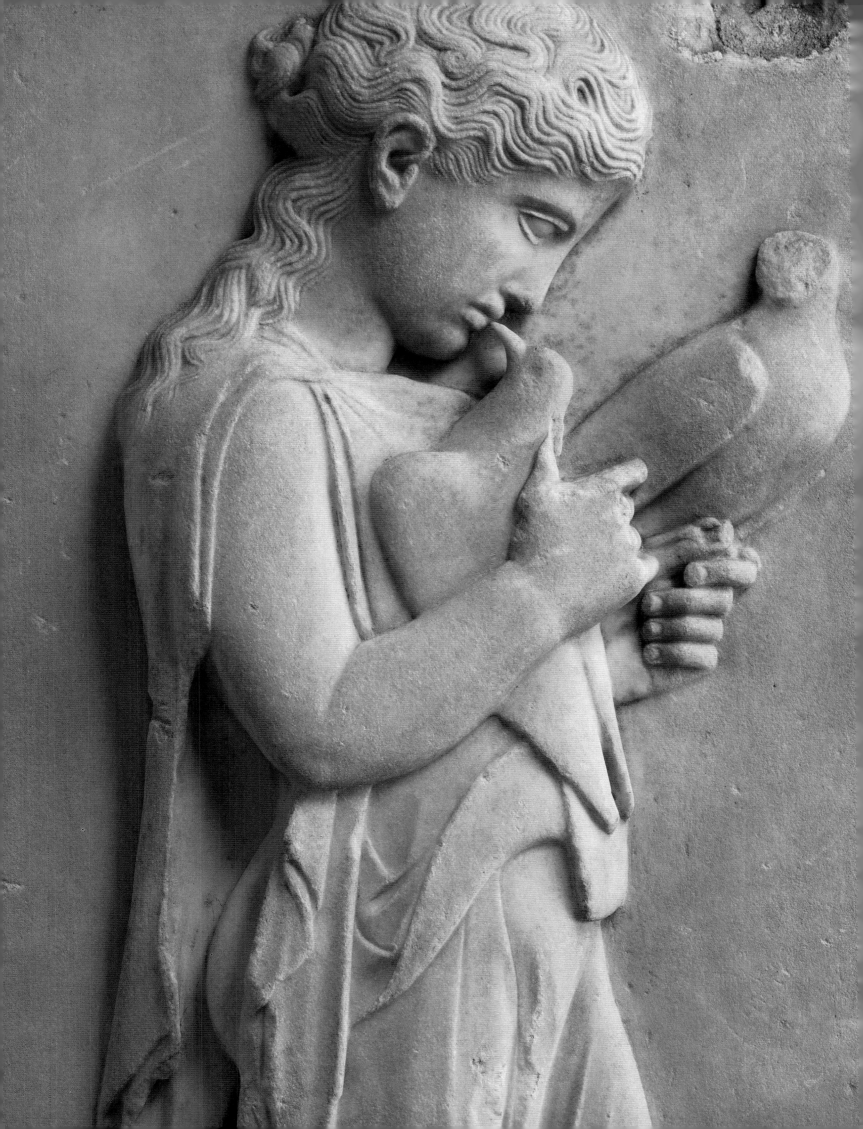

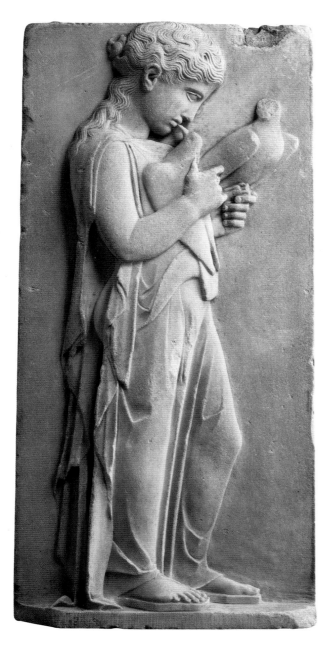

28
Grave Stele of a Little Girl

marble, 450–440 B.C.
height 0.80 m (31½ in.)
The Metropolitan Museum of Art, New York, Fletcher
Fund, 1927, 27.45

Gravestones were set up for children as well as for men
and women. Boys and girls were shown engaged in child-
ish activities by which their parents and friends wished
them to be remembered. Children often kept pets such as
birds, and here a little girl holds two doves, one with its
beak close to her mouth as if she were kissing it or giving
it food, the other perched on her left hand. The girl wears
a peplos fastened at both shoulders and open along her
right side revealing the rounded, childlike forms of her
arm and buttocks. The lack of a belt and the slight disarray
of the bloused upper part of her dress, which has been
flipped up by her motion in raising the dove to her face,
indicate her tender years.

This gravestone was found on the island of Paros and
was carved at a time when decorated gravestones did not
appear in Athens, perhaps because of an anti-luxury
decree. This stele is probably the work of a local Parian
sculptor whose individual style is especially apparent in
the stylized manner in which the hair is carved. The
similarity of the profile face to several of the cavalry riders
on the Parthenon frieze has suggested to some scholars that
Parian sculptors were among the many artisans who flocked
to Athens to work on the Parthenon (compare cat. 22).

Certain features of the gravestone and the relief are
missing: two dowel holes on the top edge of the slab indi-
cate that a finial, probably in the form of a palmette, once
surmounted the stone. Additionally, as was the case with
many Greek reliefs, some details must once have been
indicated with paint, here the straps of the girl's sandals
and part of the plumage of the doves. After it was found in
1775, the relief came to England from Greece and was
long in the collection of the earl of Yarborough at
Brocklesby Park near Hull, Lincolnshire.

29
Grave Stele of Eupheros
marble, 430–420 B.C.
height 1.47 m (57⅞ in.)
Kerameikos Museum, Athens, P1169

A boy of about fifteen, who in life must have loved sports, stares at his *strigil,* the curved metal tool used for cleansing the body after exercise. His name, Eupheros, is inscribed on the pediment above his head. Eupheros is dressed in a himation (large cloak) and sandals and wears a headband. The treatment of the drapery, especially where it runs under his right arm to fall over his left arm, recalls the style of the Parthenon but includes a touch of ornamental stiffness.

Offerings found in the grave near this stele help date it to the decade 430–420. It has been conjectured that Eupheros was a victim of the plague that ravaged Athens in 430–427 during the early years of the Peloponnesian War, but nothing on his stone confirms this. A desire to commemorate the many victims of the plague may have had something to do with the reappearance of decorated gravestones in Athens at this time, after a hiatus of more than eighty years. The tall, narrow shape of Eupheros' stele, with its single standing figure and pedimental crown recalling archaic examples, places it early in the series of stelai of the late fifth century (compare cat. 28).

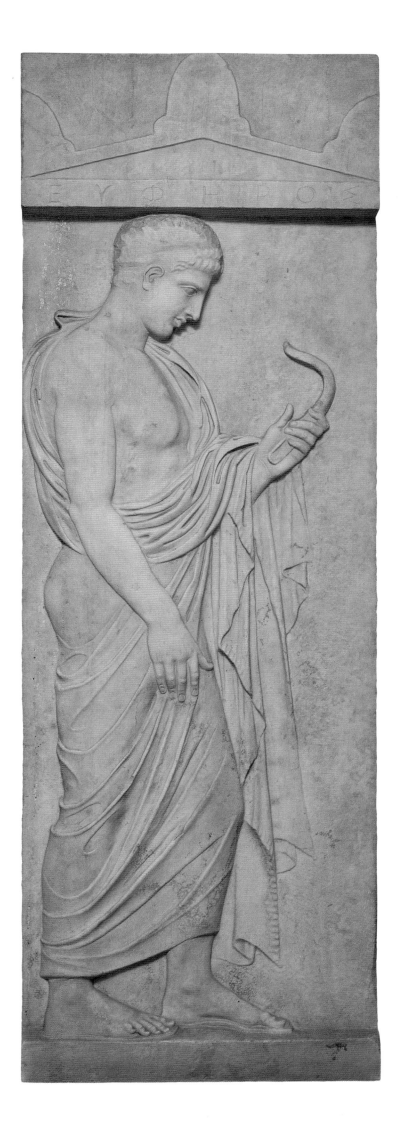

30
The Cat Stele
marble, 420–410 B.C.
height 1.09 m (42⅞ in.)
National Archaeological Museum, Athens, 715

A youth reaches out in a gesture of farewell, his hand in
front of a bird cage; with the other hand he holds a small
bird. Beside him a little boy leans against a stele on top of
which a cat sits as close as it can to the cage. The cat's
head is missing. This creature has also been interpreted as
a sculpted finial for the stele rather than the represent-
ation of a household pet.

Ambiguity surrounds what is depicted on this stele as
well as who is being mourned. Is the youth rescuing his
pet bird from his cat or simply putting the bird in its cage?
Does the bird symbolize the release of the soul or its
imprisonment in death? Is the boy mourning for the youth
or for himself? Lacking an inscription, it is impossible to
know for whom the stele was carved, who is dead and
who still lives.

This stele is an example of one that must have been
custom-made for the client. Others, such as the stele of
Eupheros (cat. 29), might have been prefabricated in the
sculptors' workshop and customized through the inscription.

After completion of the Parthenon in 432 B.C., the team
of sculptors would have been available for private com-
missions, and the best gravestones of the following
decades look as though they were carved by sculptors who
worked on the Parthenon. The style of the carving is close
to that of the Parthenon frieze, especially the face of the
youth and the treatment of his drapery. The stele is
crowned with a projecting molding decorated with lotus
flowers and palmettes connected by volutes with little
acanthus leaves.

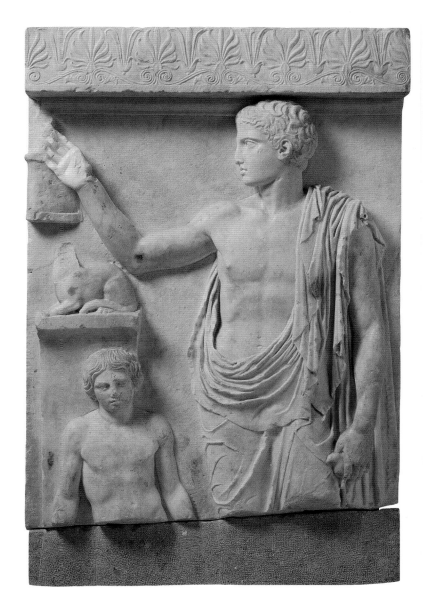

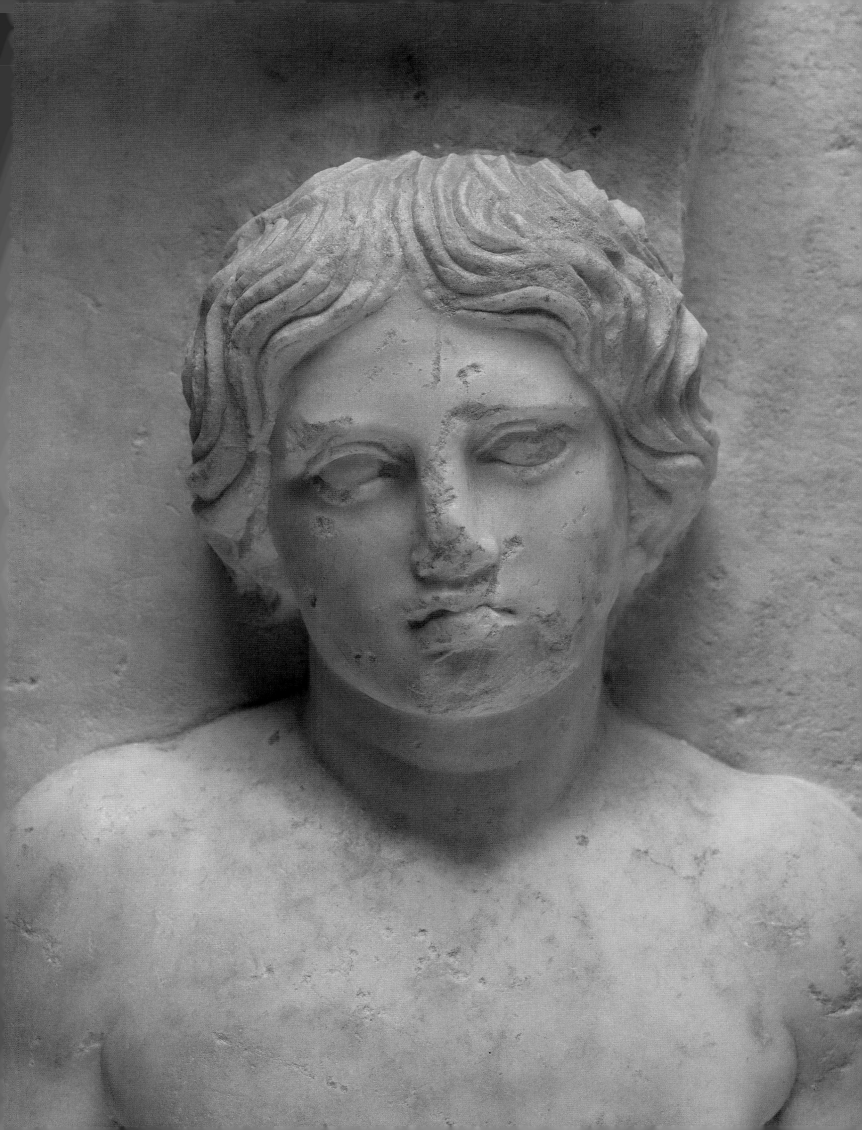

31

**Fragment of a Grave Stele: Seated Figure,
Youth with a Box**

marble, c. 420 B.C.
height 1.72 m (67¾ in.)
Archaeological Museum, Vathy, Samos, 78

The stone preserves the right side of a grave stele where a
youth stands holding a square box. The uncarved near
foot of the box suggests that it and other details were fin-
ished in paint. In the box, which is rendered in a bold and
effective but not quite accurate perspective, are two rolls of
cloth or ribbon that might be tied around grave stelai as
offerings to the dead. Perhaps the youth offers another rib-
bon to the partly visible seated figure who occupied the
left half of the stele. Only the right hand, draped lower
legs, and part of the left arm and staff held by this figure
are preserved; although it is hard to determine the sex, the
staff and the muscular forearm argue for a man. In the
background flutters a ribbon, perhaps meant to be under-
stood as tied around a stele.

Such direct references to the practice of the cult of the
dead, as seen here on this stone from Chora cemetery on
the island of Samos, do not occur on Athenian grave stelai
even though these activities are common on Athenian
white-ground *lekythoi* (vases offered at tombs).

The sculptor of this stone must have come under the
artistic influence of mainland Greece. The youth's pose
with his weight on one leg, along with the proportions,
the heavy forms of the hips, and the simplified anatomy,
as well as a sense of stillness combined with an implication
of activity, suggest the influence of Polykleitos of Argos.
The style of this renowned sculptor in bronze is known
today only through Roman copies of works famed in
antiquity such as the *Doryphoros* (Spearbearer) and
through the influence of the Argive sculptural school on
small bronzes (cats. 14, 19).

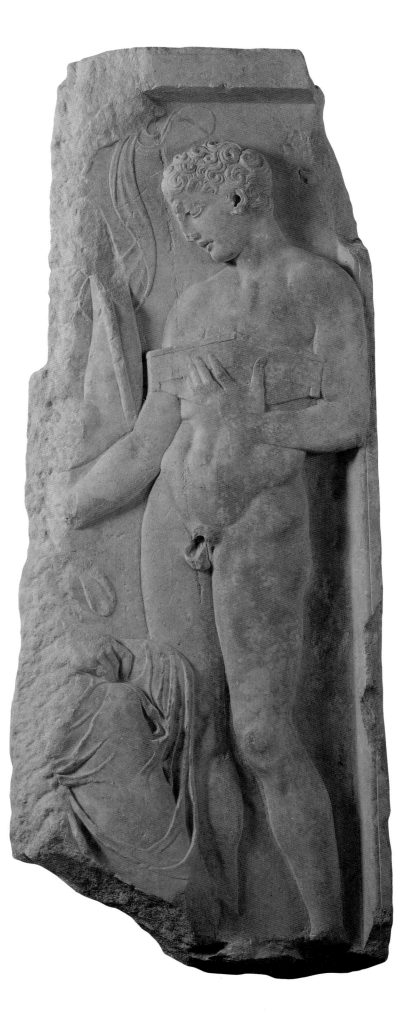

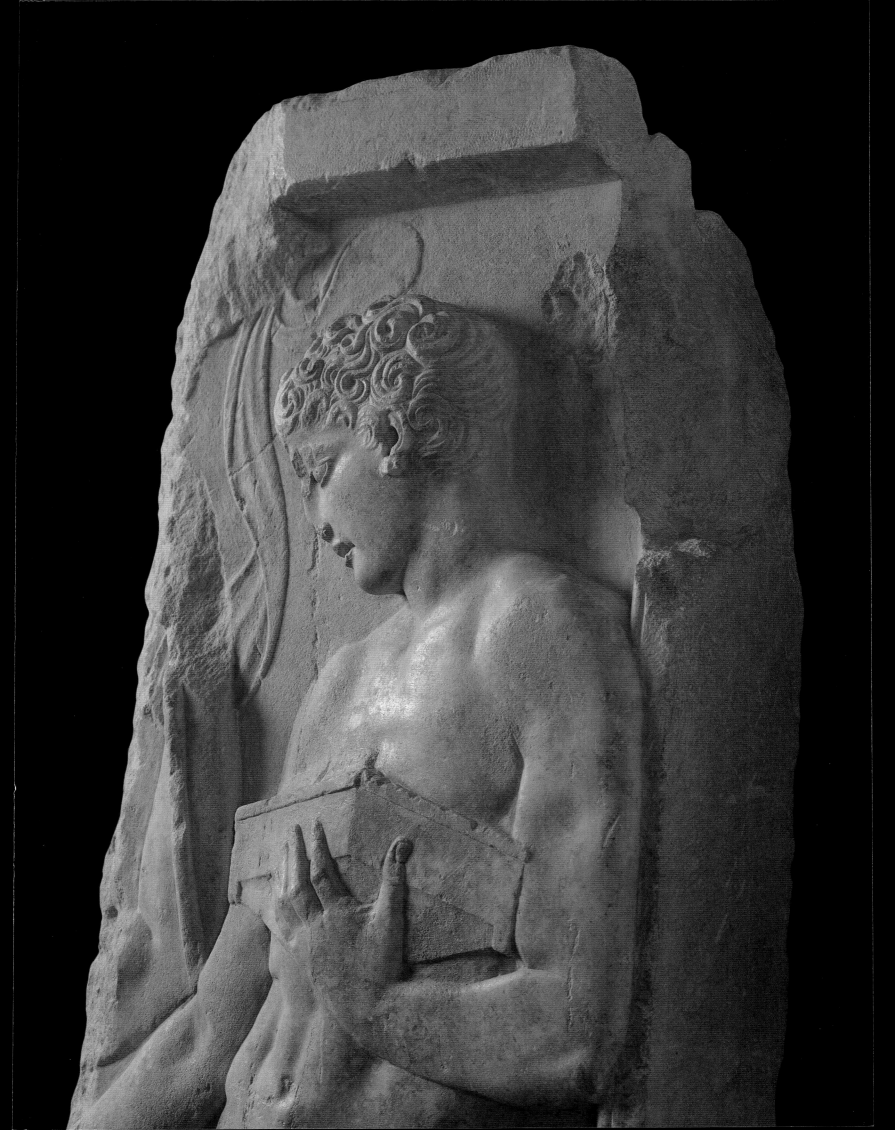

Grave Stele: Youth, Dog, and Man
marble, c. 400 B.C.
height 1.04 m (40¹⁵⁄₁₆ in.)
National Archaeological Museum, Athens, 2894

A youth, accompanied by his dog, clasps hands with an older, bearded man. The handshake appears on many gravestones, and in this context is considered to be a sign of unity between the living and the dead: the living will eventually follow the dead to the underworld and be reunited with them. The gesture can also be a sign of leave-taking as in vase paintings of hunters who were often accompanied by their dogs.

The relationship between these two figures may be that of father and son or teacher/mentor and pupil. No inscription helps to interpret the scene or identify which figure is being mourned. Over his left wrist the older man carries a small *aryballos* (container for oil), the strap for carrying it once having been painted on the background. Two dowel holes on the top edge of the stone indicate that a finial once surmounted the stele (compare cat. 28).

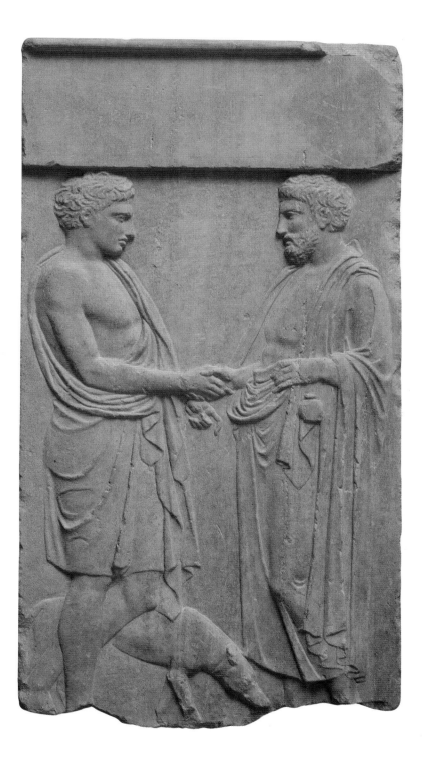

33
Grave Stele of Hegeso
marble, c. 400 B.C.
height 1.58 m (62³⁄₁₆ in.)
National Archaeological Museum, Athens, 3624

Hegeso sits in a chair with a curved back and legs, her san-daled foot resting on a small stool with lion-paw feet. A maid has handed her a jewel box. Her relaxed pose is revealed by the simple garment she wears. The chair and the maid frame the composition, the curve of the chair back reflected in the curve of the maid's body. Mistress and maid connect at the jewel box from which Hegeso has taken a necklace, once rendered in paint; the position of her fingers indicates that she held the necklace with both hands. The slight inclination of the women's heads lends an air of sorrow to this scene of everyday life that recalls the pleasures of a woman who loved pretty things and has left them behind in death. The beauty of the drapery also evokes the theme of adornment. Hegeso's tunic of nearly transparent linen clings like a second skin, revealing her breasts and legs. Over the tunic she wears a cloak of some fine material bunched up over her stomach and falling over the side of the chair in beautifully ordered folds. Her hair, dressed in waves, is bound with three ribbons and covered behind with a transparent veil. The two figures are placed within an architectural frame formed by two pilasters supporting a pediment topped with palmettes. Hegeso's name and that of Proxenos, her father, are writ-ten in the lintel. This stele once stood in the Kerameikos Cemetery in Athens.

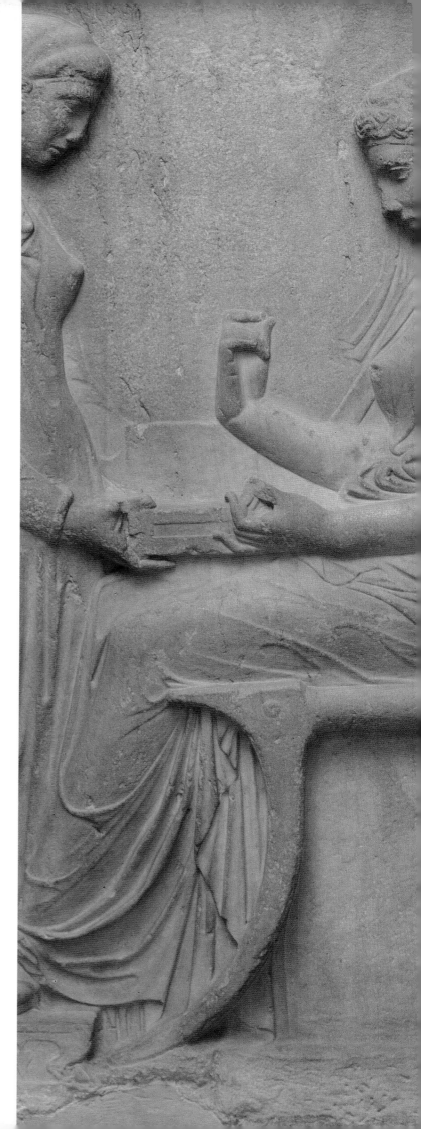

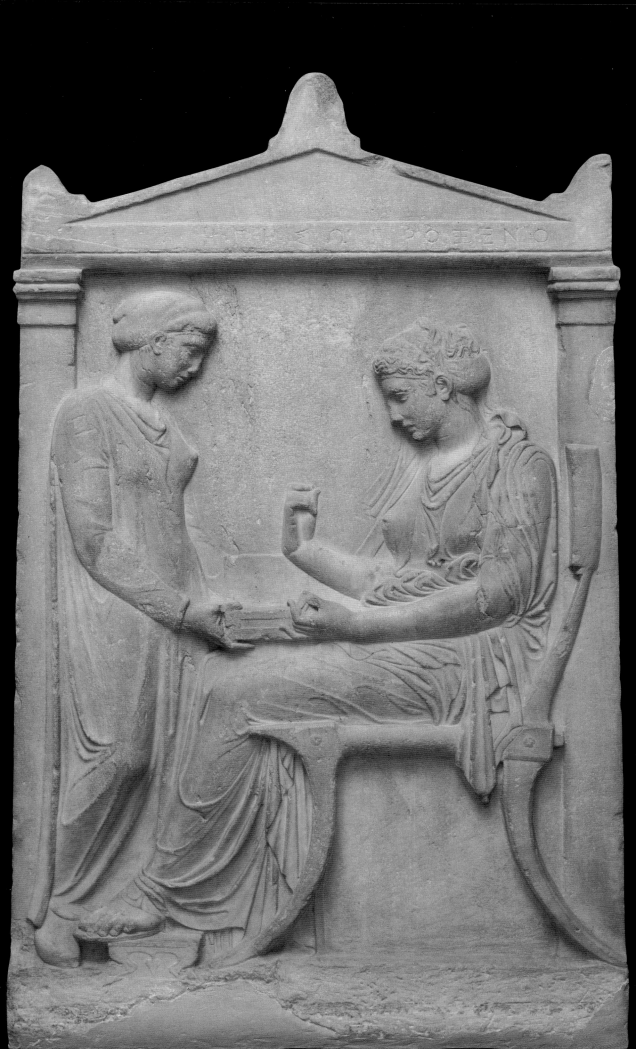

34
Grave Stele of Ktesilaos and Theano
marble, 400–390 B.C.
height 0.93 m (36⅝ in.)
National Archaeological Museum, Athens, 3472

Within an architectural frame similar to that of Hegeso's
stele, the sculptor has portrayed two people, Ktesilaos and
Theano, whose names appear on the lintel of the pedi-
ment. Ktesilaos stands with one leg crossed over the other,
hands clasped together, gazing intently at Theano. She
makes a gesture with her cloak that is often associated
with brides and suggests the modesty of the well-bred
young woman who veils herself but reveals her loveliness
to her husband. Because the two names are inscribed, it is
likely that both rested in the grave once marked by this
stele, but, since they do not seem to communicate with
each other, it may be that they died at different times.

Ktesilaos' furrowed brow and Theano's distant gaze
suggest subtle emotions. An interest in conveying
the feelings of figures on gravestones was to become
more evident in the fourth century B.C.

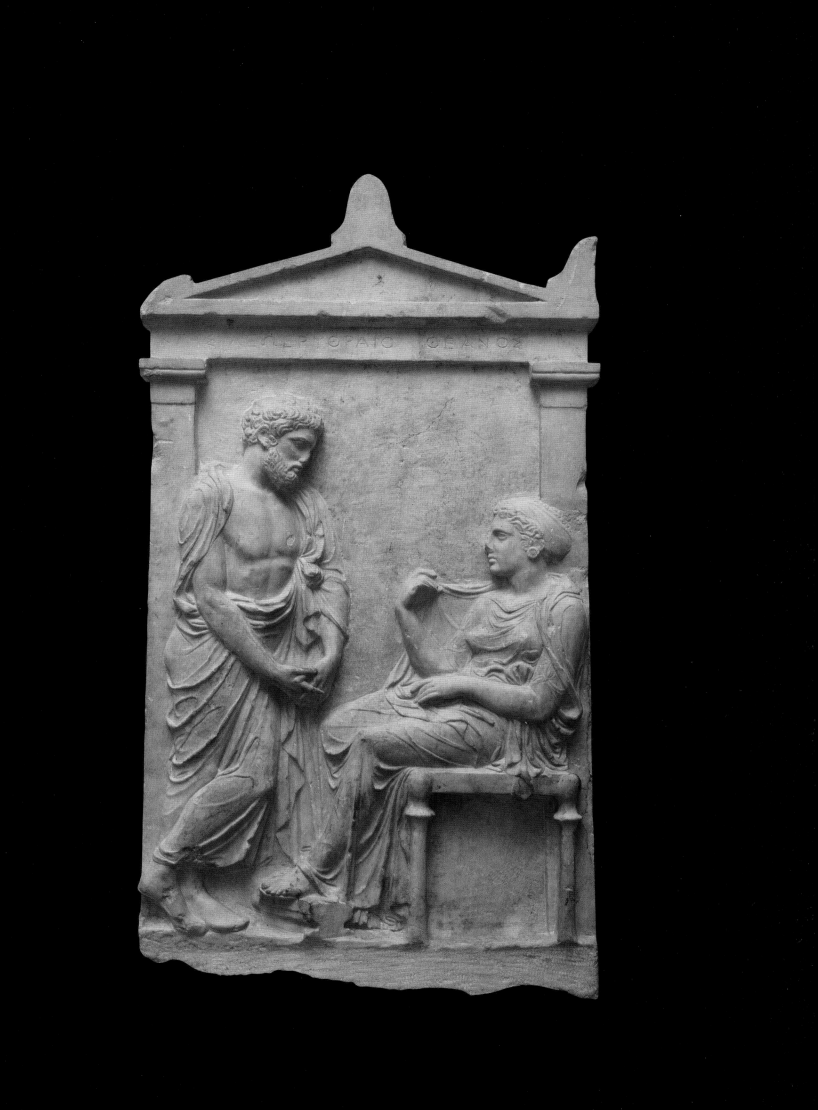

DIAGRAMS OF EAST PEDIMENT,
TEMPLE OF APHAIA, AEGINA

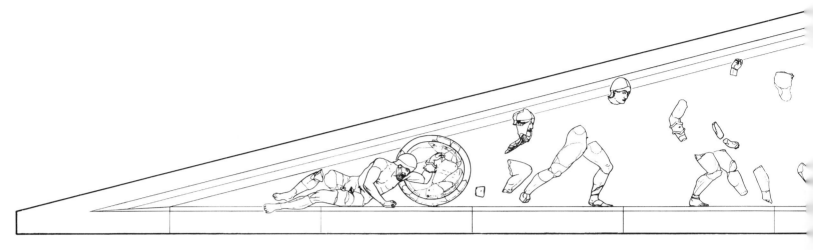

Drawing of Extant Remains (see also cat. 3)

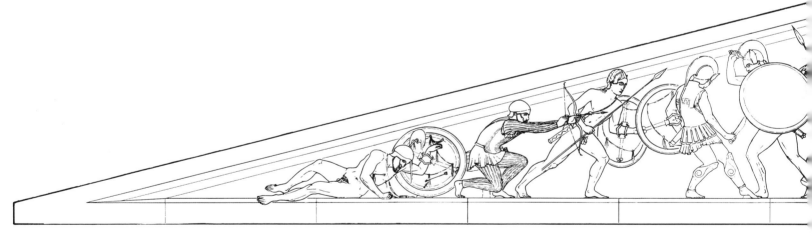

Reconstruction Drawing

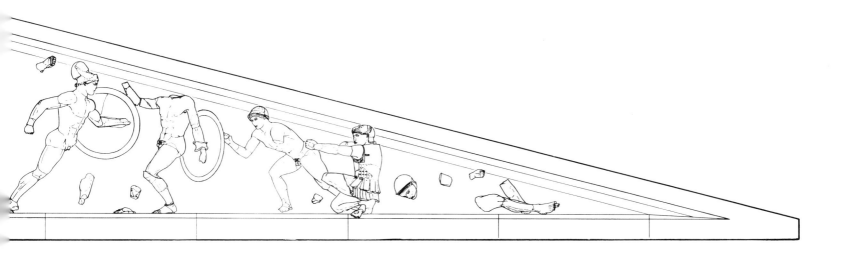

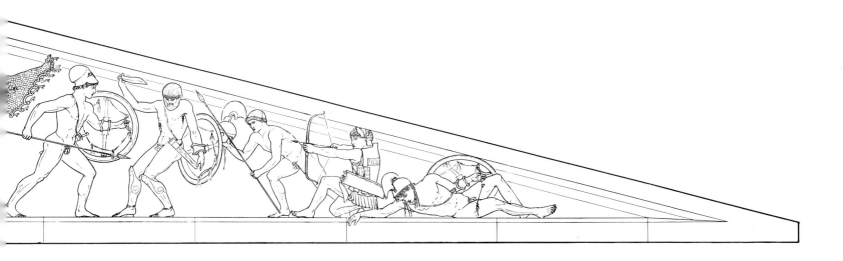

adapted from Dieter Ohly, *Die Aegineten*. Munich, 1976.

Drawing of Extant Remains (see also cat. 23)

Reconstruction Drawing

adapted from Eugenio La Rocca, *Amazzonomachia, Le sculture frontonali del tempio di Apollo Sosiano*. Rome, 1985.

Suggestions for Further Reading

Palagia, *Development of Classical Style in Athens*

Ashmole, Bernard. *Architect and Sculptor in Classical Greece.* London, 1972.

Boardman, John. *Greek Sculpture: The Classical Period.* London, 1985.

Boardman, John. *The Parthenon and Its Sculptures.* London, 1985.

Brommer, Frank. *The Sculptures of the Parthenon.* London, 1979.

Carpenter, Rhys. *Greek Sculpture.* Chicago, 1960.

Cook, B. F. *The Elgin Marbles.* London, 1984.

The Eye of Greece. Edited by D. Kurtz and B. Sparkes. Cambridge, England, 1982.

Gombrich, E. G. *Art and Illusion.* 4th edition. London, 1972.

Greek Art: Archaic into Classical. Edited by C. G. Boulter. Leiden, 1985.

Mattusch, C. C. *Greek Bronze Statuary.* Ithaca, 1988.

Pollitt, J. J. *Art and Experience in Classical Greece.* Cambridge, England, 1972.

Pollitt, J. J. *The Art of Ancient Greece: Sources and Documents.* 2d edition. Cambridge, England, 1990.

Ridgway, Brunilde S. *The Severe Style in Greek Sculpture.* Princeton, 1970.

Ridgway, Brunilde S. *Fifth Century Styles in Greek Sculpture.* Princeton, 1981.

Robertson, Martin. *A History of Greek Art.* 2 vols. London, 1975.

Alexandri, *Athenian Democracy*

Andrewes, Anthony. *Probouleusis, Sparta's Contribution to the Technique of Government.* Oxford, 1954.

Bieicken, J. *Die athenische Demokratie.* Paderborn, 1985.

Davies, John Kenyon. *Wealth and the Power of Wealth in Classical Athens.* New York, 1981.

Ehrenberg, Victor. *The Greek State.* Oxford, 1960.

Farrar, Cynthia. *The Origins of Democratic Thinking.* Cambridge, England, 1988.

Forde, Steven. *The Ambition to Rule: Alcibiades and the Politics of Imperialism in Thucydides.* Ithaca, 1989.

Hansen, Mogens Herman. *Eisangelia.* Odense, 1975.

Hansen, Mogens Herman. *The Athenian Ecclesia.* Copenhagen, 1983.

Hansen, Mogens Herman. *The Athenian Assembly.* Oxford, 1987.

Hignett, C. *A History of the Athenian Constitution to the End of the Fifth Century B.C.* Oxford, 1952.

Jones, A. H. M. *Athenian Democracy.* Oxford, 1957.

Jordan, Borimir. *The Athenian Navy in the Classical Period.* Berkeley, 1975.

Kagan, D. *Pericles of Athens and the Birth of Democracy.* New York, 1991.

Kron, U. "Demos, Pnyx and Nymphenhügel. Zu Demos-Darstellungen und zum ältesten Kultort des Demos in Athen." *Archäologische Mitteilungen* 94 (1979), 49–75.

Meiggs, Russell. *The Athenian Empire.* Oxford, 1972.

Ober, Josiah. *Mass and Elite in Democratic Athens: Rhetoric, Ideology, and the Power of the People.* Princeton, 1989.

Oliver, J. H. *Demokratia, the Gods and the Free World.* Baltimore, 1960.

Osborne, Robin. *Demos: The Discovery of Classical Attika.* Cambridge, England, 1985.

Rhodes, P. J. *The Athenian Boule.* Oxford, 1972.

de Romilly, Jacqueline. *Thucydides and Athenian Imperialism.* Oxford, 1963.

Sealey, R. *The Athenian Republic.* University Park, Pa., 1987.

Sinclair, R. K. *Democracy and Participation in Athens.* Cambridge, England, 1988.

Starr, Chester G. *The Birth of Athenian Democracy: The Assembly in the Fifth Century B.C.* New York, 1990.

Thomsen, Rudi. *The Origin of Ostracism.* Copenhagen, 1972.

Traill, John S. *Demos and Trittys.* Toronto, 1986.

Tzachou-Alexandri, O. "Demos, Demokratia." *Lexicon Iconographicum Mythologiae Classicae* 3, 1 (1986).

Wallace, Robert W. *The Areopagus Council, to 307 B.C.* Baltimore, 1989.

Whitehead, David. *The Demes of Attica, 508/7–ca. 250 B.C.* Princeton, 1986.

Lambrinoudakis, *Architecture*

Berve, Helmut, and G. Gruben, photographs by M. Hirmer. *Greek Temples, Theatres, and Shrines.* New York and London, 1963.

Boersma, Joh S. *Athenian Building Policy from 561/0 to 405/4 B.C.* Groningen, 1970.

Gruben, Gottfried. *Die Tempel der Griechen: W. Müller-Wiener Griechisches Bauwesen in der Antike.* 4th ed. Munich, 1989

Hoepfner, Wolfram, and Ernst-Ludwig Schwandner. *Haus und Stadt im Klassischen Griechenland.* Wohnen in der Klassischen Polis, Book I. Munich, 1986.

Schuller, W., W. Hoepfner, and E.-L. Schwandner, ed. *Demokratie und Architektur.* Deutsches Archäologisches Institut: Konstanzer Symposion vom 17. bis 19, Juli 1987. Munich, 1989.

Delivorrias, *The Human Figure*

Alscher, Ludger. *Griechische Plastik,* vol. 2/2–3. Berlin, 1982, 1956.

Bianchi Bandinelli, Ranuccio. *Storicità dell'arte Classica*. New ed. Florence, 1950.

Boardman, John. *The Parthenon and Its Sculptures*. London, 1985.

Borbein, A. "Die Griechische Statue des 4. Jhs. v. Chr. Formanalytische Untersuchungen zur Kunst der Nachklassik." *Jahrbuch des Instituts* 88 (1973), 43–212.

Carpenter, Rhys. *The Esthetic Basis of Greek Art of the Fifth and Fourth Centuries B.C.* 2d ed. Bloomington, 1959.

Fehr, Burckhardt. *Bewegungsweisen und Verhaltensideale*. Bad Bramstedt, 1979.

Fehr, Burckhardt. *Die Tyrannentöter*. Frankfurt, 1984.

Fuchs, Werner. *Die Skulptur der Griechen*. 2d ed. Munich, 1979.

Harrison, E. B. "The South Frieze of the Nike Temple and the Marathon Painting in the Painted Stoa." *American Journal of Archaeology* 76 (1972), 353–378.

Hölscher, Tonio. *Griechische Historienbilder des 5. und 4. Jahrhunderts v. Chr.* Würzburg, 1973.

Karusos, Christos. "A Treasure and a Struggle." *Ancient Art, Lectures-Studies* (in Greek). 2d ed. Athens, 1981.

Müller, Reimar. *Der Mensch als Mass der Dinge*. Berlin, 1976.

Pollitt, J. J. *Art and Experience in Classical Greece*. Cambridge, England, 1972.

Ridgway, Brunilde S. *The Severe Style in Greek Sculpture*. Princeton, 1970.

Ridgway, Brunilde S. *Fifth Century Styles in Greek Sculpture*. Princeton, 1981.

Rühfel, Hilde. *Das Kind in der griechischen Kunst*. Mainz, 1984.

Voutiras, Emmanuel. *Studien zu Interpretation und Stil Griechischer Porträts des 5. und früher 4. Jahrhunderts*. Bonn, 1980.

Calligas, *Bronze Sculpture*

Bol, Peter. *Antike Bronzetechnik*. Munich, 1985.

Charbonneaux, Jean. *Greek Bronzes*. London, 1962.

Comstock, Mary, and Cornelius Vermeule. *Greek, Etruscan and Roman Bronzes in the Museum of Fine Arts, Boston*. Boston, 1971.

Finn, David, and Caroline Houser. *Greek Monumental Bronze Sculpture*. New York, 1983.

Kozloff, A. P., and David G. Mitten. *The Gods' Delight: The Human Figure in Classical Bronze*. Cleveland, 1988.

Mitten, David G., and Suzannah F. Doeringer. *Master Bronzes from the Classical World*. Mainz, 1967.

Ridgway, Brunilde S. *Fifth Century Styles in Greek Sculpture*. Princeton, 1981.

Rolley, Claude. *Les Bronzes Grecs*. Fribourg, 1983.

Iakov, *Ancient Drama*

Greek Tragedy and Political Theory. Edited by J. P. Euben. Berkeley, 1986.

Die griechische Tragödie in ihrer gesellschaftlichen Funktion. Edited by H. Kuch. Berlin, 1983.

Meier, Christian. *Die politische Kunst der griechischen Tragödie.* Munich, 1988.

Podlecki, Anthony J. *The Political Background of Aeschylean Tragedy.* Ann Arbor, 1966.

de Ste. Croix, G. E. M. *The Origins of the Peloponnesian War,* Appendix XXIX, "The Political Outlook of Aristophanes," 355–376. London and Ithaca, N. Y., 1972.

Zuntz, G. *The Political Plays of Euripides.* Manchester, 1955.

Catalogue

Boardman, John. *Greek Sculpture: The Classical Period.* New York, 1985.

Carpenter, Rhys. *Greek Sculpture.* Chicago, 1960.

Lullies, Reinhard, and Max Hirmer. *Greek Sculpture.* New York, 1960.

Pollitt, J. J. *Art and Experience in Classical Greece.* Cambridge, England, 1972.

Ridgway, Brunilde S. *The Severe Style in Greek Sculpture.* Princeton, 1970.

Ridgway, Brunilde S. *Fifth Century Styles in Greek Sculpture.* Princeton, 1981.

Robertson, Martin. *A History of Greek Art.* 2 vols. London, 1975.

Cat. 1. Richter, Gisela Marie Augusta. *Kouroi, Archaic Greek Youths.* 3rd ed. New York, 1970, 122–123, no. 145, figs. 425–429, 437.

Cat. 2. Edwards, Charles M. "The Running Maiden from Eleusis and the Early Classical Image of Hekate." *American Journal of Archaeology* 90 (1986), 307–318.

Cat. 3. Ohly, Dieter. *Die Aegineten.* Munich, 1976, 92–95.

Cat. 4. Mattusch, C. C. *Greek Bronze Statuary.* Ithaca, N.Y., 1988, 92, fig. 5.2.

Cat. 5. Hurwit, Jeffrey M. "The Kritios Boy: Discovery, Reconstruction, and Date." *American Journal of Archaeology* 93 (1989), 41–80.

Cat. 6. Finn, David, and Caroline Houser. *Greek Monumental Bronze Sculpture.* New York, 1983, 41–42; Mattusch *Bronze Statuary* 1988, 94–95.

Cat. 7. Brouskari, Maria S. *The Acropolis Museum, A Descriptive Catalogue.* Athens, 1974, 129, fig. 248.

Cat. 8. Brouskari *Acropolis* 1974, 123, pl. 237; Boardman, John. *Greek Sculpture: The Classical Period.* London, 1985, 66, fig. 41.

Cat. 9. Ashmole, Bernard, and Nicholas Yalouris. *Olympia, The Sculptures of the Temple of Zeus.* London, 1967, 183–184; Ashmole, Bernard, *Architect and Sculptor in Classical Greece.* New York, 1972.

Cat. 10. Haynes, D. E. L. "The Technique of the Chatsworth Head." *Revue Archéologique* (1968). Finn and Houser *Monumental* 1983, 72–74. Mattusch *Bronze Statuary* 1988, 154–155, fig. 7.1.

Cat. 11. Kunze, Emil, and Hans Schleif. *III Bericht über die Ausgrabungen in Olympia.* Winter 1938/1939, 131–143, pls. 59–64. Lullies and Hirmer *Sculpture* 1960, 72, pl. 106.

Cat. 12. Mertens, Joan R. "Greek Bronzes in the Metropolitan Museum of Art." *The Metropolitan Museum of Art Bulletin* (Fall 1985), no. 21.

Cat. 13. Charbonneaux, Jean. "Bronze grec, statuette de jeune homme." *Bulletin des Musées de France* (March 1937), 41–42.

Cat. 14. Walter-Karydi, Elena. "Bronzen aus Dodona—Eine Epirotische Erzbilderschule." *Jahrbuch der Berliner Museen* 23 (1981), 36–37, fig. 37. Rolley *Bronzes* 1983, 89–90, fig. 67.

Cat. 15. Villefosse, Heron de. In *Monument Piot* 1 (1894), 105–114. Bol, Peter C. In *Polyklet, Der Bildhauer der griechischen Klassik.* Exh. cat. Museum alter Plastik, Frankfurt. Mainz, 1990, 509, no. 4.

Cat. 16. Richter, Gisela Marie Augusta. *Korai: Archaic Greek Maidens.* London, 1968, 109, figs. 664–666. *Hommes et Dieux de la Grèce Antique.* Exh. cat. Palais des Beaux-Arts. Brussels, 1982, 68, no. 22.

Cat. 17. Neugebauer, Karl Anton. *Staatliche Museen zu Berlin, Die Griechische Bronzen der klassischen Zeit und des Hellenismus.* Berlin, 1951, 13–16, pls. 8–10. Tolle-Kastenbein, Renate. *Frühklassische Peplosfiguren, Originale.* Mainz, 1980, 38–40, pl. 26.

Cat. 18. Tolle-Kastenbein *Peplosfiguren* 1980, 36–37, pls. 24–25. Congdon, Lenore O. Keene. *Caryatid Mirrors of Ancient Greece.* Mainz, 1981, 183–184, no. 74, pl. 67.

Cat. 19. Neugebauer *Staatliche* 1951, 8–12, pl. 6. Rolley *Bronzes* 1983, 89, fig. 66. Bol *Polyklet* 1990, 508–509, no. 3.

Cat. 20. Walter-Karydi, Elena. "Bronzen aus Dodona—Eine Epirotische Erzbilderschule." *Jahrbuch der Berliner Museen* 23 (1981), 40–42, fig. 47. *Albanien: Schätze aus dem Land der Skipetaren.* Exh. cat. Hildesheim. Mainz, 1988, no. 293.

Cat. 21. Neugebauer *Staatliche* 1951, 60–62, pl. 4. Walter-Karydi *Dodona* 1981, 14–15, figs. 4–7.

Cat. 22. Brouskari *Acropolis* 1974, 152, fig. 317. Robertson, Martin, and Alison Frantz. *The Parthenon Frieze.* London, 1975. Brommer, Frank. *The Sculptures of the Parthenon.* London, 1979.

Cat. 23. La Rocca, Eugenio. *Amazzonomachia: Le sculture frontonali del tempio di Apollo Sosiano.* Rome, 1985. La Rocca, Eugenio. In *Kaiser Augustus und die verlorene Republik.* Exh. cat. Martin-Gropius-Bau. Berlin, 1988, 121–136, no. 25.

Cat. 24. Thompson, Dorothy B. "The Golden Nikai Reconsidered." *Hesperia* 13 (1944), 178–181. Thompson, Homer A., and R. E. Wycherley. "The Agora of Athens." *The Athenian Agora* XIV (Princeton, 1972), 190–191, frontispiece and pl. 98. Mattusch *Bronze Statuary* 1988, 172–176, fig. 7.7.

Cat. 25. Carpenter, Rhys. *The Sculpture of the Nike Temple Parapet.* Cambridge, Mass., 1929. Brouskari *Acropolis* 1974, 158, fig. 333.

Cat. 26. Boardman *Classical* 1985, fig. 168 a–b. Edwards, Charles M. "Greek Votive Reliefs to Pan and the Nymphs." PhD diss. Institute of Fine Arts, New York University, 1985.

Cat. 27. Boardman *Classical* 1985, fig. 116. Evelyn B. Harrison. "Style Phases in Greek Sculpture from 450 to 370 B.C." *Praktika,* 12th International Congress of Classical Archaeology, Athens, 4–10 September 1983, vol. 3 (Athens, 1988), 99–105.

Cat. 28. Richter, Gisela M. A. *Catalogue of Greek Sculpture in the Metropolitan Museum of Art.* Oxford, 1954, 49–50, no. 73, pl. LX:a.

Cat. 29. *Athenische Mitteilungen* 79 (1964), 85–104; Schmaltz, Bernhard. *Griechische Grabreliefs.* Darmstadt, 1983, 199, pl. 7:2. Boardman *Classical* 1985, fig. 147.

Cat. 30. Lullies and Hirmer *Sculpture* 1960, 82, pl. 182; Robertson *History* 1975, 367, pl. 121b; Boardman *Classical* 1985, fig. 148.

Cat. 31. Zanker, P. In *Antike Kunst* 9 (1966), 16–20, pl. 5:1, 4. Boardman *Classical* 1985, fig. 159.

Cat. 32. *Greek Art of the Aegean Islands.* Exh. cat. Metropolitan Museum of Art. New York, 1979, 233, no. 189.

Cat. 33. Robertson *History* 1975, 367, pl. 121d. Stewart, Andrew. *Greek Sculpture, An Exploration.* New Haven, 1990, 172, fig. 477.

Cat. 34. Lullies and Hirmer *Sculpture* 1960, 87, pls. 200–201; Boardman *Classical* 1985, fig. 157.